OUR
WORLD
NOW
5

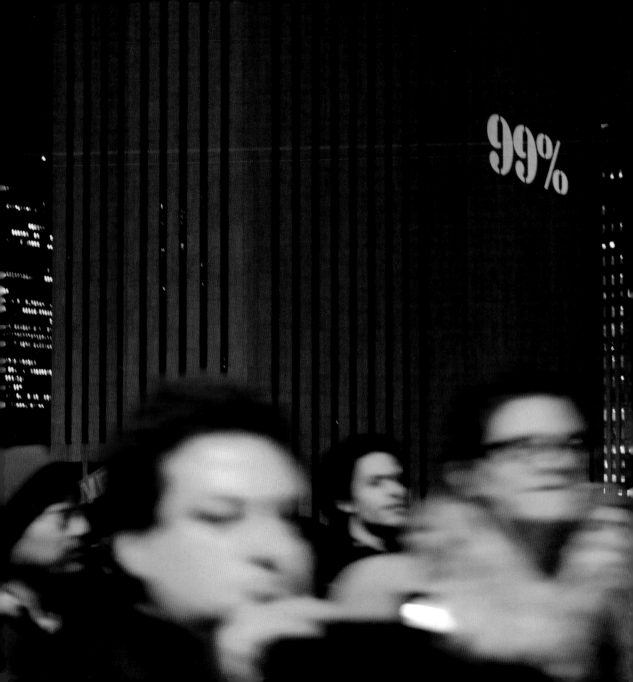

REUTERS
OUR WORLD NOW 5

With 332 colour illustrations

Thames & Hudson

Picture Editor and *Reuters Vice-President, Pictures*
Ayperi Karabuda Ecer
Reuters Global Head of Multimedia & Interactive Innovation
Jassim Ahmad
Reuters Pictures Projects Manager Shannon Ghannam

First published in the United Kingdom in 2012 by
Thames & Hudson Ltd, 181A High Holborn, London WC1V 7QX

British Library Cataloguing-in-Publication Data
A catalogue record for this book is available from
the British Library

ISBN 978-0-500-28986-0

Printed and bound in Italy by Printer Trento

To find out about all our publications, please visit
www.thamesandhudson.com. There you can subscribe
to our e-newsletter, browse or download our current
catalogue, and buy any titles that are in print.

PAGE 2 Occupy Wall Street
demonstrators march over
the Brooklyn Bridge as '99%'
is projected onto the side of
the Verizon Building in New York.
17 November 2011. New York, United
States. Jessica Rinaldi.

Visit **reuters.com/ourworldnow**
for more information

Visit **reuters.com/pictures**
to license Reuters pictures

Follow Reuters Pictures on Twitter
twitter.com/reuterspictures
to receive the latest slideshows,
photographer blogs and news.

Contents

2011

Introduction

It all began with a slap and a slur hurled at a vegetable seller by a policewoman in a poor provincial city. Mohamed Bouazizi set himself alight in protest. One year after his death, he would scarcely recognize the Middle East he knew.

From the Atlantic coast to the shores of the Gulf, pro-democracy demonstrators poured into the streets, trampling on pictures of their leaders and chanting with one thundering voice: 'The people want the downfall of the regime.' Popular uprisings against entrenched autocrats swept the region and these seismic changes encapsulated the year.

Protesters defied riot police, live ammunition, beatings, arrest, torture and killing from Tahrir Square in Egypt to Bab al-Aziziya in Libya. Their revolt conveyed the growing rage of young Arabs, their determination to forge a new future for themselves and to reclaim a sense of personal destiny from rulers who controlled their lives with an arsenal of repression.

The balance sheet for 2011: four dictators gone in Tunisia, Egypt, Libya and Yemen; another under siege in Syria; and a host of other Arab leaders felt their thrones start to wobble.

The chilling footage of Muammar Gaddafi's brutal and humiliating end, the capture of his son Saif al-Islam and images of toppled Egyptian President Hosni Mubarak and his sons appearing in court in a cage sent unmistakable messages that the ground had shifted under these ruling elites and the unimaginable had happened. A new Middle East order was emerging.

The last Arab despot I had seen overthrown was Saddam Hussein. That was all very different from the fall of Mubarak, Tunisia's Zine al-Abidine Ben Ali, Libya's Gaddafi, and Yemen's Ali Abdullah Saleh, toppled by their own people not the might of a foreign army.

In 2003, I spent 18 days under fire in Baghdad as waves of cruise missiles vaporized swathes of the city. It was pounded day after day by American B-52s and British Tornados, before U.S. tanks rolled into a prostrate capital and declared Iraq liberated from a brutal dictator.

Iraq, and the Arab world, was shocked and awed. But the fall of Saddam, at a cost of thousands of lives – a foreboding of so much more blood to come – failed to ignite the sense of national triumph among Iraqis that had Egyptians dancing in the streets after 18 days of popular unrest.

No one who has worked and lived under these autocrats, as I did in the 1990s, could easily imagine them going, other than through illness or an assassin's bullet. Watching the sheer inebriation of euphoria in many Arab capitals at their leaders' departure, few had ever really imagined they would live to witness that day. People too many to count said it was like a dream.

As the election process unfolds in Tunisia and Egypt it is becoming clear that Islamist parties will become the leading political influence. For many the Arab Spring is turning into an Islamist Spring, but that is the choice of the people. Banned groups previously able to hide behind slogans such as the Muslim Brotherhood's 'Islam is the Solution' will now have to come up with solutions to their countries' long stagnation – and what a task they have taken on.

It was not just within the context of the Arab Spring that a silent majority found its voice. The occupation of Tahrir Square was in part the inspiration for demonstrators from London to New York, Hong Kong to Australia to set up semi-permanent camps near financial institutions, protesting against fiscal irresponsibility, corporate greed and corruption in big business and politics. These members of 'the 1%' – a small group supposedly holding an inordinate amount of power over fiscal systems – found themselves under increased scrutiny at a time when many of the world's major economies were contracting.

Pictures of violent confrontations between riot police and protesters against austerity measures in Greece showed the scale of the eurozone crisis as the irresistible might of the bond markets forced Europe to put its fiscal house in order.

There were other tremors but these were of nature, like the Japanese tsunami. Images of survivors looking at the ruins of their houses destroyed in the earthquake and lethal tidal wave easily eclipsed the power of words.

Across the world the winds of change have blown. Over the following pages Reuters photographers bear witness to the incredible events of 2011 and offer glimpses into destinies unfolding across the globe.

Samia Nakhoul
Editor, Middle East, North Africa and Turkey

"For the first time in the Arab world soldiers did not take the side of the government"

ZOHRA BENSEMRA Tunis

'On 14 January 2011 the anti-government protests that had been spreading through Tunisia reached the capital, and a huge crowd gathered outside the Interior Ministry to demand that President Zine al-Abidine Ben Ali step down. The police were firing teargas into the crowd and the protesters began throwing stones at police. Tunisian soldiers stood in the middle, between police and protesters, trying to calm the two sides down. It was at this point I took this shot. I couldn't believe my eyes: for the first time in the Arab world soldiers did not take the side of the government against the people. This was the crucial moment. When the army refused Ben Ali's requests to use force against the protesters in the capital, he realized his power had evaporated. I had tears in my eyes; it was wonderful to be present at this historic moment.'

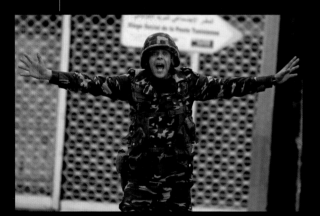 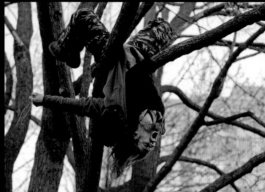

"I found one last man hanging upside down, screaming from a tree at the police officers"

MARK BLINCH Toronto Image 313

'I had been at St James Park since 3 a.m. on 23 November 2011, after receiving word that the Toronto Police Service would move in at the break of dawn to dismantle the Occupy Toronto camp. It had been more than a month since demonstrators settled at the park, turning it into a makeshift tent city. Their inspiration came from the Occupy Wall Street movement that had been organized in New York to draw attention to the financial inequality affecting what they call the 99%. As expected, the police started to evict the protesters at around 5 a.m. Over 12 hours later most of the tents and people had been cleared out from the park. I found one last man hanging upside down, screaming from a tree at police officers – defending the Occupy Toronto camp to its last breath.'

"A masked youth attacked my camera with a metal bar"

YANNIS BEHRAKIS Athens Image 110

'How do you cover a story like this? The Greek financial crisis and riots are news that affect you and your family, have left friends and colleagues without a job – without hope for the future. You have the feeling that everybody hates you or loves you depending on their needs. Protesters want you to photograph the police beating them up, but they don't want to be photographed throwing petrol bombs at the police. Once a policeman threw a stun grenade at me, and more recently a masked youth attacked my camera with a metal bar, resulting in the death of my 16–35 mm zoom lens. Being a photojournalist who has covered wars with Reuters for over 24 years I felt sad to be covering a "financial war" in my own country, but despite all this I still felt privileged to lead a team of very dedicated and talented photographers covering a story of this magnitude. I'm the witness to some of the most important moments of Greece's modern history.

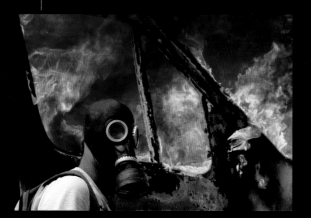
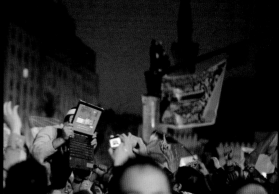

"Some days will stay with you forever"

DYLAN MARTINEZ Cairo Image 016

'You know how some days will stay with you forever? Well even now I could tell you what I had for breakfast on 11 February 2011. What a day and what a night. I was out shooting when my editor called saying there were more rumours that Mubarak was about to quit and I should hurry to Tahrir Square. Lucky me – I was a couple of minutes away. Not so lucky was that when I'd arrived in Cairo, custom officials had confiscated most of my kit – leaving me with a small camera and a 50 mm lens, but no flash gun. A power cut had made the streetlights redundant. When the news finally broke that Mubarak had gone I had to find light. I could only watch as jubilant protesters jumped, hugged, kissed and prayed. Thankfully the power came back on and I saw a guy holding a computer aloft like it was the World Cup and chanting "Internet! Internet!" I took a lot of frames that night but this one seems to tell the story of what had become known as the "Facebook revolution".'

RAFAEL MARCHANTE Lisbon Image 262
'The economic crisis in Portugal is difficult to photograph because there is nothing special
happening on the streets – it is happening behind closed doors. When we go out to find images
of the crisis we use the expression "trekking and fishing". The days are often long, spent walking
with our eyes open. In this photo, Matheus Silva is consoling his daughter as they arrive at school
in the Nossa Senhora de Fátima neighbourhood, Lisbon. Silva was unemployed and had no money
to rent an apartment, he lived in a caravan with his wife and their two daughters.
To me they were clearly the first victims of the economic crisis in Portugal.'

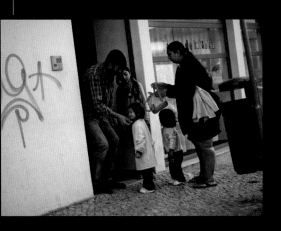 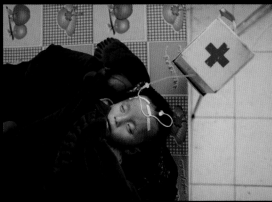

"This child's body showed almost no signs of life"

DAMIR SAGOLJ North Korea Image 250
'I was on a trip to North Korea with colleagues from the Thomson Reuters Foundation's Alertnet,
and though our visit was organized and tightly controlled by government officials, we had been granted
rare access to rural places that the media does not visit very often, if ever. I knew that despite this there
would be frustrating moments when I would not to be able to photograph what I thought important.
But I was determined to get the most out of the trip, no matter how little that might be. Photographing
in orphanages and hospitals was very emotional – we are only human despite all the experiences under our
belts. This child's body showed almost no signs of life. I escaped behind the camera; played with angles
and lenses but knew it would not work. In that moment, there was no wider context, no bigger picture –
just the eyes of a child who might die soon because of the lack of food; an unacceptable and sad reality.'

"This city was once covered with smiles"

TORU HANAI Japan Image 083

'The tsunami generated by the giant earthquake washed away not only people, cars and houses, but also family photographs loaded with memories. I visited Ofunato, Iwate prefecture, to shoot volunteers cleaning family photographs about one month after the tsunami struck. Rescue teams, police, firefighters and the Japan Self-Defence Force gathered the muddied and damaged pictures during their search for missing people and brought the photos to the centre to be restored. There was an enormous quantity. As volunteers cleaned the mud from the photos they were careful not to damage those captured smiles. It reminded me that this city, now overflowing with disaster, was once covered with smiles. All the photographs in this picture are of the same baby. The number on the work surface helped me feel the deep love of the baby's parents and I worried about how this disaster had affected the family. I later found out that the baby girl is now a 4-year-old, well and living with her family. '

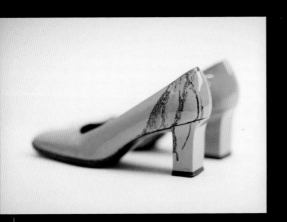
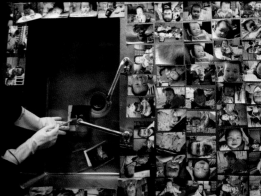

"She ran barefoot out of the South Tower, across broken glass and other debris"

LUCAS JACKSON New York Image 213

'This image was part of a collection that we photographed in collaboration with the National September 11 Memorial and Museum in New York before the 10th anniversary of the September 11 attacks. We photographed around 20 different artefacts that had been donated to the museum, each with a direct connection to the attacks. Most of the items that we photographed that day – including these shoes – were donated by the people who had worn or had some connection with the item. In this particular image I photographed shoes worn by Linda Lopez during her escape from the 97th floor of the South Tower. She ran barefoot out of the building, across broken glass and other debris. Seeing the hardened blood on the side of these heels was a poignant detail and I decided that in this image I wanted to isolate that element of the story.'

"Everywhere on the shore were corpses"

LASSE TUR Norway Image 168

'In the hours after the bombing in Oslo and shooting of youths by anti-immigration zealot Anders Behring Breivik at Utoeya Island I took a plane from Berlin and then reached Lake Tyrifjorden by car. The only way to get a picture of what had happened on the island was to get onto the lake. Police and rescue teams on boats were searching for missing victims, and I wasn't sure how close we could get. A local Norwegian photographer and I rented a boat from a nearby campsite. He knew the area well and steered toward the island. As we got nearer, we began to see white spots on the rocks along the shoreline. What was covered by the white blankets? I connected my 1.4X converter to get a 700 mm telephoto lens. With the help of that I could see legs and feet under the blankets. Everywhere on the shore were the corpses of the youths shot by Breivik. It was an eerie, gruesome and frightening moment. Around me was a total silence. No voices, just the monotonous sound of our boat engine. We drove around the island and we saw more bodies. On the other side, we were finally stopped by a police boat.'

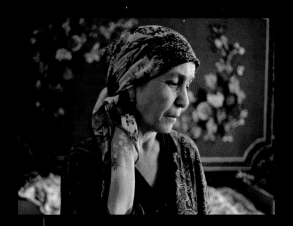

"During the conversation she sat on her dead son's bed"

DIANA MARKOSIAN Russia Image 032

'I was in Chechnya when the Moscow airport suicide bomber's name, Magomed Yevloyev, was announced. His family lived in the nearby republic of Ingushetia, but a colleague warned me that other journalists had been arrested for trying to get into Yevloyev's home for an interview with his mother. I waited a day before driving there, leaving Grozny early in the morning and parking my car a distance from the home. It was incredibly difficult to operate in the North Caucasus due to the insurgency taking place in the region. Luckily I made it into the house, and was the first to interview and photograph the suicide bomber's mother. During the conversation she sat on her dead son's bed and apologized to the world: "We are so ashamed, so bitterly sad. We really worry for all the people who died, who he wounded." I took her portrait right away and hid the camera's memory card in my shoe, just in case I was stopped.'

The Palestinian female was an Israeli undercover officer carrying a pistol"

BAZ RATNER West Bank Image 150

'On 15 May 2011, clashes broke out across the West Bank and Jerusalem. It was the anniversary of the Nakba (an Arabic word meaning "catastrophe"). The date marks the expulsion of hundreds of thousands of Palestinians from Israel in 1948. I was assigned to the Shuafat refugee camp in East Jerusalem, where Palestinian youths were throwing stones at Israeli security forces. Police retaliated by firing rubber bullets and teargas at the protesters. After several hours the police charged, scattering the Palestinians. Down an alley, I saw riot police with a group of masked men and what I thought was a woman – all armed – detaining a few Palestinians. Over the next few seconds I took this picture, realizing that the "Palestinian female" was an Israeli undercover officer carrying a pistol. He jumped into a vehicle, leaving the detained protesters to the riot police.'

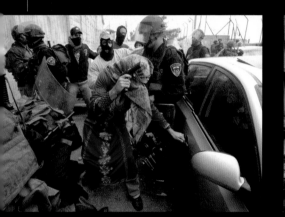
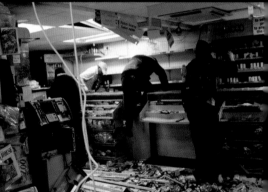

"With every frame I took another step into the shop – away from a safe exit."

OLIVIA HARRIS London Image 21(

I'd heard of photographers being mugged and assaulted during the rioting and looting in the British capital, so I arranged to meet up with som other snappers. At the top of the street in Hackney, London, there was a burning car, lines of riot police with dogs, and hooded men throwing bottles, sticks and stones. Suddenly the police withdrew, leaving the rioters to it. I could see people climbing in and out of a shop with smashed ndows. I started to shoot and with every frame took another step into the shop – away from a safe exit. Inside, a couple of men were filling bag ith spirits and cigarettes. Another checked the till. I kept shooting until one of them noticed me. After that I quickly left the shop but two of the ters came over and accused me of being police, then tried to take my cameras. Luckily some of the photographers who had been with me when arrived pulled me away. It was a lesson, not only in not overstaying your welcome, but also how important your colleagues ar

1

January / February / March

001 Cairo, Egypt

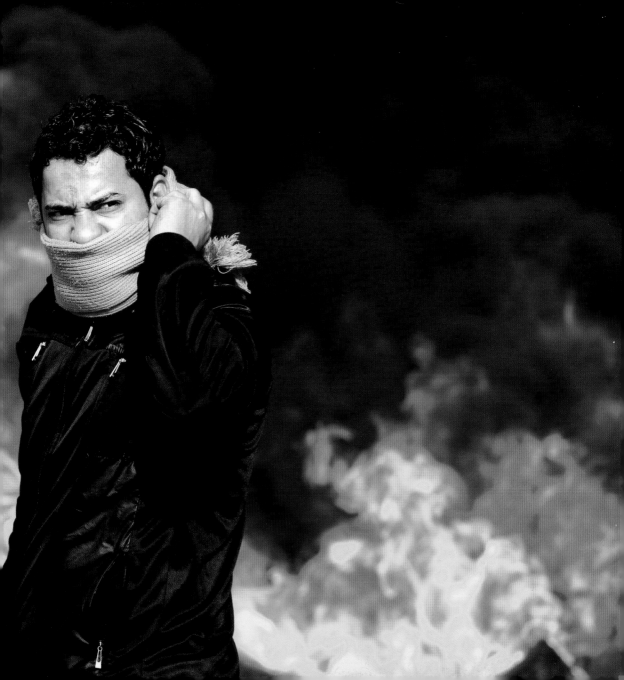

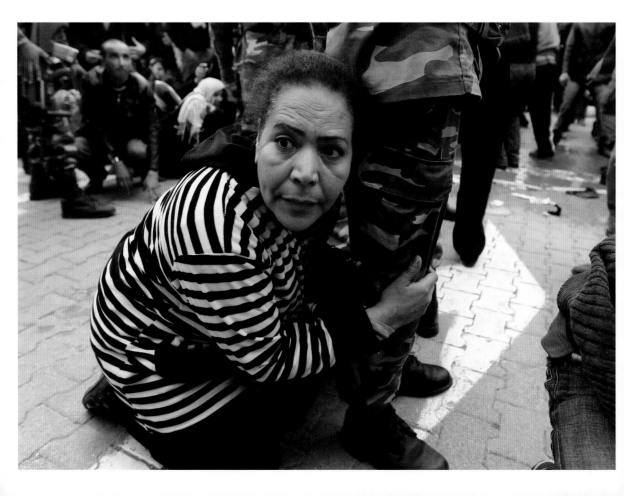

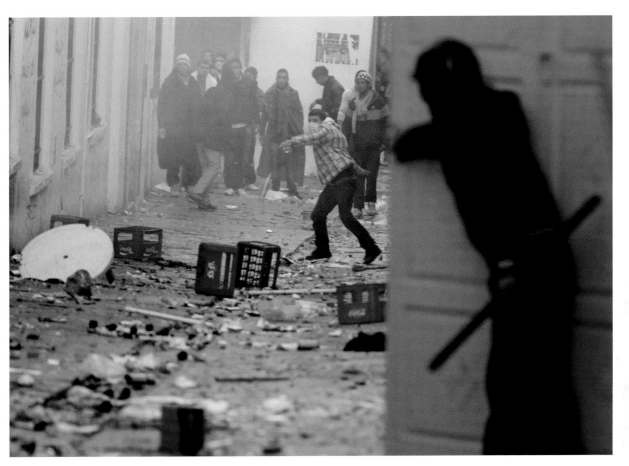

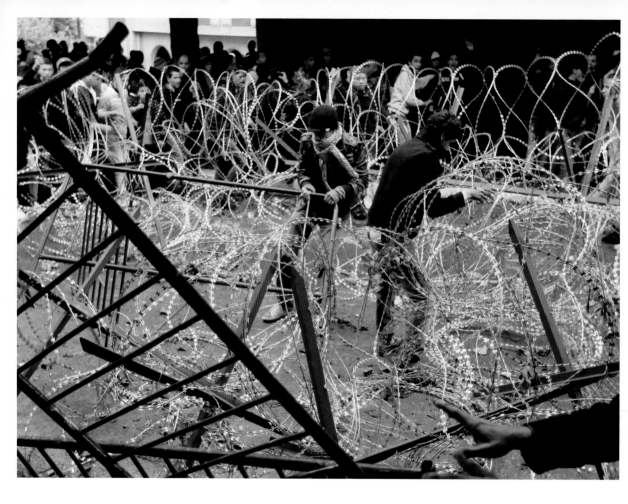

004 Tunis, Tunisia

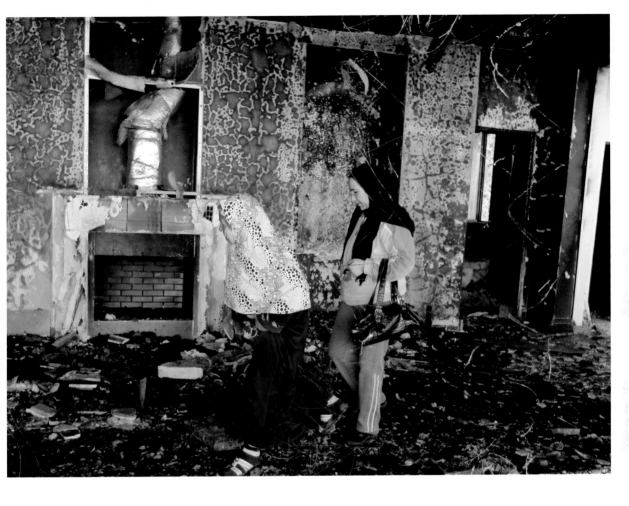

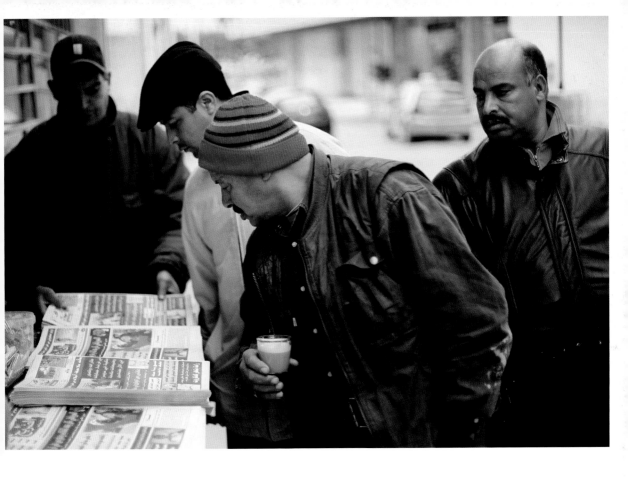

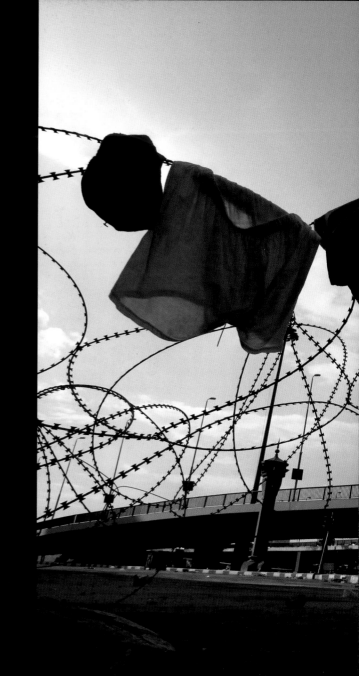

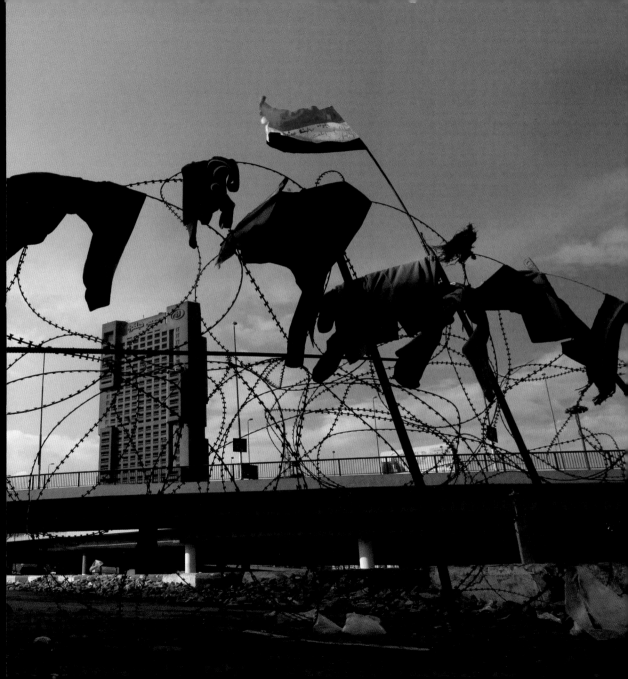

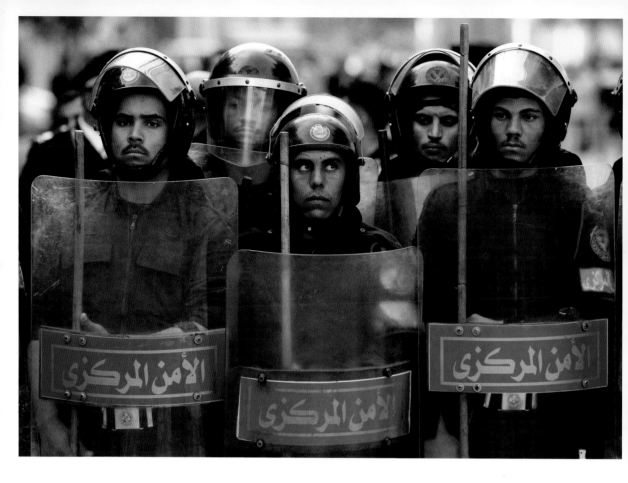

009 Cairo, Egypt

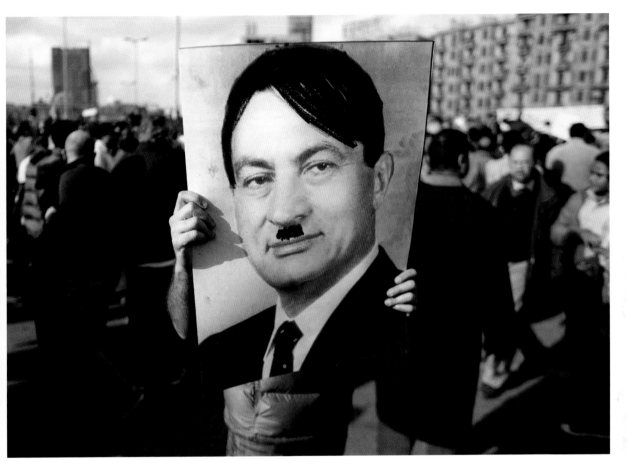

001 A protester stands in front of a burning barricade in Cairo. Egypt was just one of the countries in north Africa and the Middle East that experienced unprecedented demonstrations and violence as the Arab Spring unfolded. 28 January 2011. Cairo, Egypt. Goran Tomasevic.

002 A Tunisian protester grabs a soldier's leg for safety as shots are fired into the air to try to disperse hundreds of demonstrators near the headquarters of the Constitutional Democratic Rally Party of ousted President Zine al-Abidine Ben Ali. 20 January 2011. Tunis, Tunisia. Zohra Bensemra.

003 A Tunisian riot policeman takes shelter behind a door while protesters throw stones during clashes in Tunis. 28 January 2011. Tunis, Tunisia. Zohra Bensemra.

004 Tunisian demonstrators near government offices in the Kasbah (the old city of Tunis) pull away barbed wire to let others through the police barricade. 27 January 2011. Tunis, Tunisia. Zohra Bensemra.

005 Tunisians visit the empty and ransacked home of Kaif Ben Ali, nephew of Zine al-Abidine Ben Ali, in the Mediterranean resort of Hammamet, about 60 km (40 miles) from Tunis. Showing their contempt for the former president's family, several hundred people filed through the house, taking photographs of the ruin and removing plants and plumbing fixtures as souvenirs. 16 January 2011. Hammamet, Tunisia. Zohra Bensemra.

006 An inhabitant of Tunisia's poor rural heartlands lies in front of the prime minister's office in Tunis, part of protests demanding the removal of the fallen president's old guard from power. 16 January 2011. Tunis, Tunisia. Zohra Bensemra.

007 Men look at newspapers at a street kiosk in downtown Tunis. Tunisia's caretaker prime minister was preparing to gather his national unity cabinet for a first meeting, amid the threat of revolt from opposition nominees demanding he fire more of the ex-president's allies. 19 January 2011. Tunis, Tunisia. Finbarr O'Reilly.

008 Anti-government protesters' clothes are hung out to dry on barbed wire at the frontline of their stronghold in Tahrir (Freedom) Square, Cairo. 10 February 2011. Cairo, Egypt. Yannis Behrakis.

009 Riot police hold shields during clashes with protesters in Cairo. Thousands of Egyptians defied a ban on protests by taking to Egypt's streets and calling for President Hosni Mubarak to leave office. 26 January 2011. Cairo, Egypt. Goran Tomasevic.

010 A man carries a picture depicting President Hosni Mubarak as Adolf Hitler during a protest in Cairo. Mubarak had overhauled his government to try to defuse the uprising against his rule, but protesters rejected the changes and said he must surrender power. 31 January 2011. Cairo, Egypt. Goran Tomasevic.

011 A woman carries a mock-up of a Facebook friend-request page referring to the former Tunisian President Zine al-Abidine Ben Ali, and Egypt's President Hosni Mubarak. 5 February 2011. Beirut, Lebanon. Sharif Karim.

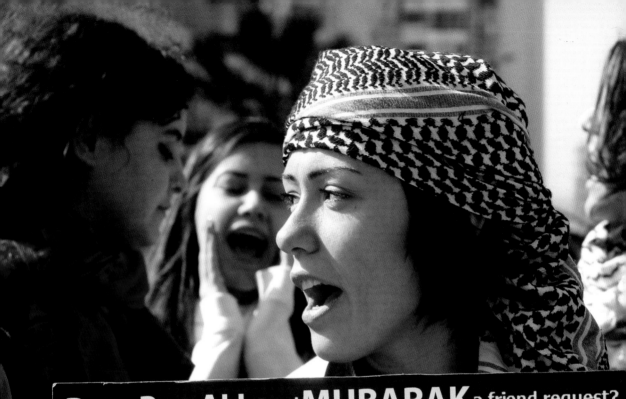

Dear Ben ALI, Send **MUBARAK** a friend request?

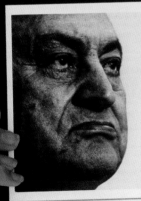

MUBARAK(criminal arab dictator) will have to confirm your request. Please only send this request if you know him personally.

⠿ **Add to list** ▼

✏ Add a personal message...

Send request Cancel

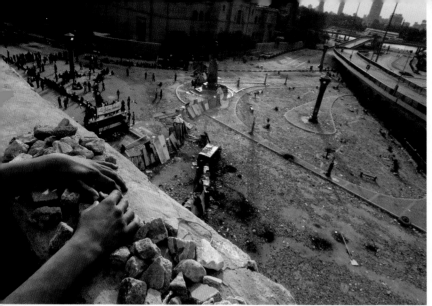
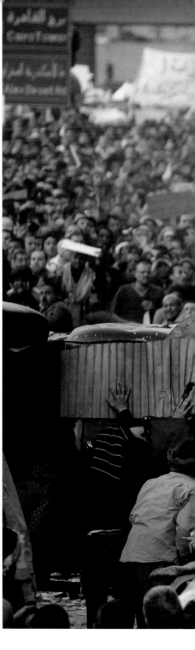
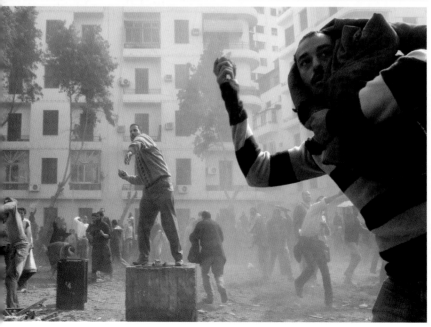

012 [TOP] 013 [ABOVE] Cairo, Egypt

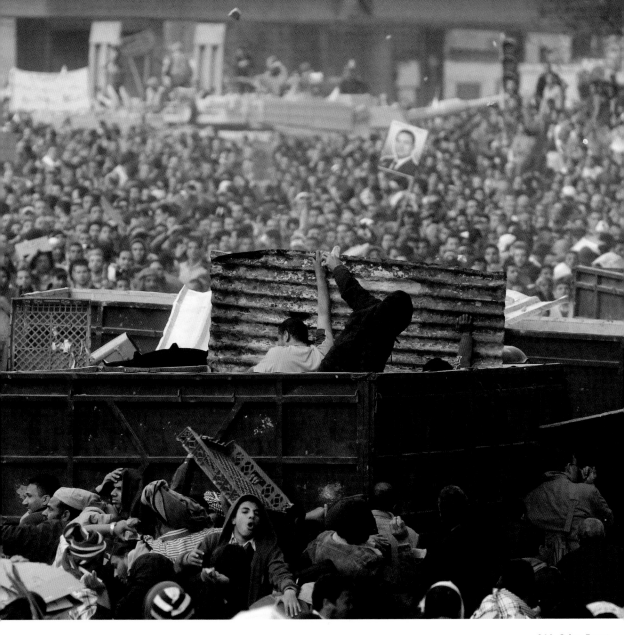

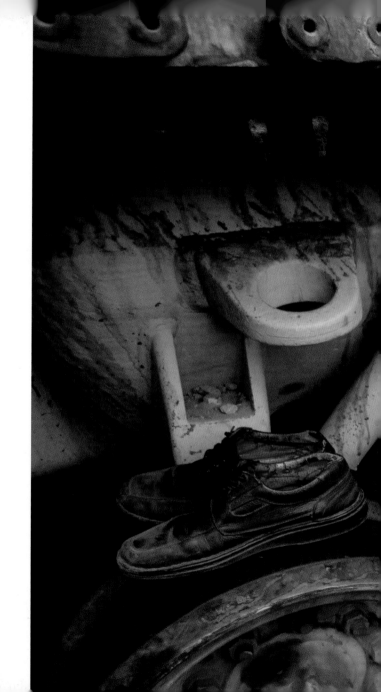

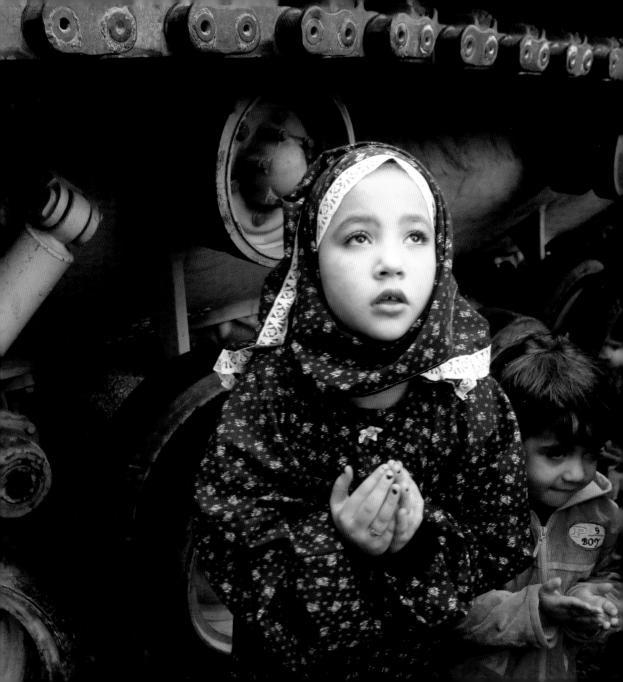

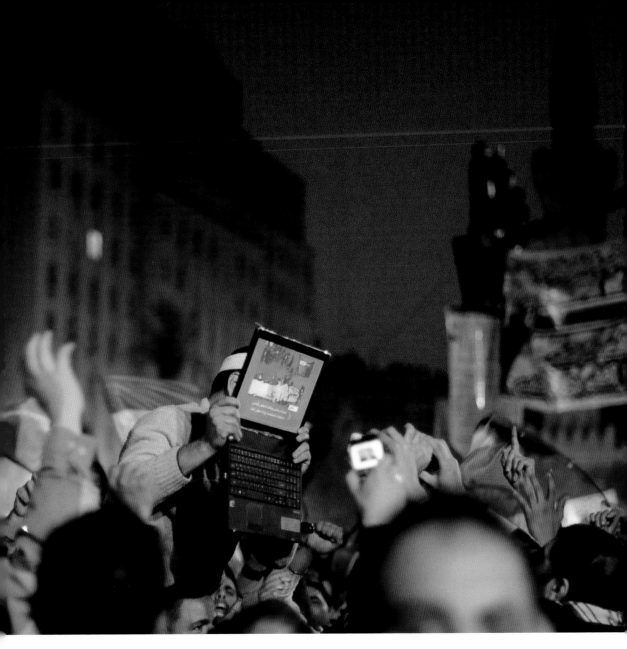

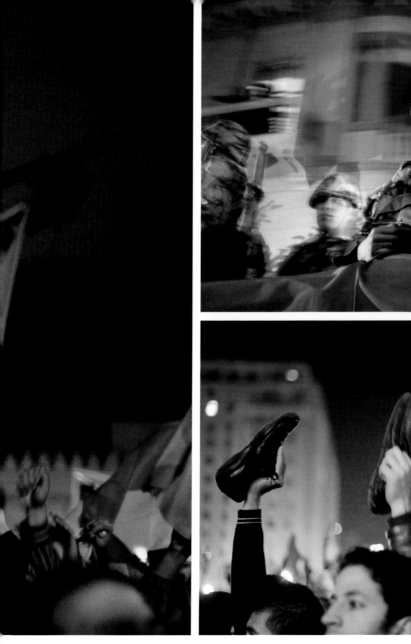

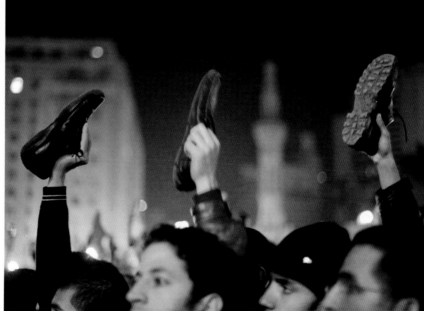

017 [TOP] **018** [ABOVE] Cairo, Egypt

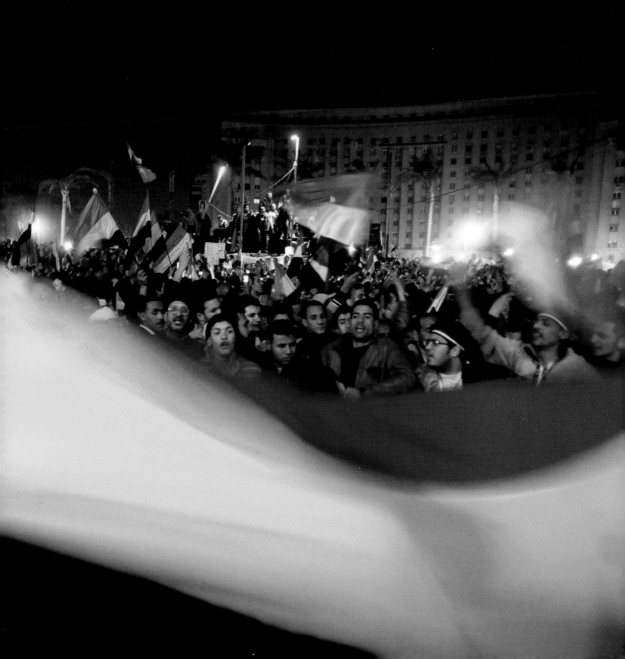

012 013 014 015 016 017
018 019

012 A protester mans a rooftop alongside the Egyptian Museum near Tahrir Square. Tens of thousands of Egyptians prayed in the square for an immediate end to Hosni Mubarak's rule, hoping a million more would join them in what they called the 'Day of Departure'. 4 February 2011. Cairo, Egypt. Yannis Behrakis.

013 Opposition supporters throw stones at pro-Mubarak demonstrators in Tahrir Square. The opposing factions clashed in a bout of violence that continued overnight, killing six and wounding over 800 people. 3 February 2011. Cairo, Egypt. Goran Tomasevic.

014 Anti-government protesters and supporters of Mubarak are separated by a barricade in Tahrir Square. Opponents and followers of Egypt's president fought with fists, stones and clubs in what appeared to be a move by forces loyal to the Egyptian leader to end demonstrations calling for him to quit. 2 February 2011. Cairo, Egypt. Goran Tomasevic.

015 A girl attends Friday prayers in front of an army tank in Tahrir Square on 18 February, one week after the overthrow of Hosni Mubarak. Egyptians held a nationwide Victory March to celebrate the end of Mubarak's 30-year rule, and to remind the new military rulers of the power of the street. The rallies were also a memorial to the people who died during the 18-day uprising. About 850 people were killed. 18 February 2011. Cairo, Egypt. Suhaib Salem.

016 An opposition supporter holds up a laptop showing images of celebrations after Hosni Mubarak resigned, handing power to the army. Abdel Fattah of the Al Ahram Centre for Political and Strategic Studies said 'New media, mainly satellite channels, have managed to spread the message of the revolution everywhere, including rural areas; and social networking sites such as Twitter and Facebook have been a key means of communications for the protesters.' 11 February 2011. Cairo, Egypt. Dylan Martinez.

017 An Egyptian army soldier smiles at protesters in Cairo. 28 January 2011. Cairo, Egypt. Amr Abdallah Dalsh.

018 Anti-government protesters in Tahrir Square wave shoes in dismay as President Hosni Mubarak spoke to the nation on 10 February. Demonstrators chanted 'Down, down with Hosni Mubarak' and 'Leave, leave' in rage at the speech. 10 February 2011. Cairo, Egypt. Dylan Martinez.

019 Youths wave a large Egyptian flag as they celebrate President Hosni Mubarak's resignation in Tahrir Square on 11 February. The furious wave of protests finally swept Mubarak from power after 30 years of one-man rule, sparking jubilation on the streets and sending a warning to autocrats across the Arab world and beyond. 11 February 2011. Cairo, Egypt. Asmaa Waguih.

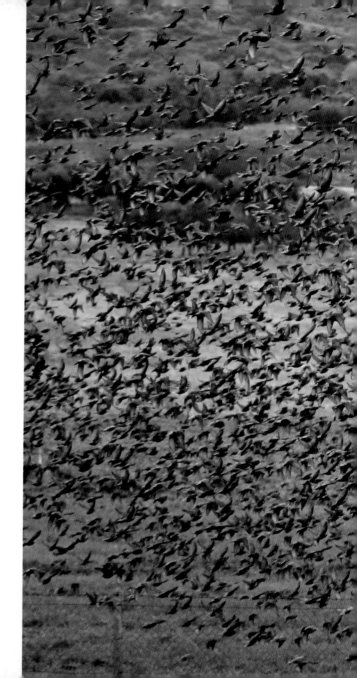

020 Eleftheroupolis, Greece

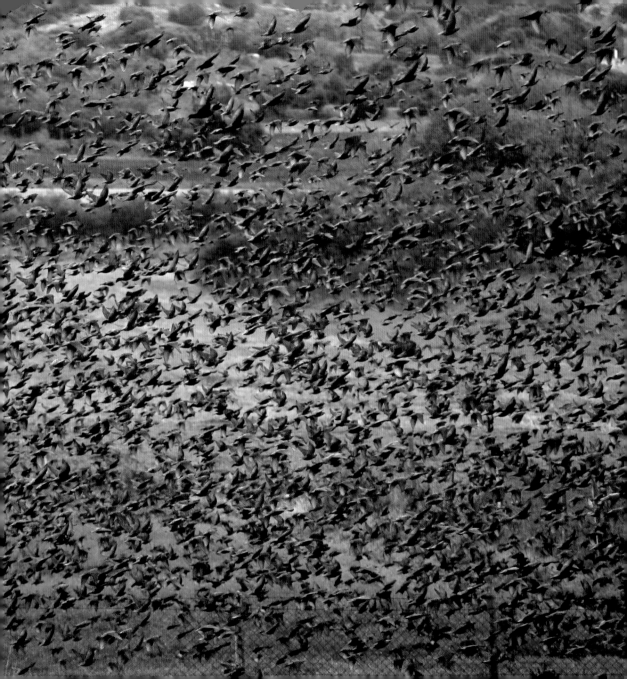

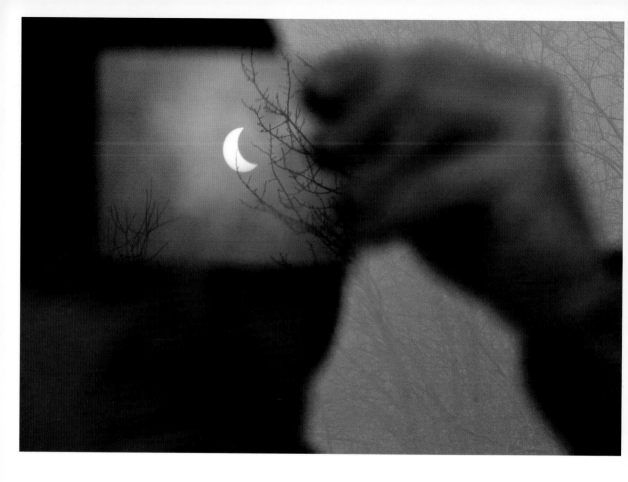

021 Galyatetö, Hungary

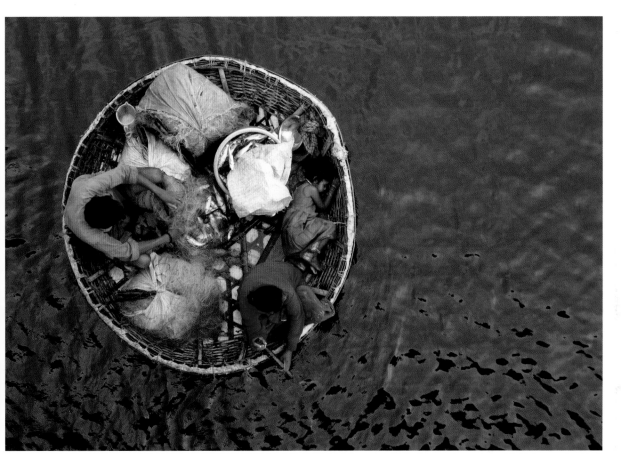

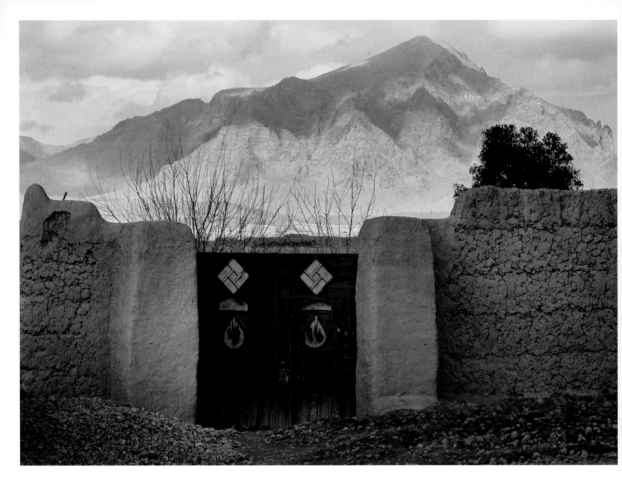

023 Kunjak, Afghanistan

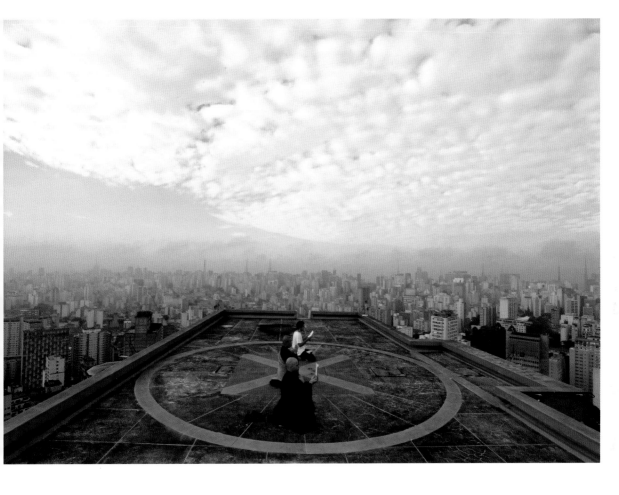

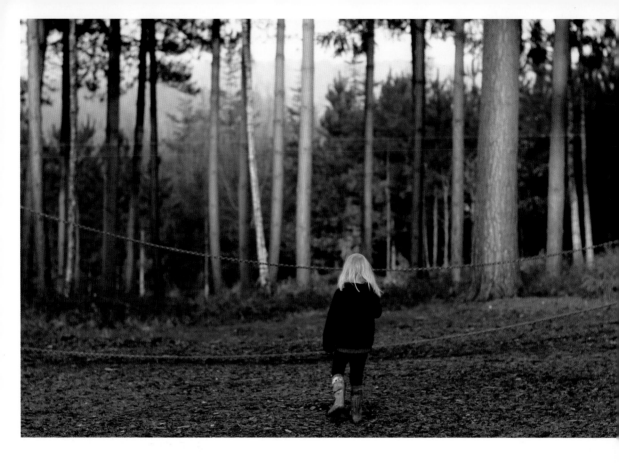

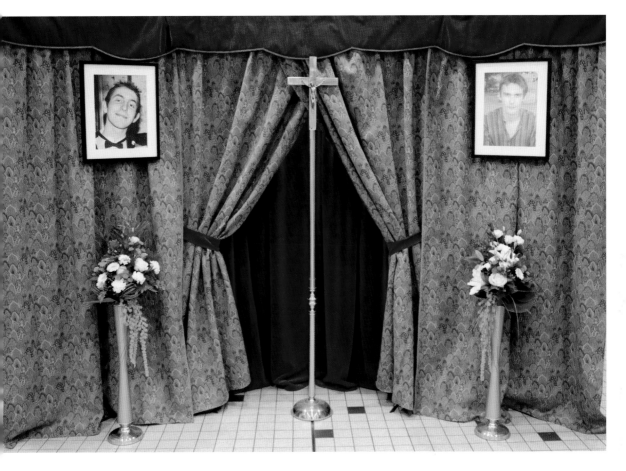

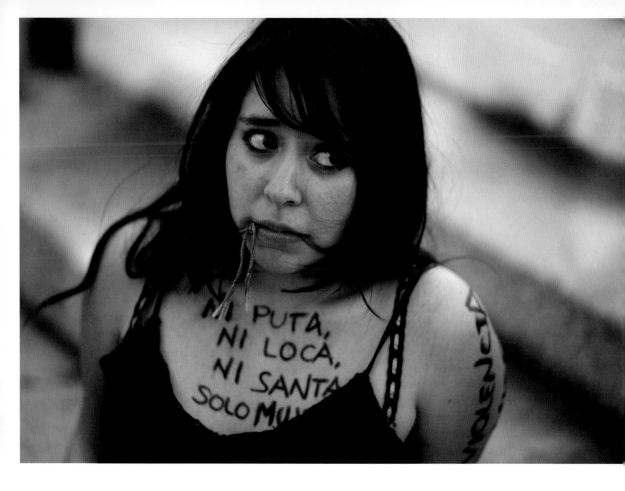

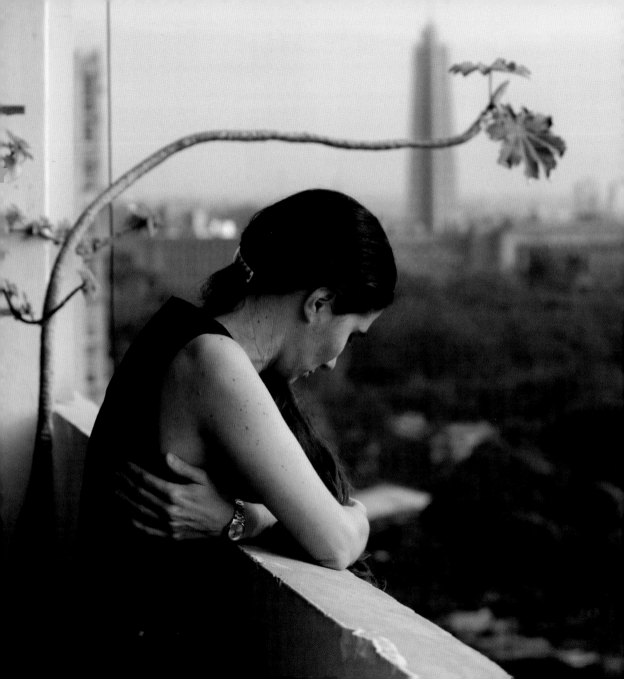

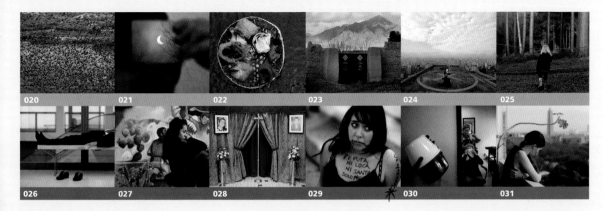

020 Thousands of starlings flock above farmland near Eleftheroupolis in northern Greece. 3 January 2011. Eleftheroupolis, Greece. Yannis Behrakis.

021 A man watches a partial solar eclipse through a filter in Galyatetö, 100 km (60 miles) east of Budapest. 4 January 2011. Galyatetö, Hungary. Bernadett Szabo.

022 A fisherman arranges a net as his wife paddles their boat in the waters of the Periyar River, southern India. 5 January 2011. Kochi, India. Sivaram V.

023 A compound door is seen at the village of Kunjak in southern Afghanistan's Helmand province. The doors are made from a variety of scavenged materials – oil drums, shipping containers, cloth, rice sacks or tins. 23 February 2011. Helmand, Afghanistan. Finbarr O'Reilly.

024 Buddhist monks from the Busshinji Temple meditate on the helipad of the Copan Building in São Paulo. Monks meditate on top of the skyscraper once a month to help take their traditions to the streets. 18 February 2011. São Paulo, Brazil. Nacho Doce.

025 A young girl walks in Alice Holt Forest, southern England. The area would have been included in government plans for consultation on a change of ownership, but moves to sell the bulk of England's publicly owned forests were scrapped after intense public opposition. 17 February 2011. Hampshire, Britain. Eddie Keogh.

026 A man sleeps on a bench at the 76th Internationale Grüne Woche (International Green Week) agriculture and food fair in Berlin. 21 January 2011. Berlin, Germany. Thomas Peter.

027 Friends of Ramses Barron hug outside his home while mourning his death in Nogales, Mexico. The 17-year-old was shot in an incident at the Arizona–Mexico border. 6 January 2011. Nogales, Mexico. Alonso Castillo.

028 The chapel of rest in Linselles, northern France, where the coffins of Antoine de Leocour and Vincent Delory were shown. The Frenchmen were found dead, apparently executed after a failed attempt to rescue them in the African state of Niger. 14 January 2011. Linselles, France.

029 A woman pretends to be gagged while taking part in a protest on International Women's Day in Mexico City. The writing on the demonstrator's chest reads, 'Neither a whore, nor crazy, nor a saint, just a woman.' 8 March 2011. Mexico City, Mexico. Jorge Dan Lopez.

030 Obdulia Sanz, 92, covers her face to prevent hairspray from getting in her eyes. On 28 January Spain's government approved an increase in the retirement age from 65 to 67 years, raising it to one of the highest in Europe. 28 January 2011. Madrid, Spain. Susana Vera.

031 Cuban dissident blogger Yoani Sánchez looks out from her balcony at her home near Havana's Revolution Square. Sánchez said the Cuban government had apparently unblocked access to her blog, which had been off limits on the island's Internet since 2008 – part of Cuba's ongoing ideological conflict with the United States. 9 February 2011. Havana, Cuba. Desmond Boylan.

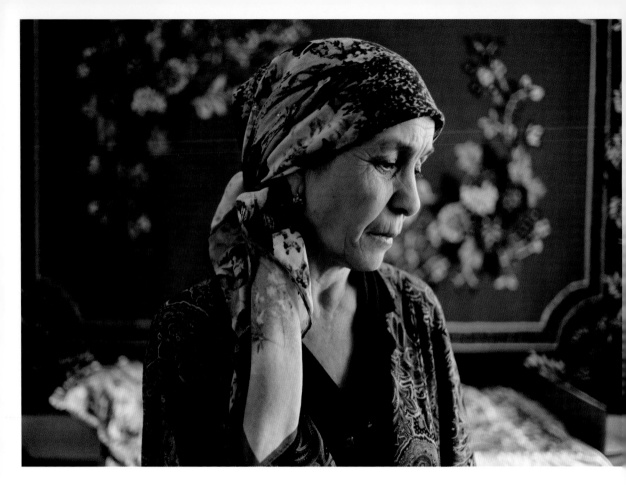

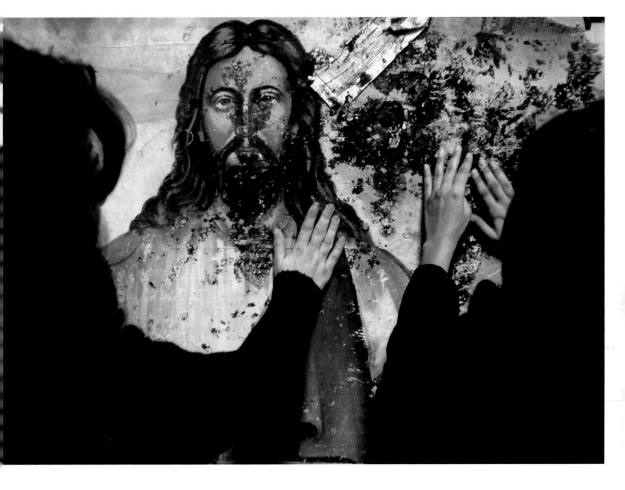

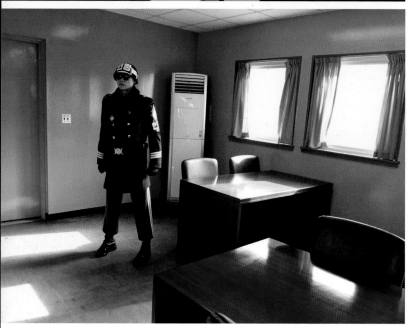

034 [TOP] New York, United States **035** [ABOVE] Panmunjom, Korean Demilitarized Zone

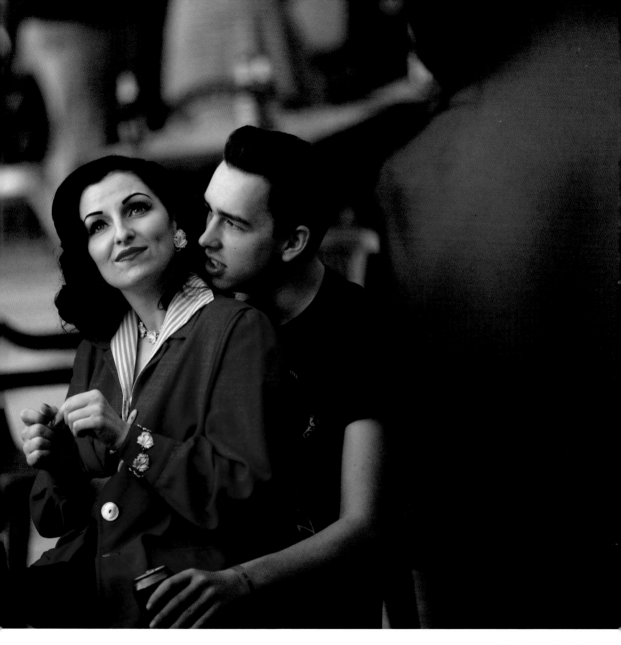

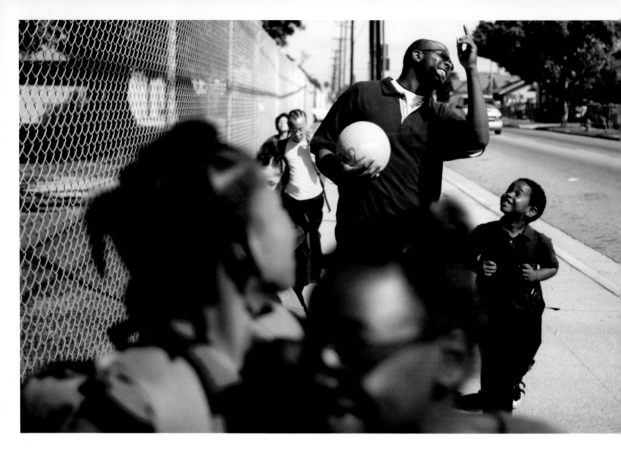

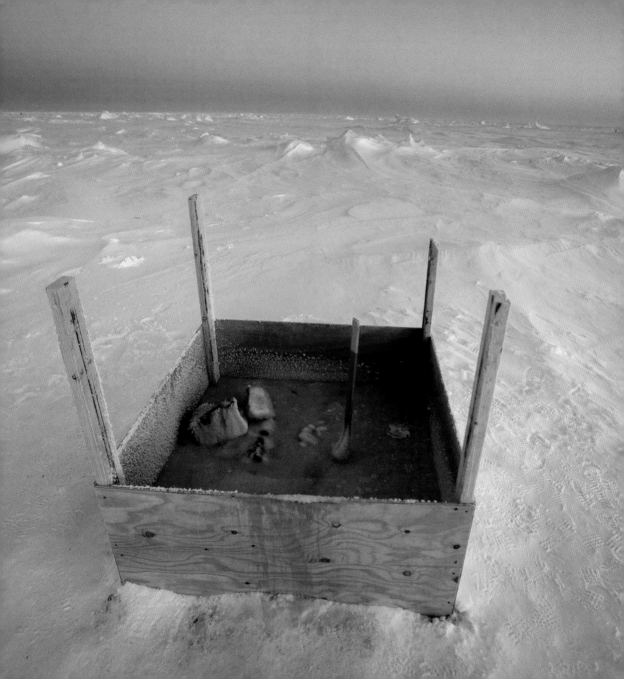

032 Roza Yevloyeva, mother of 20-year-old suicide bomber Magomed Yevloyev, gives an interview in which she tearfully apologized for her son's attack on Moscow's Domodedovo Airport. Yevloyev detonated explosives strapped to his body at Russia's busiest airport on 24 January, killing 36 people. 16 February 2011. Ali-Yurt, Russia. Diana Markosian.

033 Egyptian Christians touch a blood-splashed image of Jesus Christ at the Coptic Orthodox Church in Alexandria. A bomb killed at least 21 people outside the church early on New Year's Day. The Interior Ministry said a foreign-backed suicide bomber may have been responsible. 2 January 2011. Alexandria, Egypt. Amr Abdallah Dalsh.

034 A portrait of actress Elizabeth Taylor by Andy Warhol is seen at the Phillips de Pury Gallery in New York. The piece entitled *Liz #5* was completed by Warhol in 1963, and sold at auction for just under 27 million dollars on 12 May – 20 days after Taylor's death. 28 March 2011. New York, United States. Shannon Stapleton.

035 A South Korean soldier stands on the North Korean side in the U.N. Command Military Armistice Commission Conference Building. The centre is located in the truce village of Panmunjom in the demilitarized zone separating the North and South in the city of Paju, north of Seoul. 19 January 2011. Panmunjom, Korean Demilitarized Zone. Lee Jae-Won.

036 A couple dressed in 1950s-style clothes sit on a chair during the 17th Rockin' Race Jamboree festival in the southern Spanish town of Torremolinos, near Malaga. 5 February 2011. Torremolinos, Spain. Jon Nazca.

037 Regional coordinator Charles Evans picks up children from school to take them to an after-class programme at South Los Angeles Learning Center. The programme uses volunteers to tutor homeless children in shelters, parks, motels and two centres. There has been a surge in the number of homeless children in Los Angeles over the last five years due to persistent unemployment and mounting foreclosures. 16 March 2011. Los Angeles, United States. Lucy Nicholson.

038 Marus, 7, warms his hands next to a portable stove before going to school on the day his family were due to be evicted from their trailer and bus home in Las Tablas, northern Madrid. Two Romanian gypsy families of four adults and 10 children had been living in the bus and trailer since 2008, but were evicted under orders from Madrid's town planning board. 21 March 2011. Las Tablas, Spain. Susana Vera.

039 A man takes a shower near the Monument of the Revolution in Mexico City. The city council set up booths to teach people how to save water while showering. 15 March 2011. Mexico City, Mexico. Jorge Dan Lopez.

040 A woman slides at a water park in Lima ahead of World Water Day. 20 March 2011. Lima, Peru. Enrique Castro-Mendivil.

041 Women look at jewelry displayed in the window of a Tiffany and Co. store in central London. 24 March 2011. London, Britain. Toby Melville.

042 A urinating station is lit by sunrise at the Applied Physics Laboratory Ice Station north of Prudhoe Bay. 18 March 2011. Alaska, United States. Lucas Jackson.

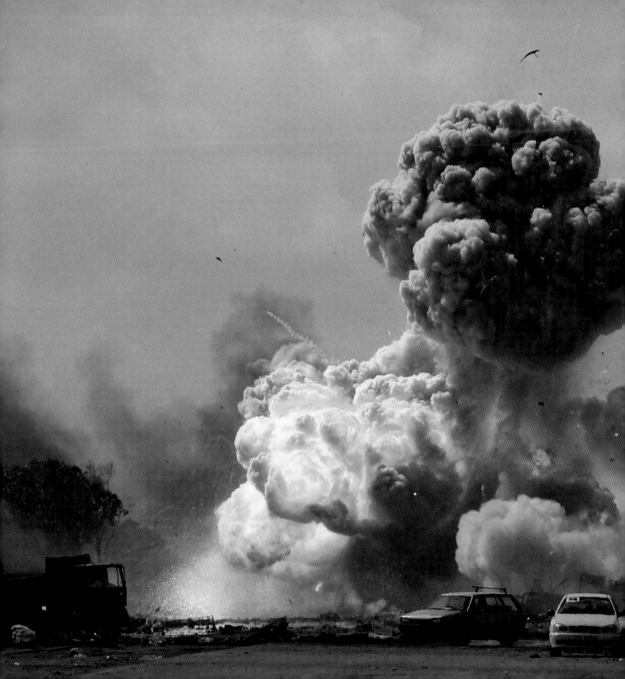

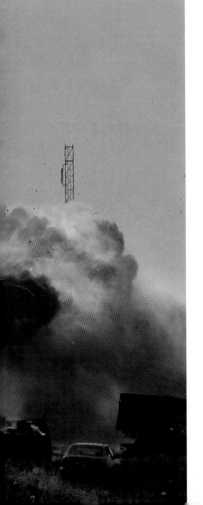

GORAN TOMASEVIC
Photographer
Born: Belgrade, Serbia, 1969
Based: Cairo, Egypt
Nationality: Serbian

Running with the rebels

I have spent half my life covering conflict – Former Yugoslavia, Iraq, Afghanistan, Pakistan, Congo, between Israel and the Palestinians, and most recently upheaval in the Arab states. Three days into a trip home to visit my mother in Belgrade I saw the stories about Libya. I landed in Cairo at 3.30 a.m. and by 5 a.m. was driving to the Egyptian–Libyan border. Once in Libya, every day my driver would take me close to the front lines of the fighting and I would travel by foot, sometimes jumping onto a vehicle belonging to the rebels. Not speaking any Arabic, communication was limited to me saying 'stop here', or 'Yallah!' (Let's go!).

I remember 8 March was a particularly terrible day and it was hard to take pictures. There were three or four rebels injured, one of them had a completely shattered leg. His feet were next to him. It happened just 100 metres in front of me; he was running back when a missile exploded – I didn't transmit the picture, it was just too horrible. Sometimes bombs would land maybe 50–200 metres away. I don't believe in running when bombs are being dropped. I usually sit down and watch exactly what is happening. The best thing you can do is to stay low; there is nowhere to run.

After that bombardment the rebels stopped being friendly to journalists for a few days. They thought that Gaddafi saw the pictures we were taking and then dropped bombs on them. They said that if I went further, they couldn't guarantee my safety from their own troops. After coalition forces started to bomb loyalist Gaddafi soldiers the rebels' attitude changed again. Not many journalists had stayed in Benghazi, and the rebels started to appreciate those who had remained.

When I took it, I didn't know that this picture would end up on front pages around the world. It's a very simple shot, which is why I was surprised it was used so widely. I was less than 200 metres from the explosion and it was easy: just point and shoot. When covering conflict – preoccupied with how you're going to eat, how you're going to charge your equipment, where you're going to sleep – you shoot by reflex; it's only later when you check the pictures you sometimes think 'wow'. I called my mother when I crossed the border back to Egypt and she just cried.

043 Vehicles belonging to forces loyal to Muammar Gaddafi explode after a coalition air strike on the road between Benghazi and Ajdabiya in Libya. 20 March 2011. Between Benghazi and Ajdabiyah, Libya. Goran Tomasevic.

WITNESS

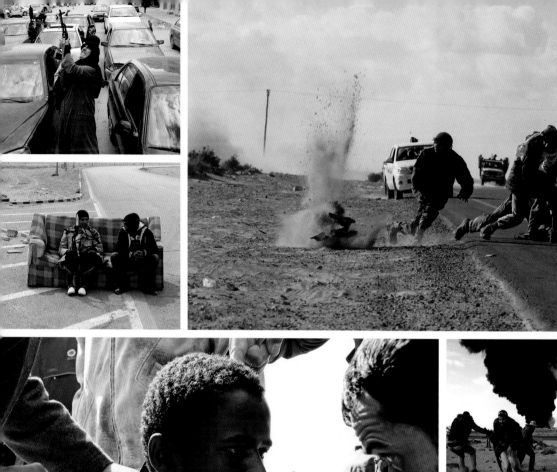

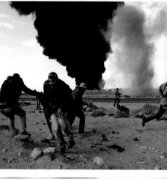

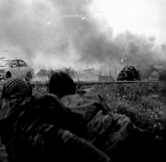

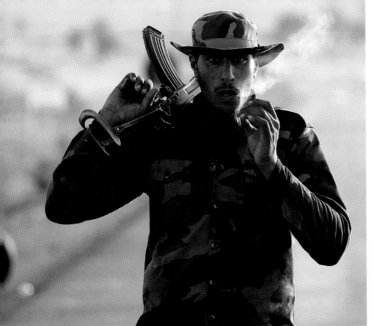

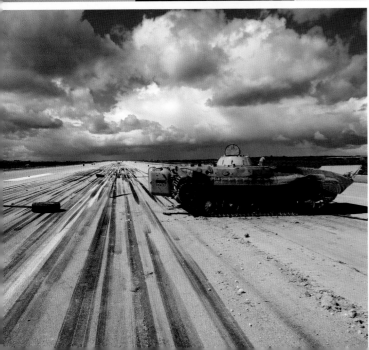

044 A supporter of the rebel fighters shoots an AK-47 rifle after hearing the news of the withdrawal of Libyan leader Muammar Gaddafi's forces from Benghazi. 19 March 2011. **045** Rebel fighters sit on a sofa at a checkpoint in Ajdabiya. 15 March 2011. **046** Anti-government troops dive away from shrapnel during heavy shelling by followers of Gaddafi near the town of Bin Jawad. 6 March 2011. **047** Rebels stationed between the towns of Brega and Ras Lanuf hold at gunpoint a young man accused of being a Gaddafi loyalist. 3 March 2011. **048** Anti-government fighters run for cover in front of a burning gas storage terminal during a hard-fought battle on the road between the towns of Ras Lanuf and Bin Jawad in east Libya. 9 March 2011. **049** Rebel fighters look at a burning vehicle belonging to Libyan forces loyal to the government after an air strike by coalition forces, along a road between Benghazi and Ajdabiya. 20 March 2011. **050** A rebel smokes at a checkpoint in Brega. 3 March 2011. **051** An armoured vehicle is seen at a military airport runway in the town of Al Abrak, east Libya. 24 February 2011. Libya. Goran Tomasevic.

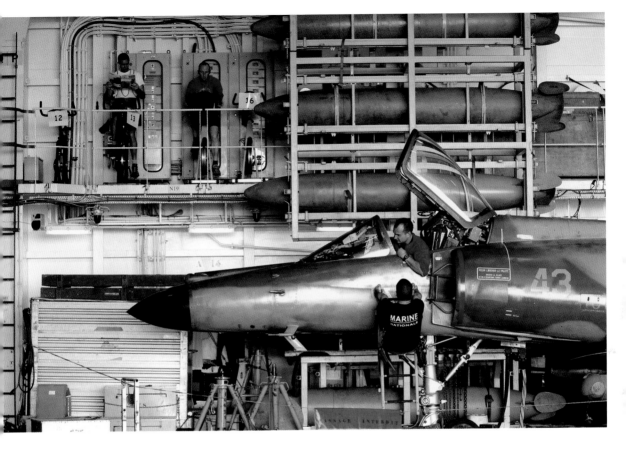

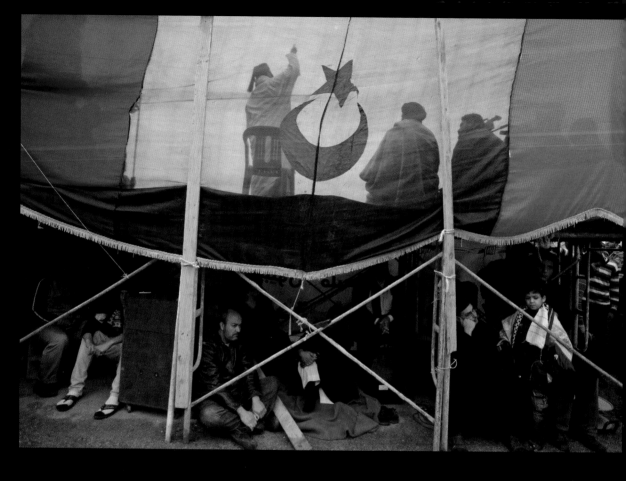

054 [ABOVE] 055–060 [OPPOSITE] Benghazi, Libya

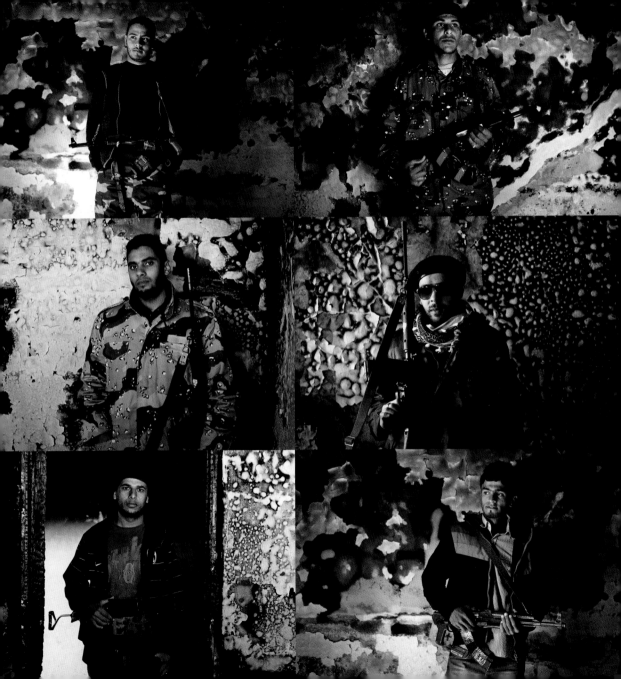

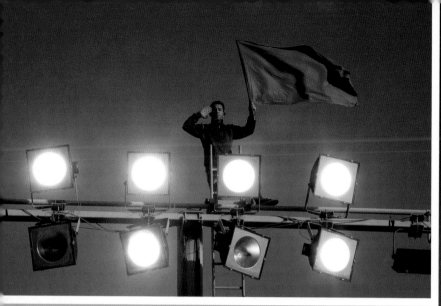

061 [TOP] Tripoli, Libya 062 [ABOVE] Zawiyah, Libya

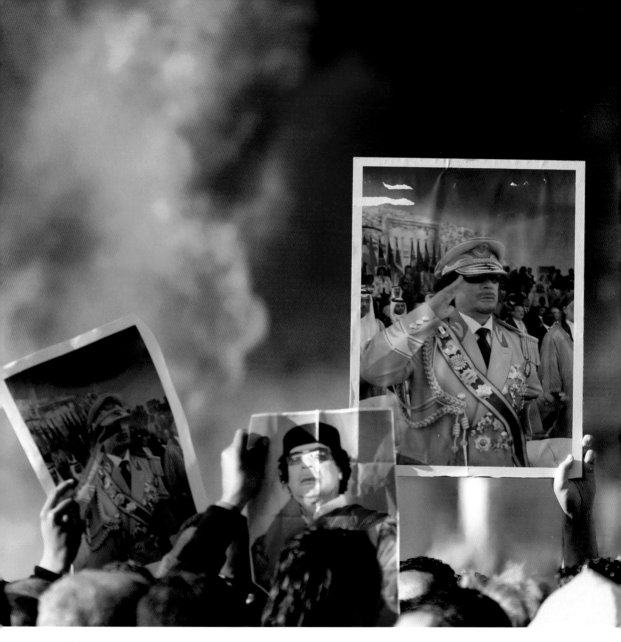

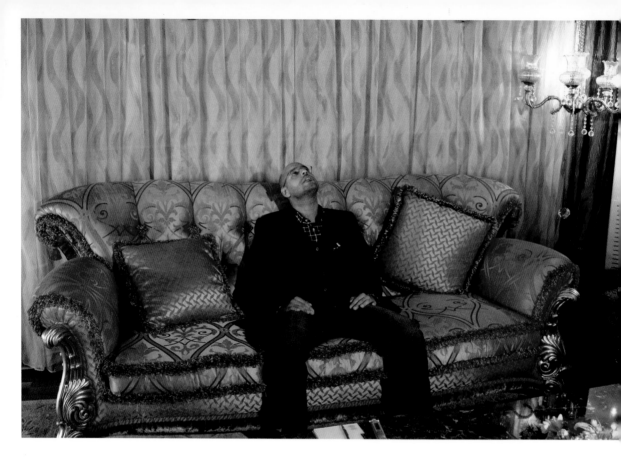

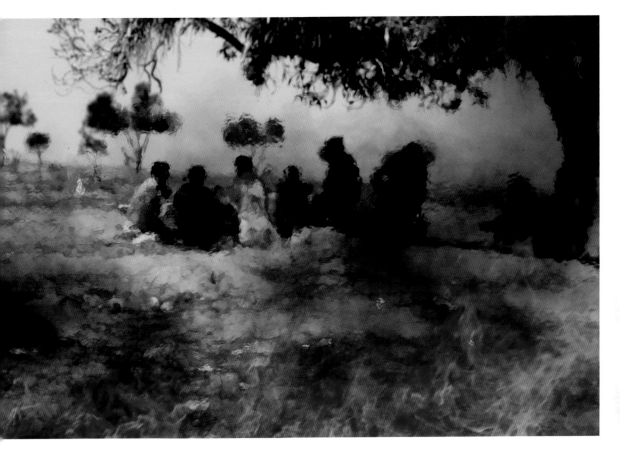

065 Ras Jdir, Tunisia

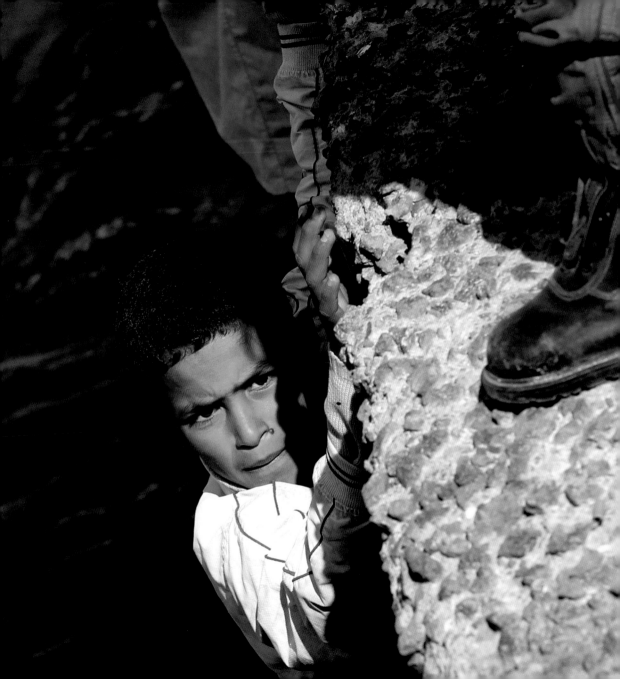

052 053 054 055–060 061 062

063 064 065 066

052 A fuel pump is defaced with a graffiti caricature of Muammar Gaddafi in the rebel-held town of Ajdabiya. Rebels massed outside nearby Brega and said their forces were still fighting Muammar Gaddafi's troops for control of the east Libya oil town. 31 March 2011. Ajdabiya, Libya. Finbarr O'Reilly.

053 Mechanics perform maintenance work on a Super Étendard in the aviation hangar aboard France's flagship *Charles de Gaulle* aircraft carrier. The vessel ran air sorties against targets in Libya as France participated in enforcing the NATO no-fly zone. 28 March 2011. Mediterranean Sea. Benoit Tessier.

054 A sheikh gives a speech in front of a Kingdom of Libya flag during Friday prayers in a street in Benghazi. 4 March 2011. Benghazi, Libya. Suhaib Salem.

55–60 A group of young men who joined the Libyan rebellion pose for portraits in a burned-out building at a military base in the rebel headquarters of Benghazi. Countless young Libyan men quit school or work to fight against Muammar Gaddafi's 42-year rule. 14 March 2011. Benghazi, Libya. Finbarr O'Reilly.

061 A supporter of Gaddafi holds a Libyan flag atop floodlights at Green Square in Tripoli. 21 March 2011. Tripoli, Libya. Zohra Bensemra.

062 Libyan women walk past flare columns burning excess gas at the Azzawiya oil refinery in Zawiyah, 50 km (30 miles) west of the capital, Tripoli. 3 March 2011. Zawiyah, Libya. Ahmed Jadallah.

063 Men hold up posters of Muammar Gaddafi. The images were distributed among a crowd who had gathered to view a burning fuel truck in Tripoli – authorities said the incident was a road traffic accident. The posters were distributed when members of the media arrived at the scene. 2 March 2011. Tripoli, Libya. Chris Helgren.

064 Gaddafi's most high-profile son, Saif al-Islam, pauses during an interview with Reuters in Tripoli. He said that Libya was preparing full-scale military action to crush the rebellion, and would not surrender even if Western powers intervened in the conflict. 10 March 2011. Tripoli, Libya. Chris Helgren.

065 Evacuees sit under a tree alongside burning refuse near a U.N. High Commissioner for Refugees Camp, having fled violence in Libya near the border crossing of Ras Jdir. 6 March 2011. Ras Jdir, Tunisia. Yannis Behrakis.

066 A boy who escaped the unrest in Tunisia is helped by the Italian police after arriving at the island of Lampedusa, southern Italy. Interior Minister Roberto Maroni said almost 15,000 people had travelled to Lampedusa since the beginning of the year, exacerbating Italian fears that the upheavals in north Africa would unleash a wave of clandestine arrivals. 24 March 2011. Lampedusa, Italy. Alessandro Bianchi.

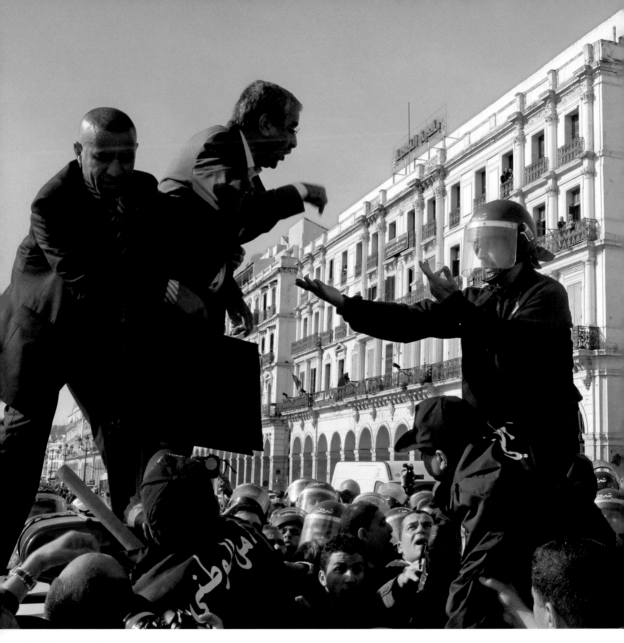

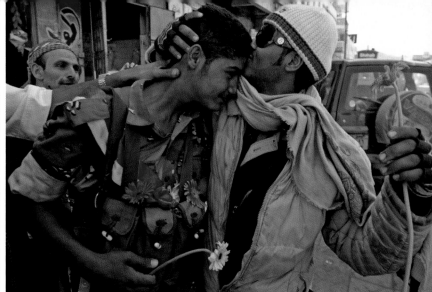

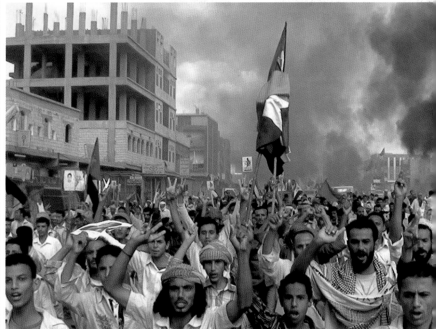

069 [TOP] Sanaa, Yemen **070** [ABOVE] Radfan, Yemen

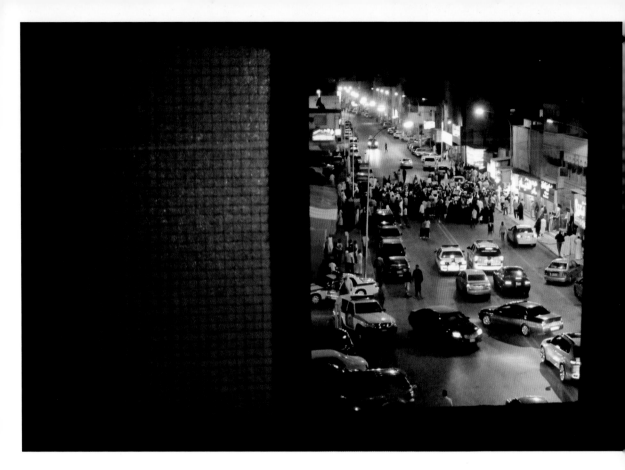

071 Qatif, Saudi Arabia

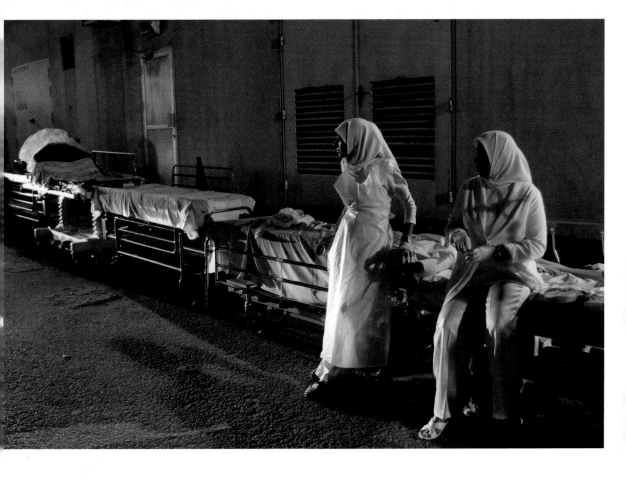

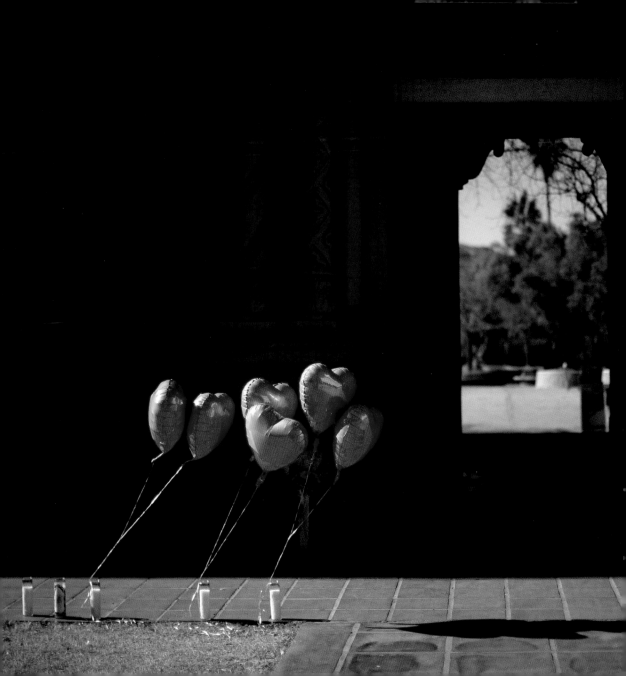

067 068 069 070 071 072

073

067 A woman takes part in a protest demanding the release of human rights activists detained during demonstrations in Sanaa. 24 January 2011. Sanaa, Yemen. Khaled Abdullah.

068 Saïd Saadi, leader of the Algerian opposition party Rally for Culture and Democracy, argues with police during an anti-government demonstration in Algiers. 26 February 2011. Algiers, Algeria. Louafi Larbi.

069 A Yemeni army soldier receives flowers and is kissed while standing guard to protect anti-government protesters during a demonstration appealing for the resignation of Yemeni President Ali Abdullah Saleh. Opposition groups called on protesters to march on Saleh's palace to force him out, hoping to end a crisis his allies abroad feared would benefit Islamic militants. 23 March 2011. Sanaa, Yemen. Ammar Awad.

070 Protesters march during an anti-government demonstration in Radfan, a district in the southern Yemeni province of Lahej. Thousands of Yemenis took to the streets of Sanaa to demand a change of government, inspired by the unrest that had ousted Tunisia's leader and spread to Egypt. 27 January 2011. Radfan, Yemen. Yasser Hassan.

071 Saudi Shi'ites stage a small protest in the kingdom's eastern province of Qatif, defying a ban on demonstrations. Onlookers said that more than 100 people, mostly young men, gathered to demand the release of prisoners they said were being held without trial. 9 March 2011. Qatif, Saudi Arabia.

072 Nurses wait for injured people at the Suleimanieh Central Hospital in Manama. A witness said Bahraini security forces shot at protesters near Pearl Square and wounded at least 23. 18 February 2011. Manama, Bahrain. Caren Firouz.

073 Balloons are displayed as part of a prayer vigil in response to a shooting at a Safeway supermarket in Tucson, Arizona. Gabrielle Giffords (a member of the U.S. House of Representatives for Arizona's 8th congressional district) was left fighting for life after an assailant shot her in the head and killed six others in a rampage that launched a debate about extreme political rhetoric in America. 9 January 2011. Arizona, United States. Eric Thayer.

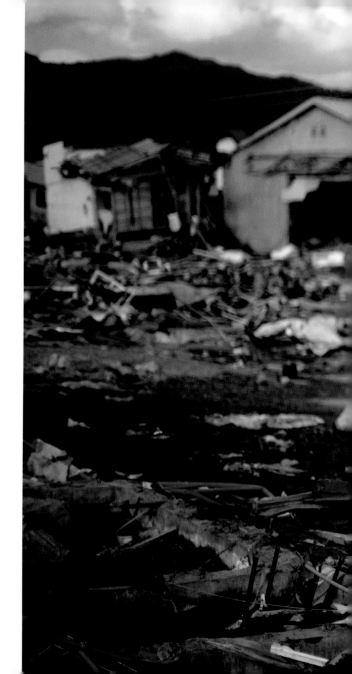

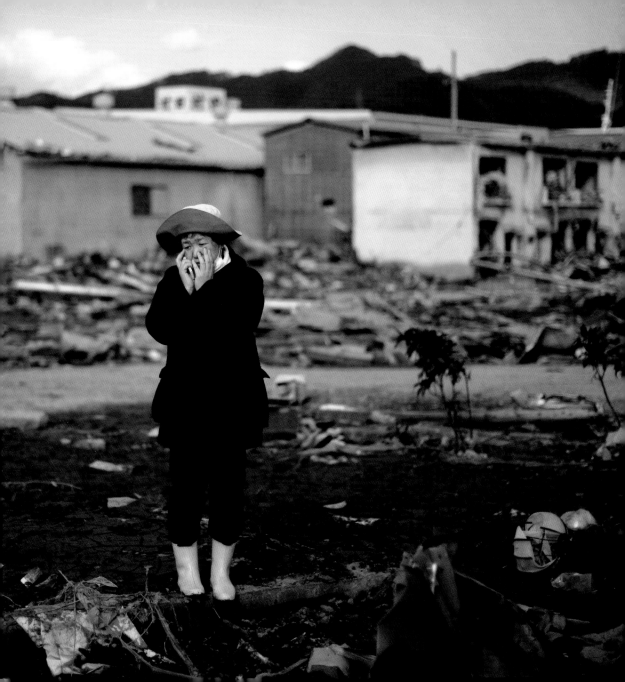

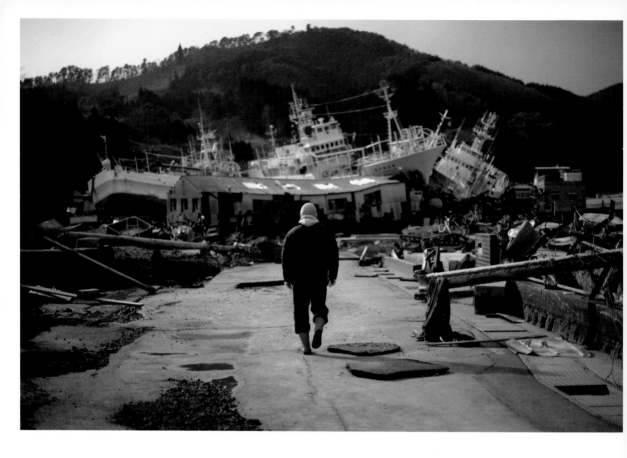

075 Kesennuma, Japan

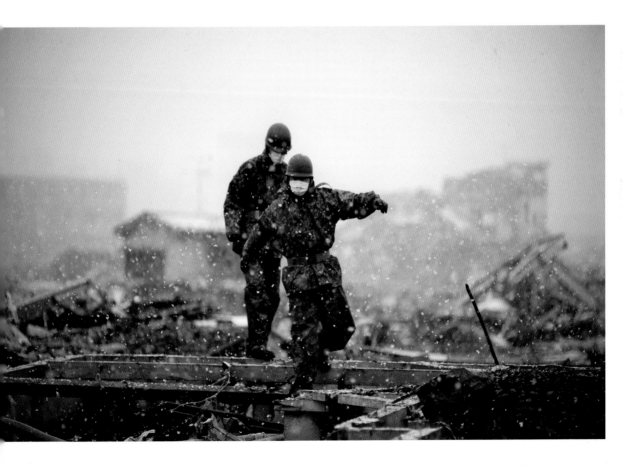

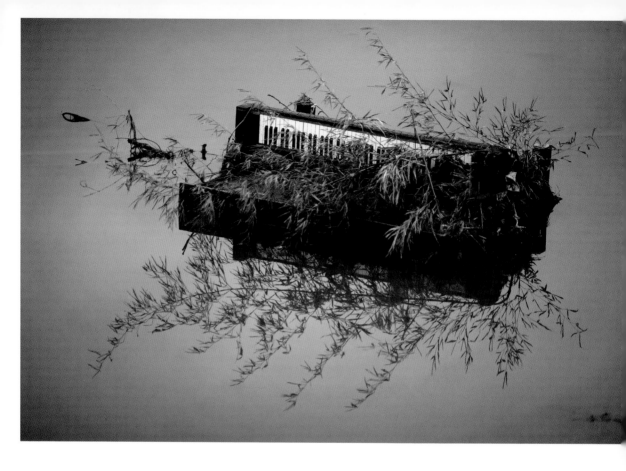

077 Rikuzentakata, Japan

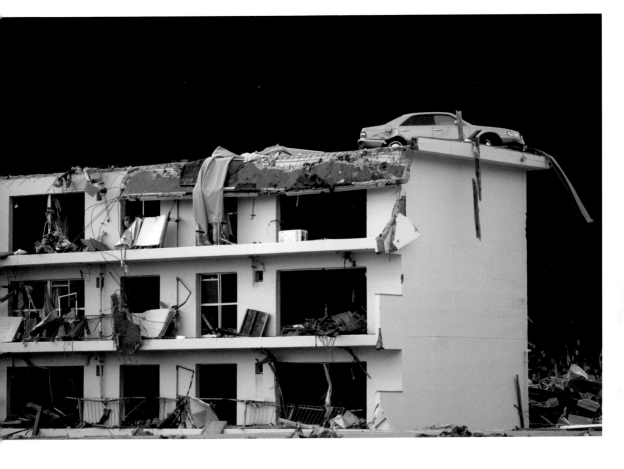

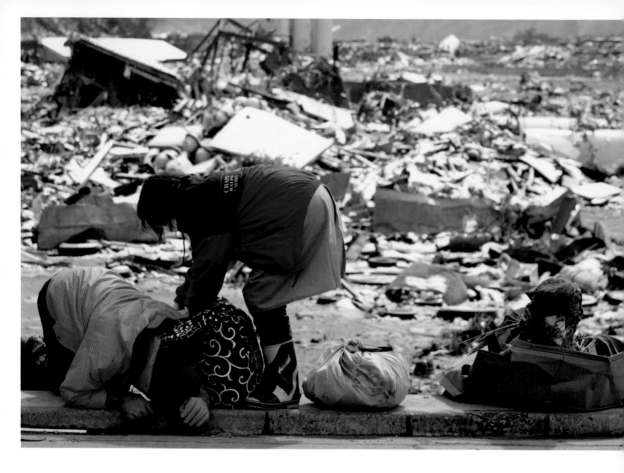

079 Otsuchi, Japan

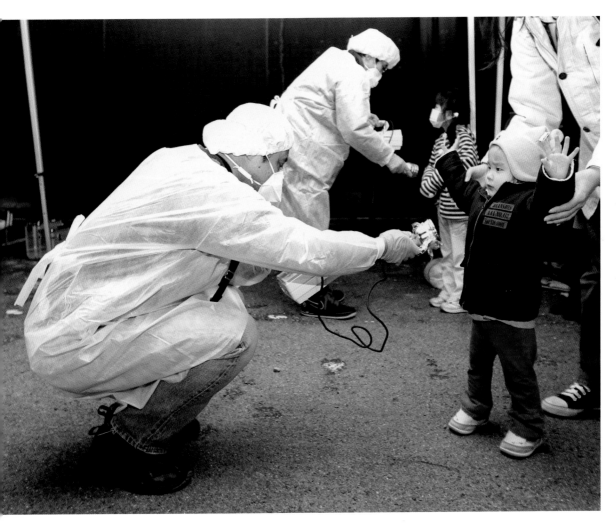

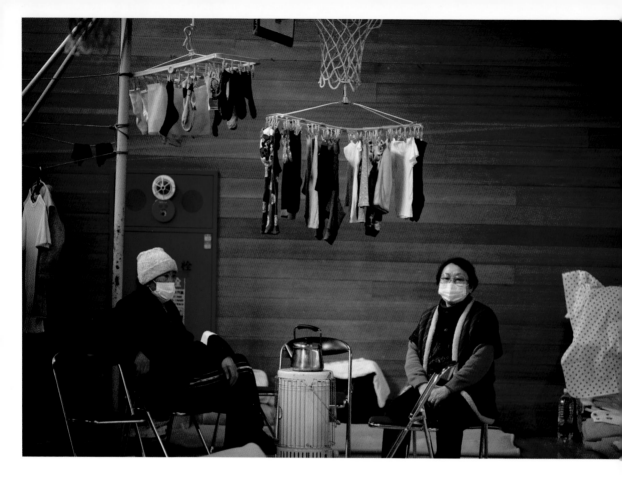

081 Yamada, Japan

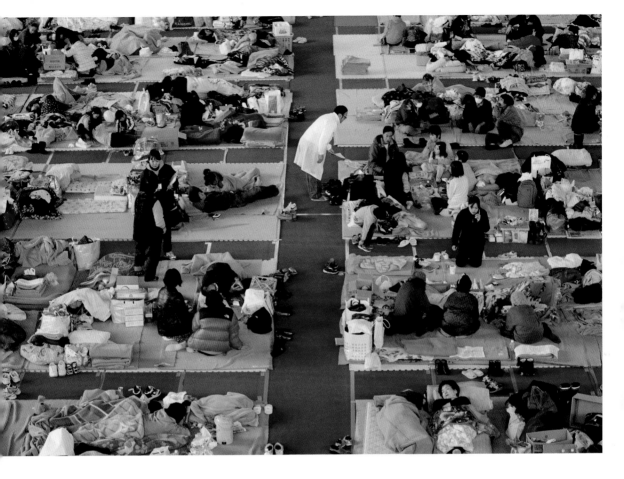

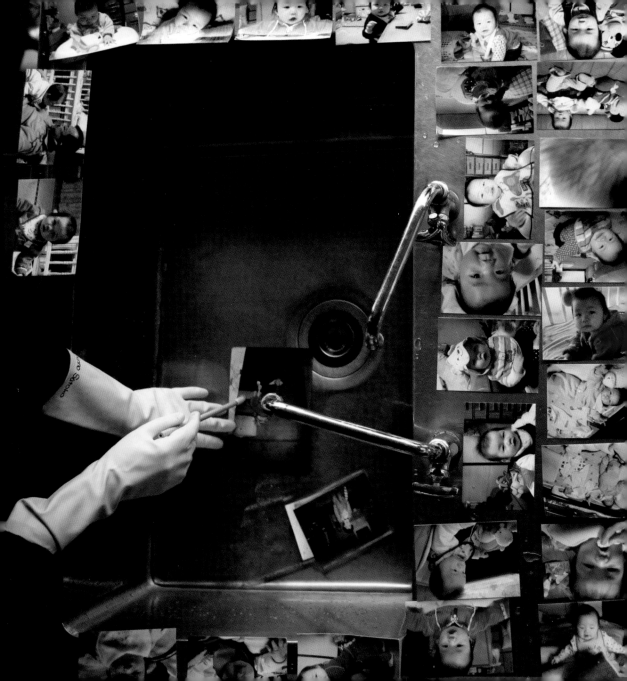

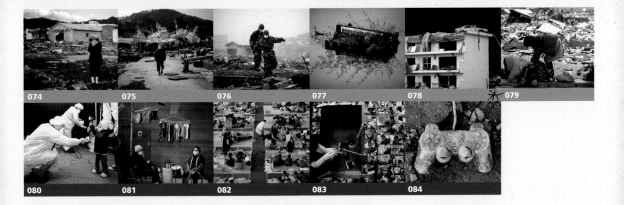

074 A woman on a phone looks at the ruins of her house, which was destroyed by the earthquake and tsunami in Kesennuma town, located in the northeastern Miyagi prefecture. 28 March 2011. Kesennuma, Japan. Carlos Barria.

075 A man walks through a devastated port area in Kesennuma. The biggest earthquake on record to hit Japan struck the northeast coast on 11 March, triggering a 10-metre (33-foot) tsunami that swept away everything in its path, including houses, ships and cars. 28 March 2011. Kesennuma, Japan. Carlos Barria.

076 Snow falls on members of the Japan Self-Defence Force making their way through the ruins of the devastated residential area in Otsuchi, Iwate prefecture. Following the earthquake and tsunami, 12,000 out of the fishing town's population of 15,000 were unaccounted for. 16 March 2011. Otsuchi, Japan. Damir Sagolj.

077 A piano floats in the floodwaters covering Rikuzentakata city, Iwate prefecture. Japan faced mammoth disaster-relief and reconstruction efforts after its worst earthquake. 21 March 2011. Rikuzentakata, Japan. Damir Sagolj.

078 A car is seen on top of a destroyed building after the earthquake and tsunami in Minamisanriku town, Miyagi prefecture. The giant wave devastated the country's northeastern coast, killing thousands and causing a severe nuclear crisis. 22 March 2011. Minamisanriku, Japan. Carlos Barria.

079 Emotional survivors collect belongings from their ruined house in Otsuchi. 17 March 2011. Otsuchi, Japan. Lee Jae-Won.

080 Officials in protective gear check for signs of radiation on children from the evacuation area near the Fukushima Daini nuclear plant in Koriyama. Japanese Chief Cabinet Secretary Yukio Edano confirmed that there had been an explosion and radiation leakage at a nuclear plant run by Tokyo Electric Power Co. 13 March 2011. Koriyama, Japan. Kim Kyung-Hoon.

081 Evacuees pass the time as their clothes dry at a shelter for those moved from the disaster zone in Yamada town, Iwate prefecture. After the area was devastated by a magnitude 9.0 earthquake and tsunami, Japan resigned itself to a long fight to contain the world's most dangerous atomic crisis in 25 years. 28 March 2011. Yamada, Japan. Damir Sagolj.

082 At an evacuation centre set up in a gymnasium in Yamagata, northern Japan, a doctor talks to people who used to reside in the vicinity of the Fukushima nuclear plant. 19 March 2011. Yamagata, Japan. Yuriko Nakao.

083 A volunteer at a centre in Ofunato, Iwate prefecture, cleans a family photo that had been lost in the tsunami. 12 April 2011. Ofunato, Japan. Toru Hanai.

084 A Sony PlayStation controller washed away by the waters in Kesennuma. 19 March 2011. Kesennuma, Japan. Kim Kyung-Hoon.

2

085 London, Britain

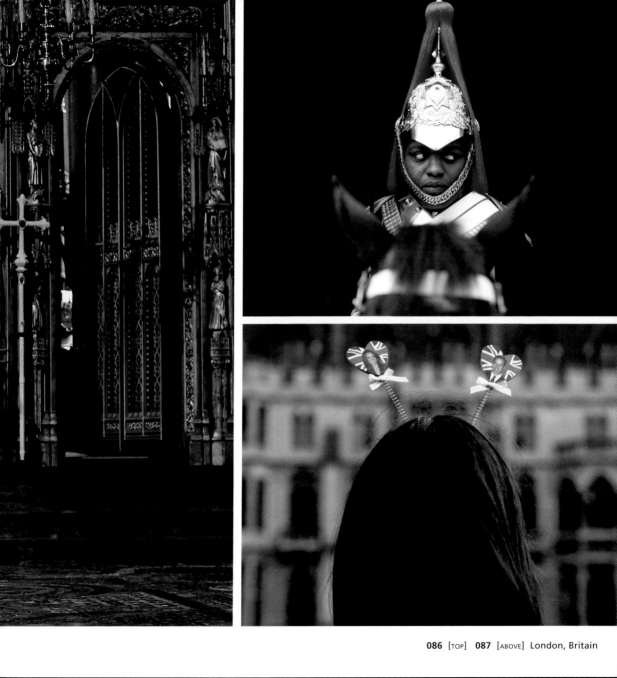

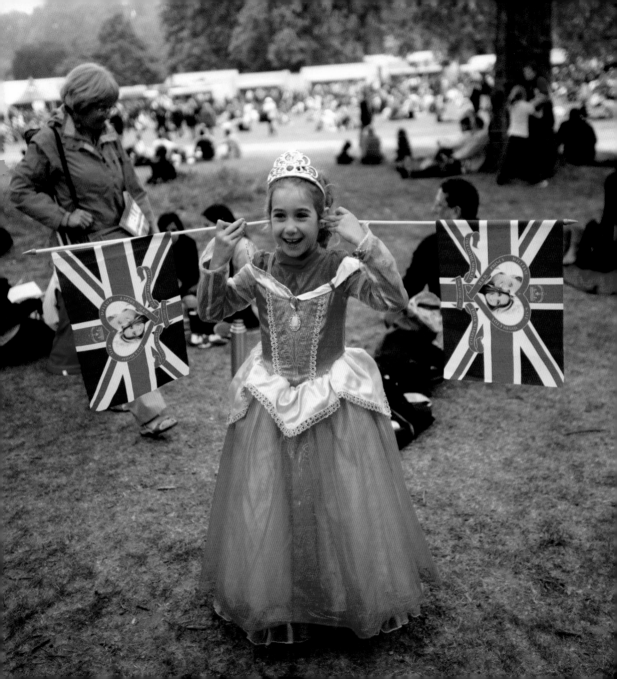

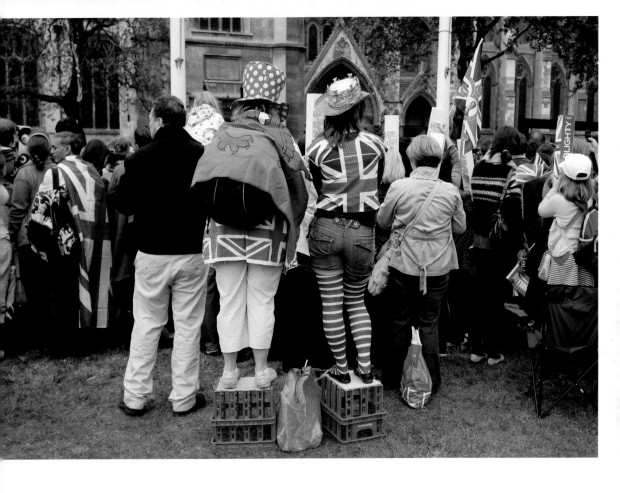

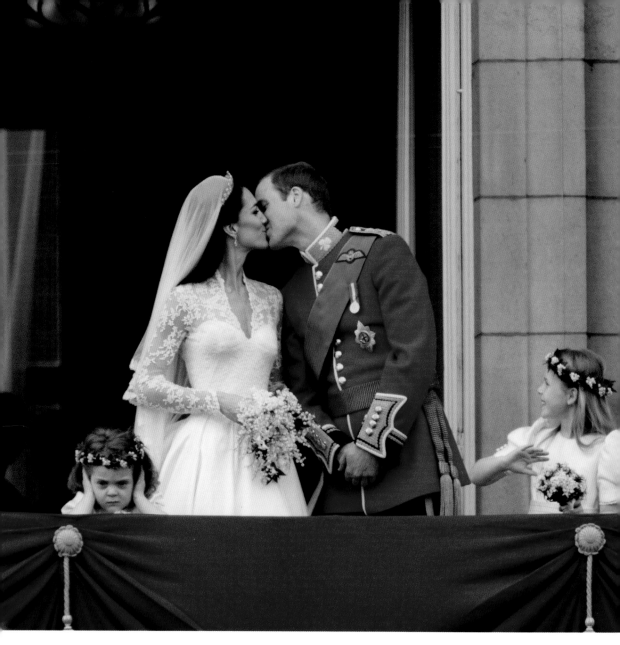

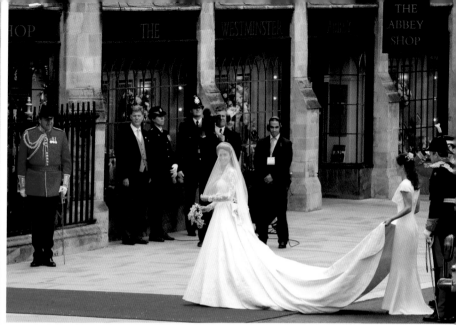

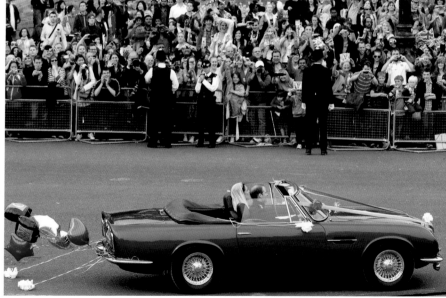

091 [TOP] **092** [ABOVE] London, Britain

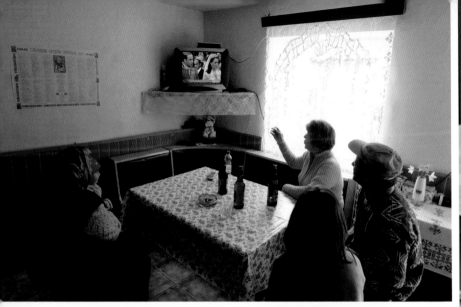

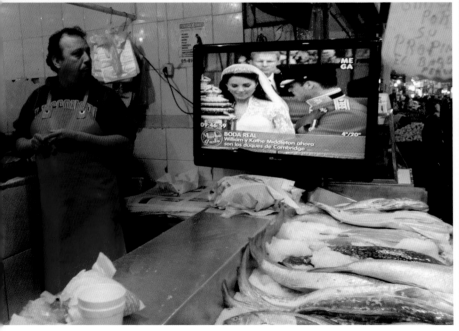

093 [TOP] Viscri, Romania **094** [ABOVE] Santiago, Chile

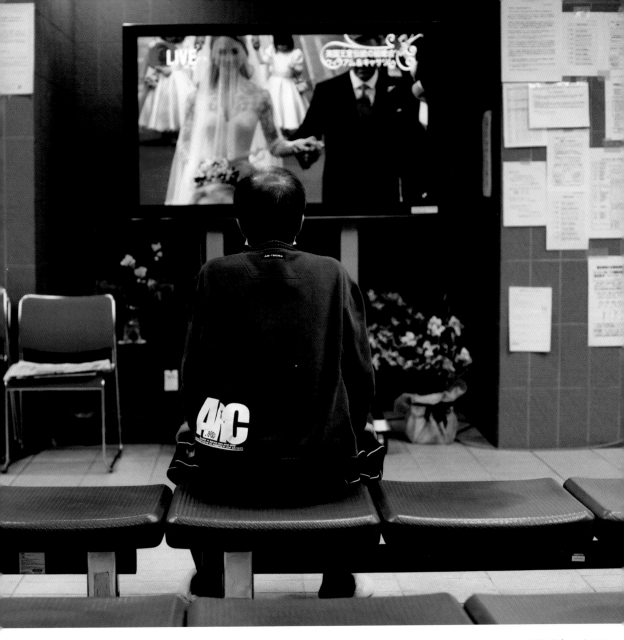

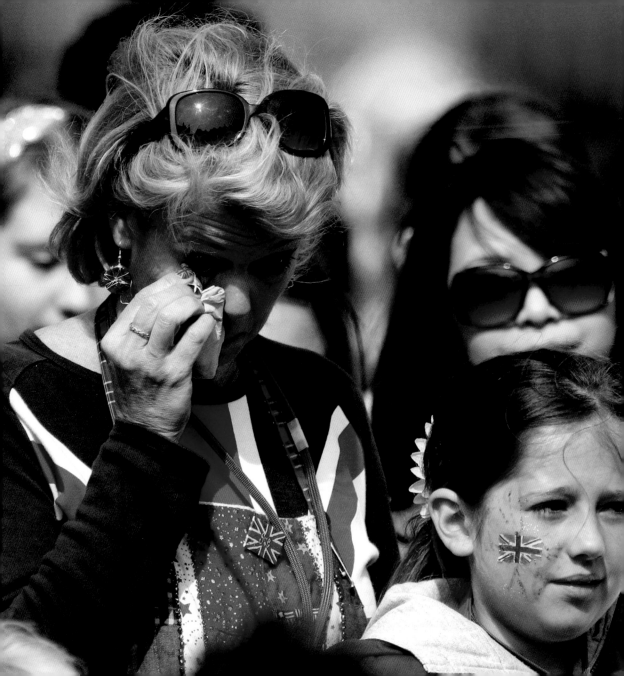

085 · 086 · 087 · 088 · 089 · 090
091 · 092 · 093 · 094 · 095 · 096

085 Westminster Abbey in London is readied for the marriage of Britain's Prince William and his fiancée, Catherine (Kate) Middleton. 20 April 2011. London, Britain. Stefan Wermuth.

086 A mounted Guardsman stationed in Whitehall, central London. Hundreds of people slept in tents on the pavement to guarantee a view of the route the royal couple took on their wedding day. 28 April 2011. London, Britain. Nir Elias.

087 A spectator wearing a hairband decorated with pictures of Prince William and Kate Middleton stands opposite Westminster Abbey. 28 April 2011. London, Britain. Nir Elias.

088 Flags bearing the image of the royal couple are carried by a girl dressed in a princess costume in St James's Park. 29 April 2011. London, Britain. Marcelo del Pozo.

089 Well-wishers in Parliament Square stand on crates to get a better view of the processional route taken by Prince William and Kate Middleton from Westminster Abbey. 29 April 2011. London, Britain. Kevin Coombs.

090 The newlyweds kiss on the balcony at Buckingham Palace. On the morning of the ceremony, William was created Duke of Cambridge, and after the ceremony Catherine became Her Royal Highness The Duchess of Cambridge. 29 April 2011. London, Britain. Dylan Martinez.

091 Kate Middleton arrives at Westminster Abbey wearing a dress designed by Sarah Burton at Alexander McQueen. 29 April 2011. London, Britain. Phil Noble.

092 The Duke and Duchess of Cambridge drive from Buckingham Palace to Clarence House in an open-topped Aston Martin. 29 April 2011. London, Britain. Darren Staples.

093 Members of the Adam family watch the royal wedding in the small Transylvanian village of Viscri, where Britain's Prince Charles is a landowner. Viscri had been touted by the media as a possible honeymoon destination for the couple. 29 April 2011. Viscri, Romania. Bogdan Cristel.

094 A fish seller watches the wedding at a local market in Santiago. 29 April 2011. Santiago, Chile. Ivan Alvarado.

095 Hajime Ajima, displaced by the earthquake and tsunami that hit Japan in March, views a TV broadcast of the wedding at a temporary evacuation centre in Chofu, western Tokyo. 29 April 2011. Tokyo, Japan. Toru Hanai.

096 A woman wipes her eyes as she watches the service on a large screen at St Andrews – the Scottish university where William and Kate met. 29 April 2011. St Andrews, Britain. David Moir.

ERIC THAYER
Photographer
Born: Los Angeles, United States, 1974
Based: New York/Los Angeles, United States
Nationality: American

Life in the U.S. Rust Belt

Abandoned homes and factories spot the Midwest region that has come to be known as the 'Rust Belt'. The area once represented the height of American industry: from the late 19th to the mid-20th century its steel built cars and skyscrapers, bringing jobs to flourishing neighbourhoods in Indiana, Michigan and upstate New York. After the 1970s downturn of industry in the area, when manufacturing began to move away, the cities' growth slowed, then contracted.

Being a news agency our focus is normally on immediacy, but with this project – a story of slow economic decline – I really wanted to take my time. I decided I would begin on one edge and travel across the Rust Belt, focusing on three key aspects: people, decay and details.

During my trip I recorded stories, places and objects that defined a once-prosperous region struggling to retain its identity. In Davenport, Iowa, I met locals who couldn't find work no matter how hard they tried. Next, in Gary, Indiana, I spent time with the police, who were busy dealing with an increase in crime, as well as calling on a food distribution centre set up to help struggling families, and after that visited Mingo Junction, Ohio. There the steel mill had closed, and the workers it would once have employed can now be found sat at the bar at 10 a.m. In Detroit there are abandoned buildings everywhere, and in Buffalo, New York, markets that once bustled no longer draw the crowds.

When I approached my subjects, I was always sure to tell them what the aim of my story was, and from there I let them decide whether they wanted to be included. Some didn't, but most did.

Travelling through the Rust Belt not only showed me how precarious life there can be, but also how positive many people have remained despite the difficulties: they opened up to tell me their stories, and they allowed me to tell their stories. While the rest of the world is focused on other news, the Rust Belt quietly goes about its day-to-day business across a decaying stretch of land that spans seven states and a couple of time zones. There are occasional glimmers of hope, but mostly it's ghosts of the past. Mostly it's a shell.

097 A house is reflected in the screen of a discarded television in Beach City, Ohio. The city is part of America's Midwestern Rust Belt. 6 April 2011. Ohio, United States. Eric Thayer.

WITNESS

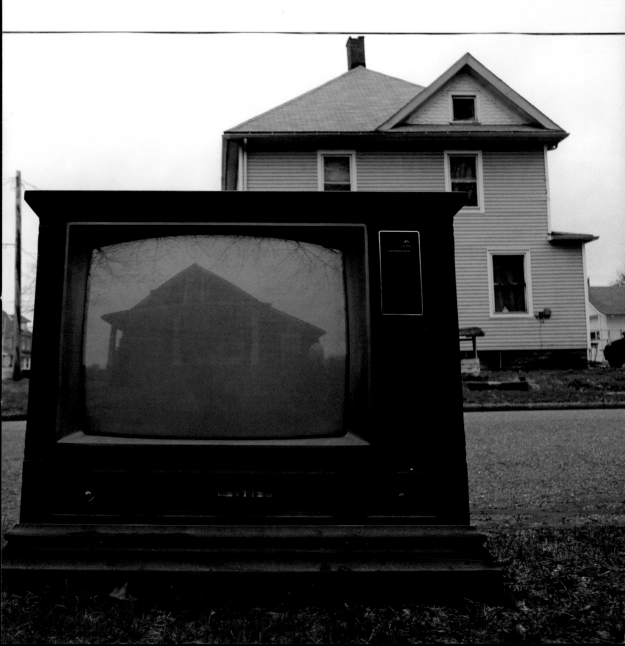

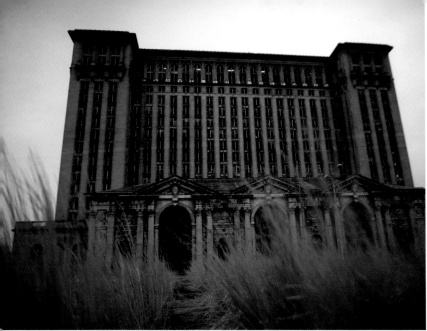

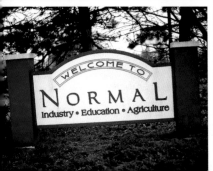

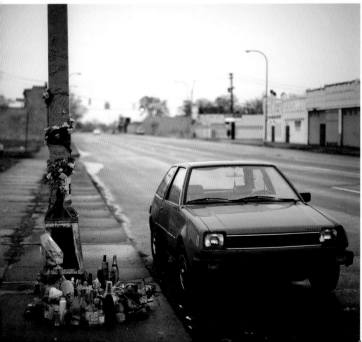

	099	104
098	100	
101	103	105
102		

098 The abandoned Michigan Central Station is seen in the American Midwestern town of Detroit. The Rust Belt is the heartland of the country with an economy that relies mainly on unionized manufacture and heavy industry, such as the auto and steel businesses. The mechanization of production, coupled with the US housing crisis and migration of business to the more economically viable southwest, has lead to increasing unemployment and foreclosures. 5 April 2011. **099** Kevin Murphy (left), Booker Jacobs and Leevan Harris (right) play basketball in Bettendorf, Iowa. 29 March 2011. **100** People receive items from a food bank in Gary, Indiana. 31 March 2011. **101** A rusting cabinet is seen at an abandoned factory in Warsaw, Indiana. 1 April 2011. **102** The sign for the Rust Belt town of Normal, Illinois. 30 March 2011. **103** Customers hug at a bar in Mingo Junction. A foreign company bought the Ohio River Valley town's only steel mill and later shut the facility down, taking away the main source of jobs. 7 April 2011. **104** A couple sit at the counter of Perison's restaurant in the Broadway Market in Buffalo, New York. Once a thriving farmers' market, the historic space has managed to survive the crisis. 10 April 2011. **105** A car is seen next to a memorial in Detroit. 5 April 2011. Eric Thayer.

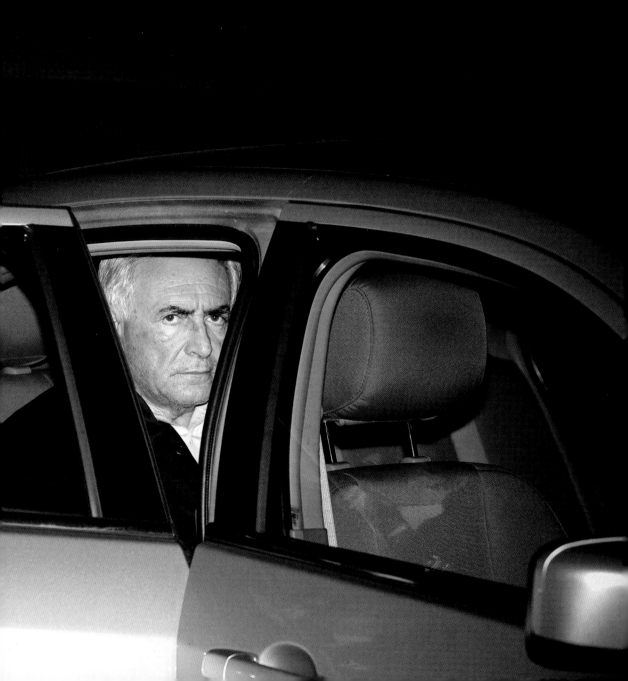

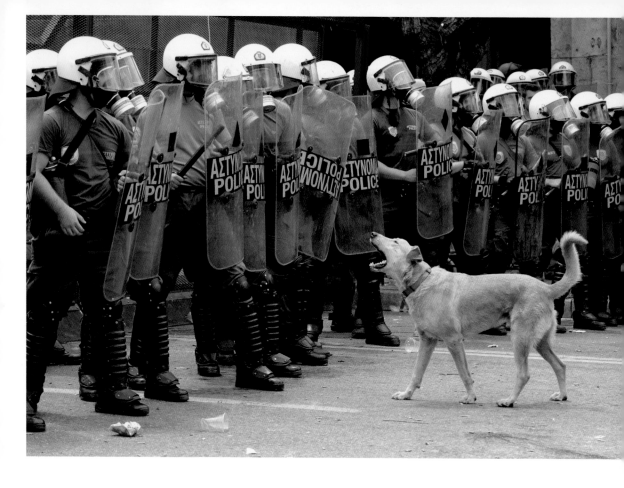

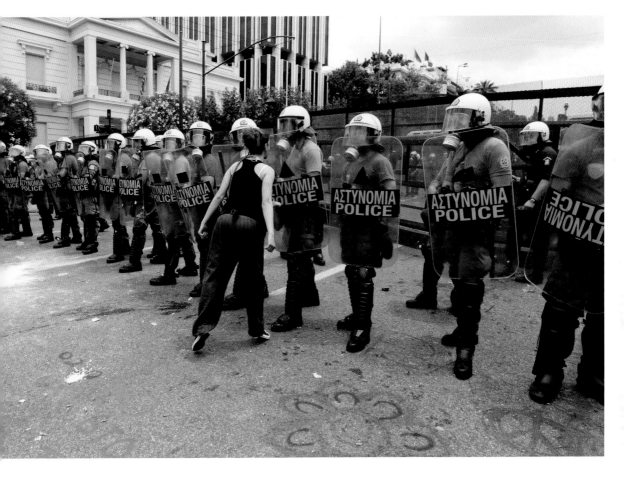

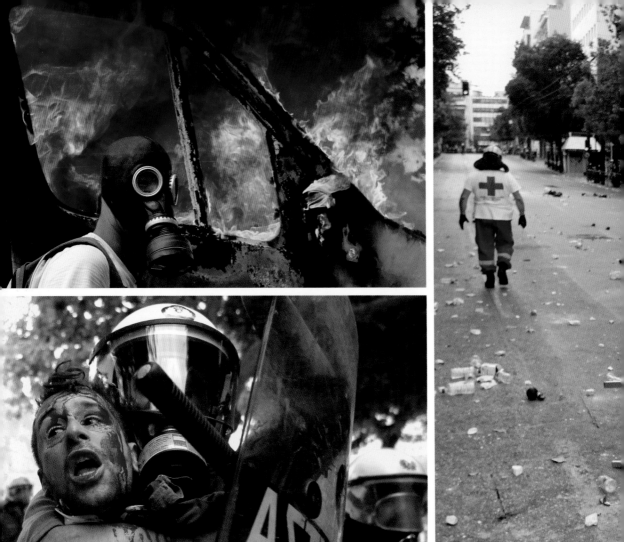

110 [TOP] **111** [ABOVE] Athens, Greece

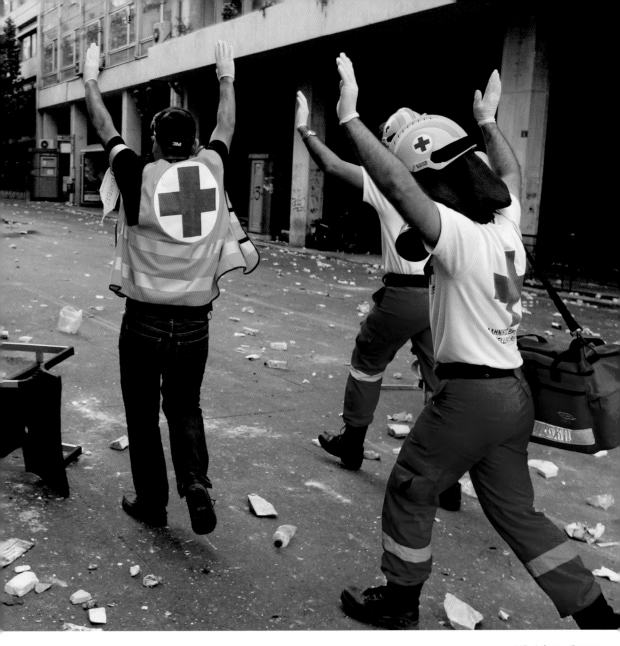

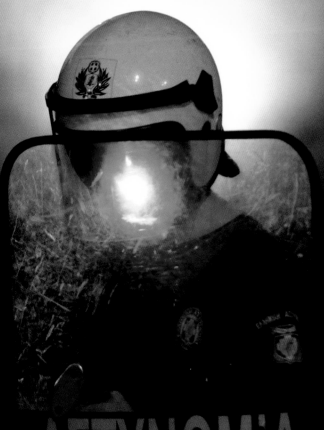

106 · 107 · 108 · 109 · 110 · 111 · 112 · 113

106 International Monetary Fund (IMF) Managing Director Dominique Strauss-Kahn leaves the headquarters of the New York Police Department Special Victims Unit. Strauss-Kahn was charged with sexually assaulting and attempting to rape a maid at the upscale Sofitel Hotel on Times Square. A New York judge dropped all criminal sexual assault charges against Strauss-Kahn in August. 15 May 2011. New York, United States. Allison Joyce.

107 Members of the New York Hotel Workers' Union protest against former IMF chief Strauss-Kahn before his arrival at Manhattan Criminal Court. The French politician pleaded not guilty to the charges in a case that cost him his job and a chance at the French presidency. 6 June 2011. New York, United States. Mike Segar.

108 A dog barks at a formation of riot police near the Greek parliament in Athens as tens of thousands of grass-roots activists and unionists converged on Athens' central Syntagma (Constitution) Square. To ensure Greece avoided default and continued to receive aid from the EU and IMF, Prime Minister George Papandreou attempted to push through austerity measures, including tax hikes, spending cuts and sales of state property. 15 June 2011. Athens, Greece. Pascal Rossignol.

109 A protester shouts at police guards outside parliament. During the clashes, riot officers fired teargas at the demonstrators in Syntagma Square. 15 June 2011. Athens, Greece. Yannis Behrakis.

110 An activist wearing a gas mask walks beside a burning van in central Athens during violent protests against the austerity measures. 28 June 2011. Athens, Greece. Yannis Behrakis.

111 Riot police detain a demonstrator after Greece's parliament approved the first of two austerity bills, despite the protests, thereby securing international funds to try to stave off the eurozone's first sovereign default. 29 June 2011. Athens, Greece. John Kolesidis.

112 Red Cross personnel raise their arms, asking police and protesters for calm during the violent confrontations that followed the passing of Greece's austerity bills. The measures, demanded by international lenders, opened the way for the EU and IMF to release a 12-billion euro loan instalment to Greece. 29 June 2011. Athens, Greece. Yiorgos Karahalis.

113 A riot police officer's shield is lit up by a protester's laser pointer during the unrest in Athens. 30 June 2011. Athens, Greece. Yiorgos Karahalis.

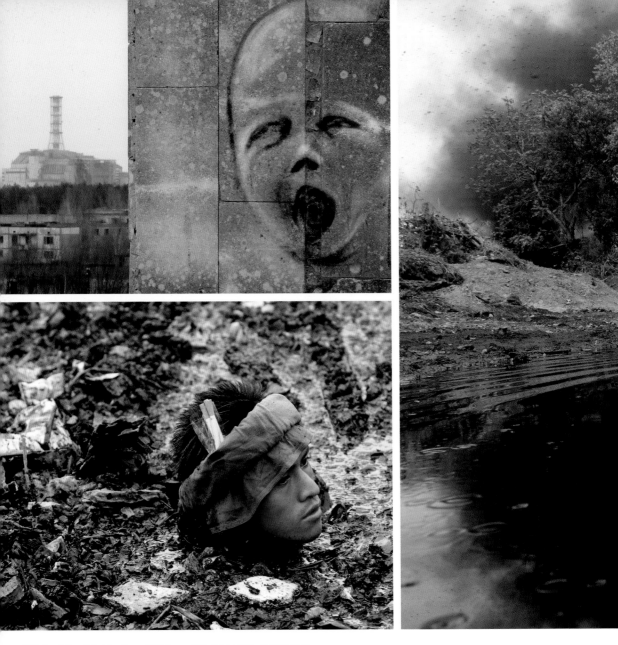

114 [TOP] Prypiat, Ukraine **115** [ABOVE] Malabon City, Philippines

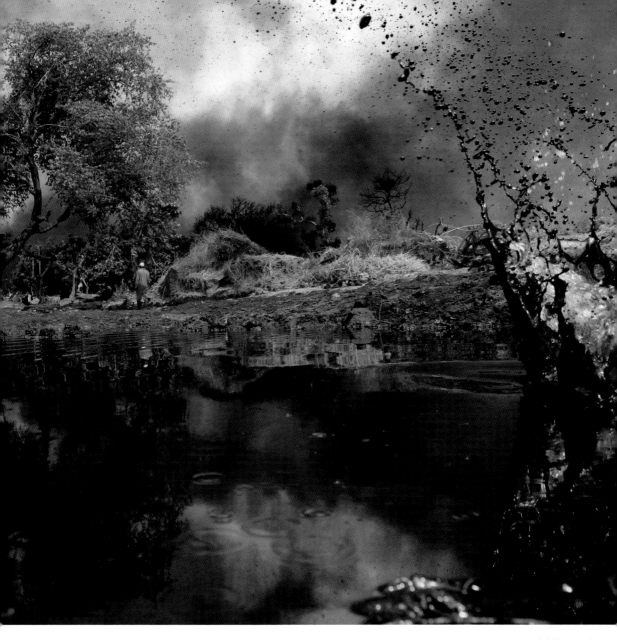

116 Dadabili, Nigeria

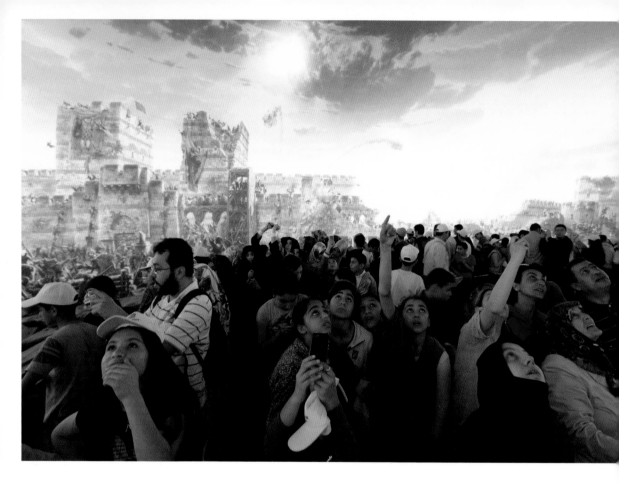

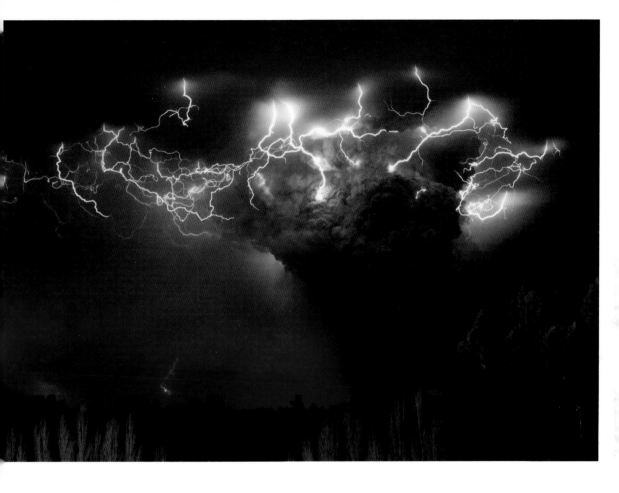

119 Dorset, Britain

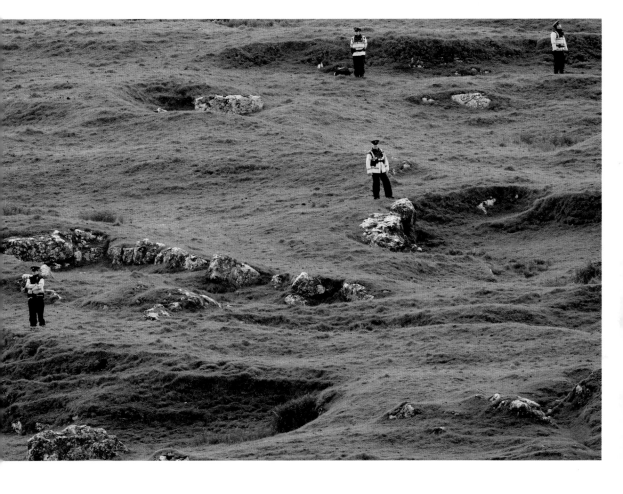

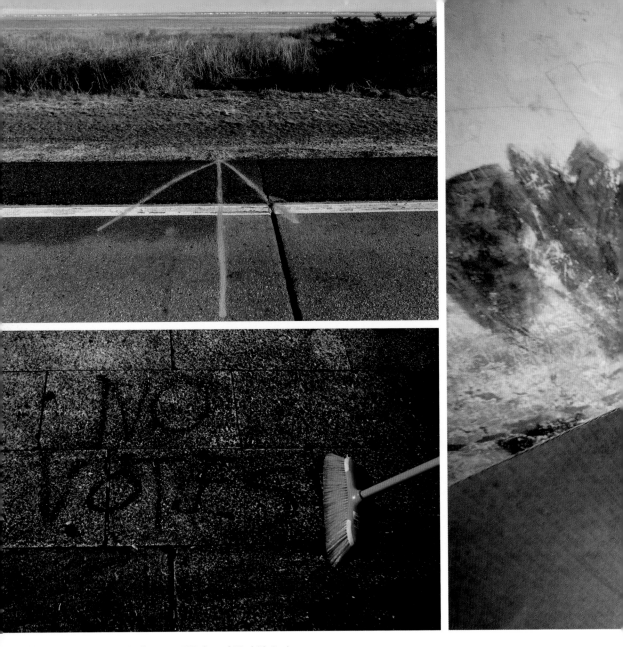

121 [TOP] New York, United States **122** [ABOVE] Madrid, Spain

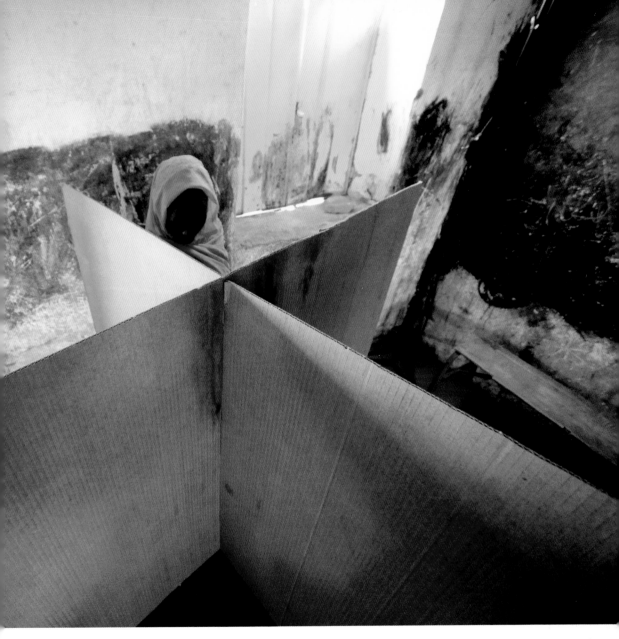

123 Kadugli, Sudan

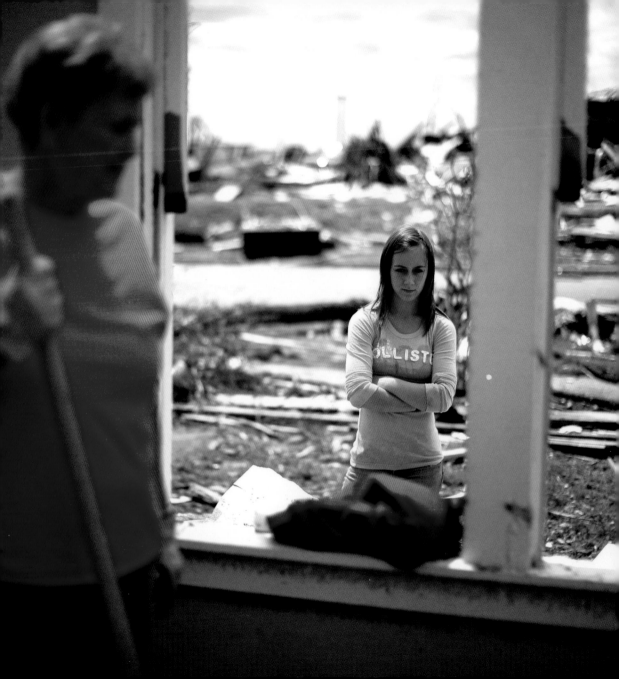

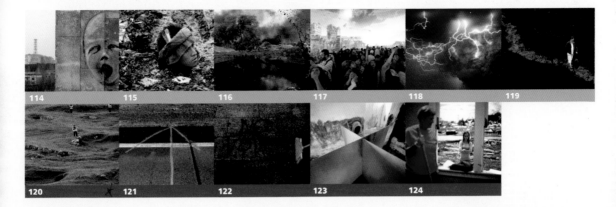

114 A concrete 'sarcophagus' covers the damaged fourth reactor at the Chernobyl Nuclear Power Plant, seen in the distance from the abandoned city of Prypiat. On 26 April, Ukraine and Russia marked the 25th anniversary of the world's worst civil nuclear accident. 4 April 2011. Prypiat, Ukraine. Gleb Garanich.

115 A man wades in neck-deep water, searching for valuable items after a fire in a coastal village in Malabon City, north of Manila. The fire, believed to have been caused by an exploding liquefied petroleum gas tank, left 3,000 residents homeless. 7 April 2011. Malabon City, Philippines. Erik de Castro.

116 Crude oil spills from a pipeline in Dadabili, western Nigeria. A U.N. report on 50 years of oil pollution in the country suggested that the clean-up operation could take 30 years and cost over a billion U.S. dollars. 2 April 2011. Dadabili, Nigeria. Afolabi Sotunde.

117 People visit the Panorama 1453 History Museum in Istanbul on the 558th anniversary of the conquest of the city by Ottoman Turks. 29 May 2011. Istanbul, Turkey. Murad Sezer.

118 Lightning flashes around the ash plume above the Puyehue-Cordón Caulle volcano chain near Entre Lagos, Chile. The plume itself grew to over 10 km (6 miles) in height. 5 June 2011. Entre Lagos, Chile. Carlos Gutierrez.

119 A man walks his dog after a fire affecting over 500 hectares (1,240 acres) of Dorset's Upton Heath, near Poole, southwest England, had been brought under control. Some areas of Britain experienced their driest spring on record. 10 June 2011. Dorset, Britain. Stefan Wermuth.

120 Guarda officers patrol as Britain's Queen Elizabeth and Prince Philip arrive for their visit to St Patrick's Rock in Cashel, Ireland. It was the first state visit by a British monarch since Ireland's independence. 20 May 2011. Cashel, Ireland. Darren Staples.

121 A painted arrow marks the location where human remains were discovered near the Gilgo Beach area of New York. Ten bodies were eventually found, the murders thought to be the work of at least one serial killer. 14 April 2011. New York, United States. Shannon Stapleton.

122 A demonstrator sweeps over the painted words 'No votes' as people camp out at Madrid's Puerta del Sol, five days after Spanish regional and local elections. Tens of thousands of people protested against the government's handling of the economic crisis. After losses in the local elections, Spain's ruling Socialist party faced both voter anger over sky-high unemployment and investor demands for strict austerity measures. 27 May 2011. Madrid, Spain. Susana Vera.

123 A voter is seen at the polling centre during the first day of balloting in Kadugli. It was feared that the election for the governor of the border state of South Kordofan might reignite tensions in the war-torn region. South Sudan became independent on 9 July. 2 May 2011. Kadugli, Sudan. Mohamed Nureldin Abdallah.

124 Ginger Slaybaugh sweeps debris from the destroyed home of Kinsie Sexton in Joplin, Missouri. Rescue teams scoured the rubble of the Midwestern city, which was devastated by a tornado that damaged about 8,000 buildings and killed at least 160. 26 May 2011. Missouri, United States. Eric Thayer.

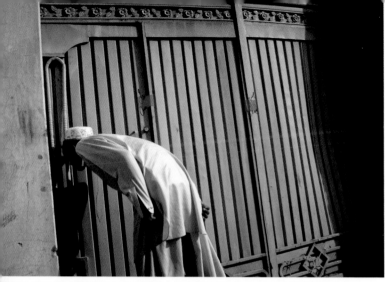

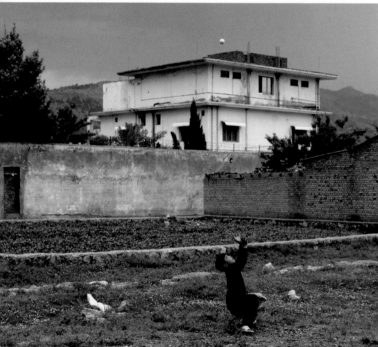

125 [TOP] **126** [ABOVE] Abbottabad, Pakistan

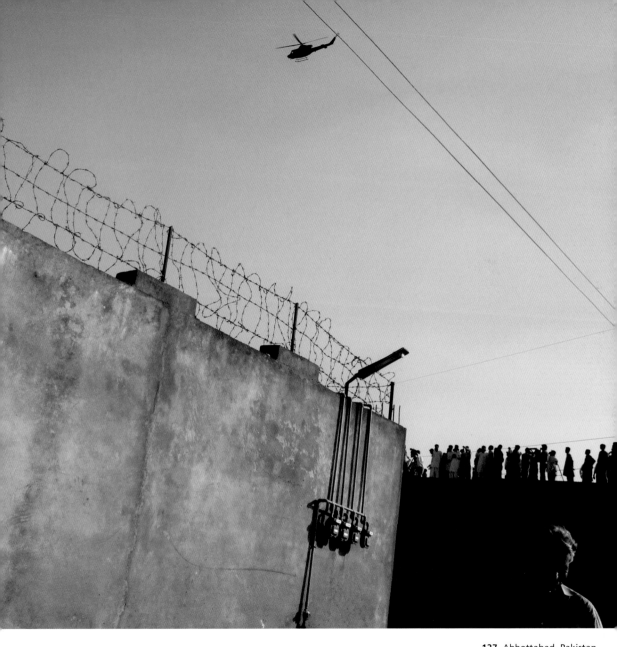

127 Abbottabad, Pakistan

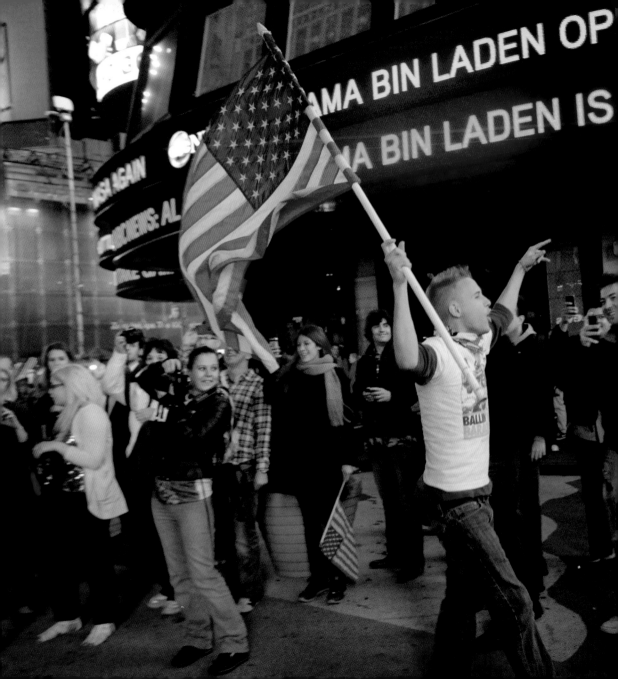

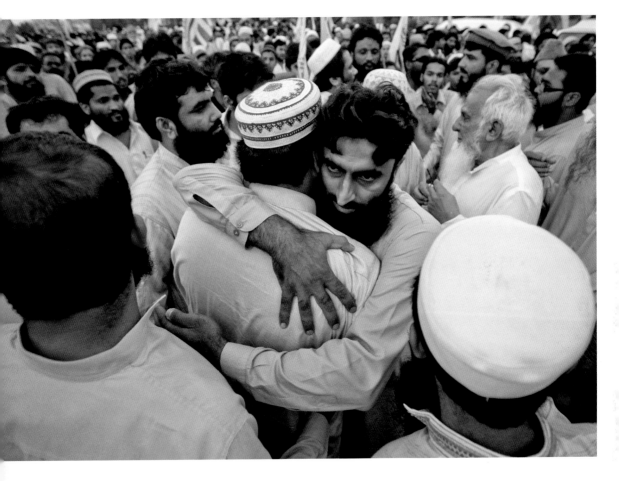

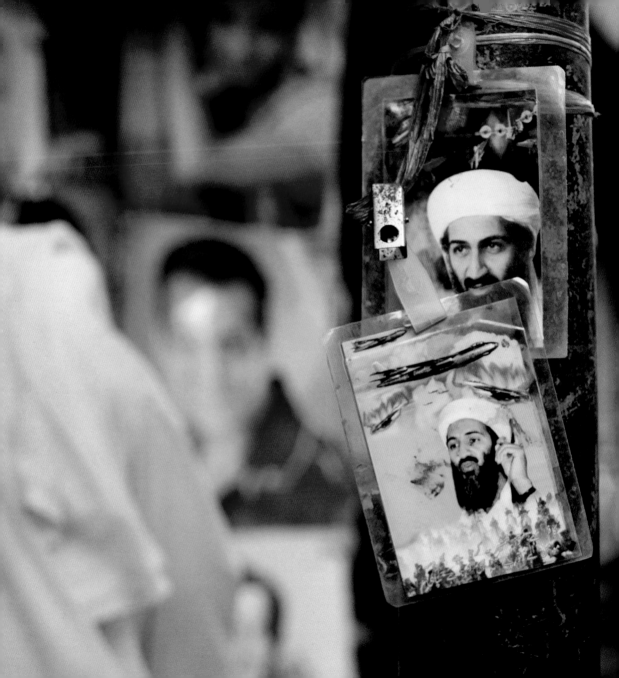

125 126 127 128 129 130

131

5 A resident looks into the compound where al-Qaeda leader Osama bin Laden was killed in Abbottabad. In the wake of the operation, the White House tried to establish whether its ally Pakistan had helped the fugitive elude a worldwide manhunt. 4 May 2011. Abbottabad, Pakistan. Faisal Mahmood.

6 Adeel, 8, plays with a ball in front of the compound three days after U.S. Navy SEAL commandos killed bin Laden. It later emerged he was unarmed during the firefight. 5 May 2011. Abbottabad, Pakistan. Akhtar Soomro.

127 Residents look up towards a military helicopter flying over the compound where bin Laden was killed. 4 May 2011. Abbottabad, Pakistan. Faisal Mahmood.

128 People in Times Square, New York, react to the news of the death. Bin Laden, who masterminded the September 11 attacks, had evaded capture for nearly 10 years. 2 May 2011. New York, United States. Eric Thayer.

129 A man injured by a suicide bomb in Charsadda awaits treatment at the Lady Reading hospital in Peshawar. The bomber, mounted on a motorcycle, killed at least 69 people at a paramilitary force academy. Pakistani Taliban militants said the attack was retaliation for the U.S. raid that killed bin Laden. 13 May 2011. Peshawar, Pakistan. K. Parvez.

130 Supporters of Islamist charity Jamaat-ud-Dawa, banned for its suspected links to militant group Lashkar-e-Taiba, embrace after taking part in a funeral prayer for bin Laden in Karachi. The founder of Lashkar-e-Taiba told Muslims to be heartened by bin Laden's death, another spokesman said his 'martyrdom' would not be in vain. 3 May 2011. Karachi, Pakistan. Athar Hussain.

131 Images of Osama bin Laden are displayed for sale outside a poster shop in Karachi. 4 May 2011. Karachi, Pakistan. Athar Hussain.

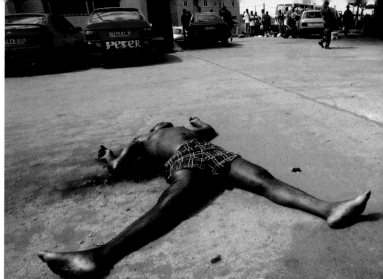

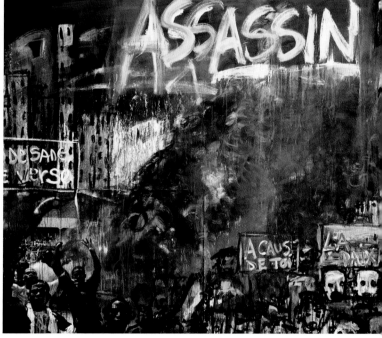

133 [TOP] **134** [ABOVE] Abidjan, Ivory Coast

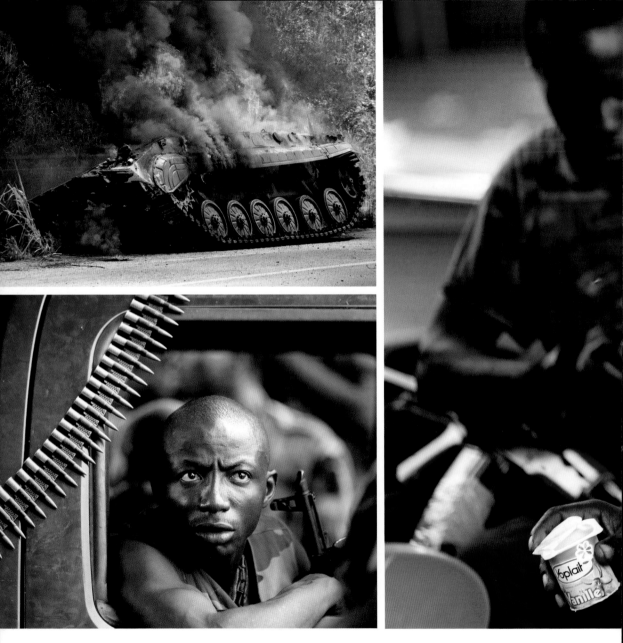

135 [TOP] Abidjan, Ivory Coast **136** [ABOVE] Yopougon, Ivory Coast

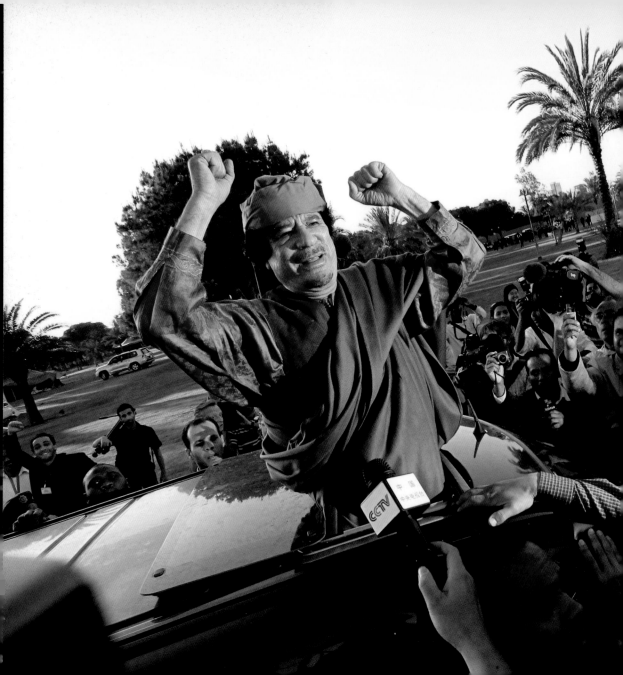

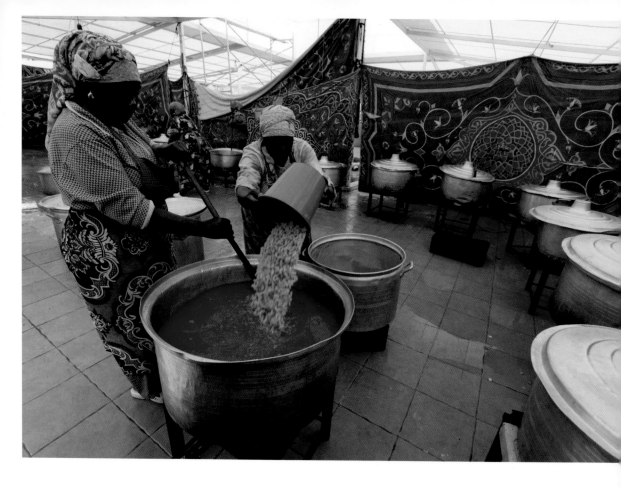

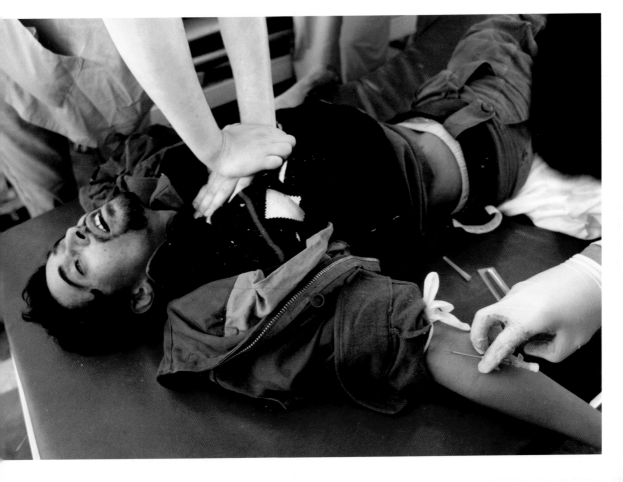

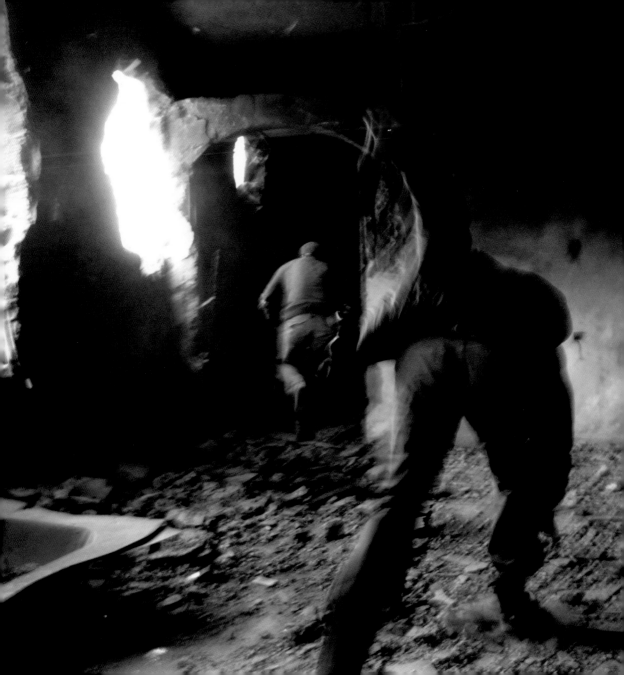

132 A prisoner, held by Ivorian forces loyal to former prime minister Alassane Ouattara, weeps in pain at a military base in Ivory Coast's main city of Abidjan. The man said that he had been shot in the leg during recent fighting, badly beaten and held in a dark cell for days. 16 April 2011. Abidjan, Ivory Coast. Finbarr O'Reilly.

133 The body of a man lies near a fuel station after heavy fighting in Abidjan. Laurent Gbagbo, leader of the Ivorian Popular Front party, had been negotiating the terms of his departure from power following a fierce assault by forces loyal to his rival, President of the Rally of the Republican Forces Alassane Ouattara. The assault was supported by the United Nations and the French government, who – like the African Union – recognized Ouattara as the victor of the disputed December 2010 election. 5 April 2011. Abidjan, Ivory Coast. Emmanuel Braun.

134 A painting by Ivorian artist Abdoulaye Diarrasouba, 26, depicting upheavals in Abidjan. The work of the artist (who goes by the name Aboudia) interprets the violence that swept the country in the wake of the contested election results. 19 April 2011. Abidjan, Ivory Coast. Finbarr O'Reilly.

135 A tank burns after heavy fighting in Abidjan. France and the United Nations assisted Ouattara by launching helicopter air strikes against Gbagbo's troops. 5 April 2011. Abidjan, Ivory Coast. Emmanuel Braun.

136 A soldier loyal to Ouattara looks out from a car draped with an ammunition belt. 29 April 2011. Yopougon, Ivory Coast. Luc Gnago.

137 A pro-Ouattara soldier holds a good luck charm at a roadside in Abidjan. 7 April 2011. Abidjan, Ivory Coast. Emmanuel Braun.

138 Libyan leader Muammar Gaddafi waves from a car in the compound of Bab al-Aziziya in Tripoli. He had been meeting with a delegation of five African leaders who sought to mediate in Libya's conflict. 10 April 2011. Tripoli, Libya. Louafi Larbi.

139 Women cook in a kitchen used to prepare thousands of meals each day for both Libyan rebel fighters and people displaced by conflict in the east of the country. 30 May 2011. Benghazi, Libya. Mohammed Salem.

140 Doctors try to resuscitate a Libyan soldier taken prisoner by anti-government fighters. On 23 April rebels captured more than a dozen wounded and dying loyalist Gaddafi troops and brought them to a hospital in Misrata. 23 April 2011. Misrata, Libya. Yannis Behrakis.

141 Rebel fighters scramble for cover inside a building in Tripoli Street, central Misrata. The street was the frontline in some of the heaviest fighting between Gaddafi loyalists and rebels. 21 April 2011. Misrata, Libya. Yannis Behrakis.

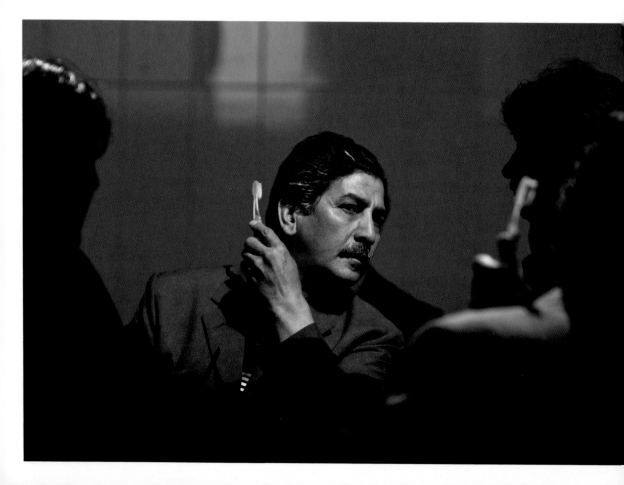

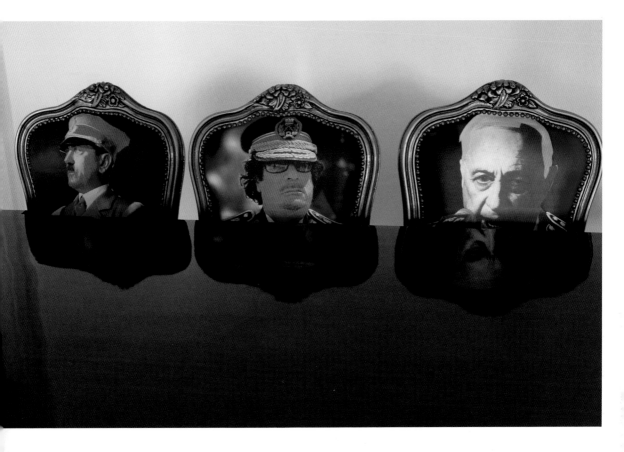

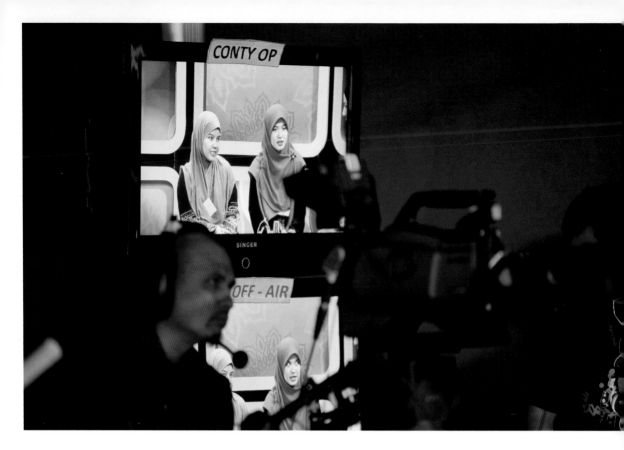

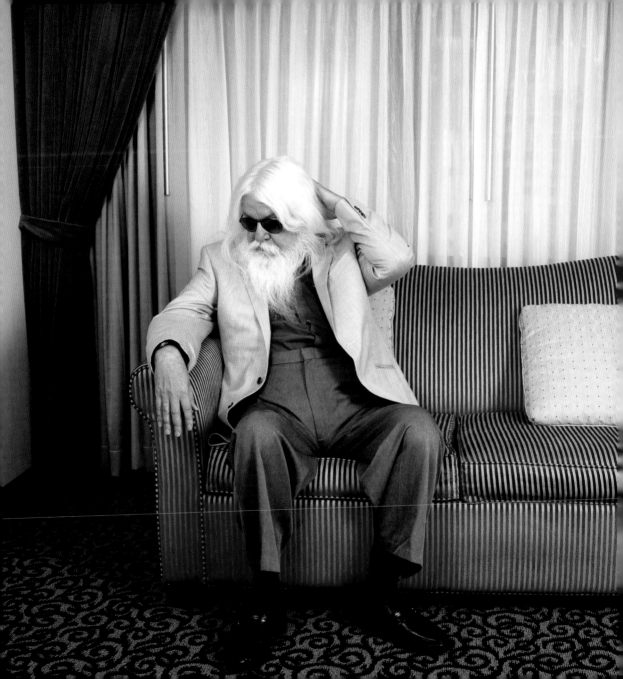

147 [ABOVE] **148** [OPPOSITE] Cannes, France

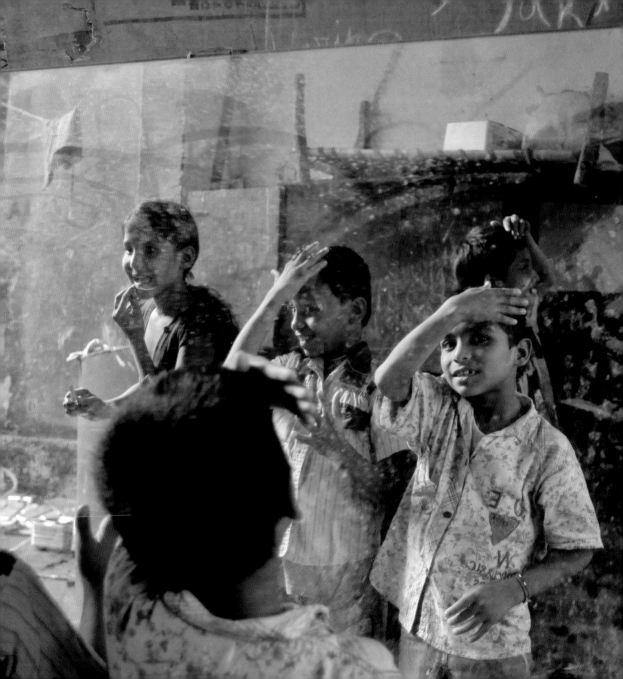

142

143

144

145

146

147

148

149

142 Afghan actor Nadir Eqbal colours his hair and moustache with toothpaste to play the role of an older man during the filming of a movie in Kabul. Throughout the austere Taliban rule from 1996 to 2001, television, music and film were banned. Amid escalating violence across Afghanistan in the 10th year of the NATO-led war, fear of the Taliban continued to affect many areas of society. The Afghan film industry said that the existence of its cinemas is affected as much by suicide attacks and bombs as by a lack of quality equipment. 23 May 2011. Kabul, Afghanistan. Ahmad Masood.

143 The 'Never-Ending Dinner' collection, designed by Jordanian Khaled Sharaan, is displayed in Amman before going to an auction house in London. The chairs are decorated with portraits of modern history's most condemned leaders. 14 June 2011. Amman, Jordan. Ali Jarekji.

144 Reality TV hopefuls Amie Sofia Ahmad (left) and Arina Ramlan are seen on screens before their audition for a new Islamic show in Kuala Lumpur. The Malaysian programme sought out female preachers in an effort to put pressure on conservative attitudes to women in Muslim societies. The series, titled *Solehah*, an Arabic word meaning 'pious female', featured charismatic young Muslim women judged by clerics on their personality, oratory skills and religious knowledge. 18 June 2011. Kuala Lumpur, Malaysia. Bazuki Muhammad.

145 At the 24th annual Nickelodeon Kids' Choice Awards in Los Angeles, actress Miley Cyrus walks onstage to accept the Favorite Movie Actress prize for her role in *The Last Song*. 2 April 2011. Los Angeles, United States. Mario Anzuoni.

146 Musician Leon Russell poses for a portrait in New York. Russell toiled in obscurity for decades until recording with Elton John brought him an unlikely comeback hit. He said he was never bitter about his fame disappearing – that's just what happens to ageing rockers. 15 June 2011. New York, United States. Lucas Jackson.

147 Lars von Trier poses during a publicity event for his film *Melancholia* at the 64th Cannes Film Festival. The director was banned from the festival after a press conference in which he said he was a Nazi and understood Hitler. 18 May 2011. Cannes, France. Yves Herman.

148 Kirsten Dunst poses for a photocall after receiving the Best Actress award for her role in *Melancholia*. 22 May 2011. Cannes, France. Vincent Kessler.

149 Young audience members take a break from the musical reality show *Sa Re Ga Ma Pa L'il Champs,* adjusting their hair outside the studio in Mumbai. Riding a West-led shift towards reality TV, as well as reflecting social changes in India's booming economy, the popular format provides a break from the family melodrama that is the staple of Indian daily television. 14 June 2011. Mumbai, India. Danish Siddiqui.

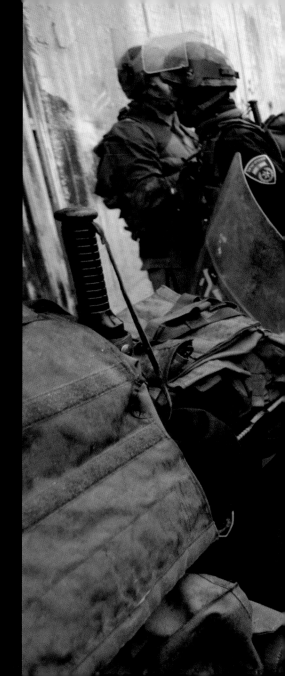

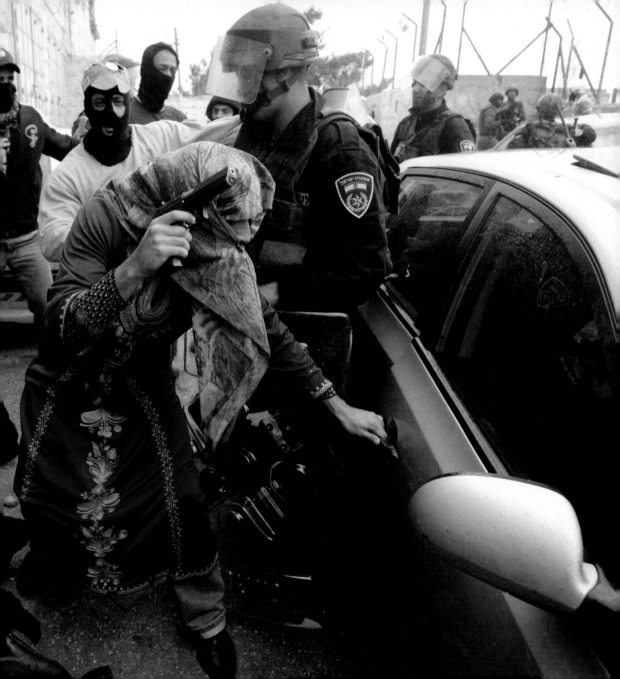

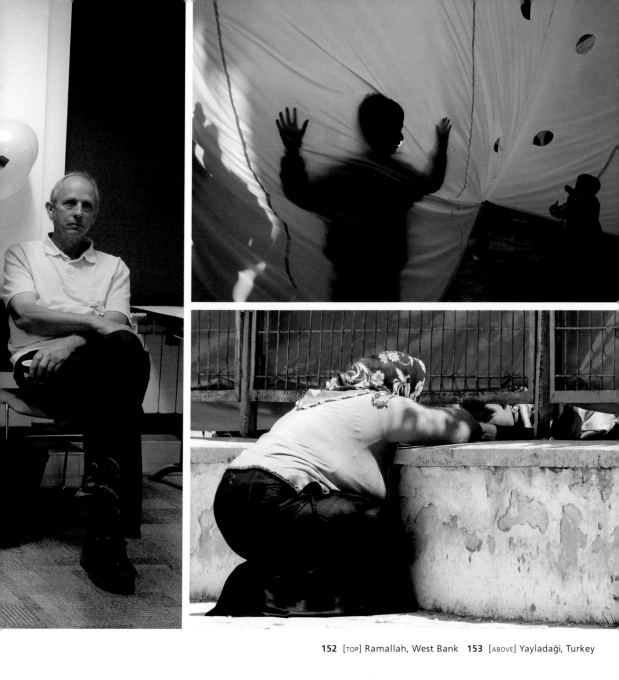

152 [TOP] Ramallah, West Bank **153** [ABOVE] Yayladaği, Turkey

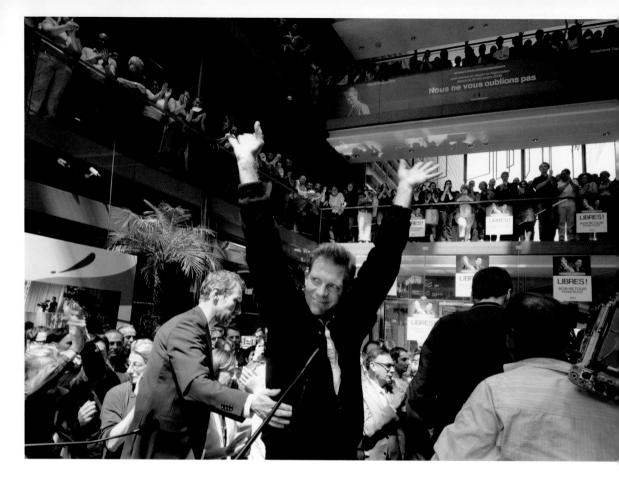

154 Paris, France

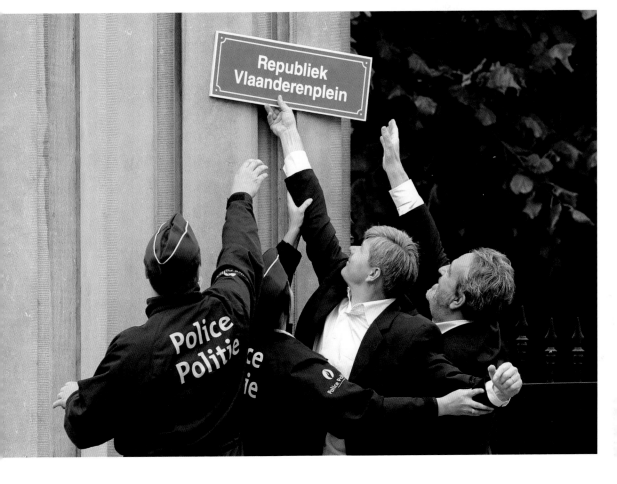

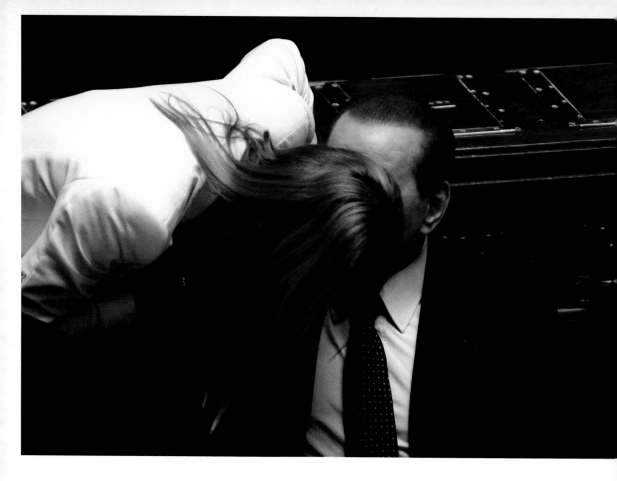

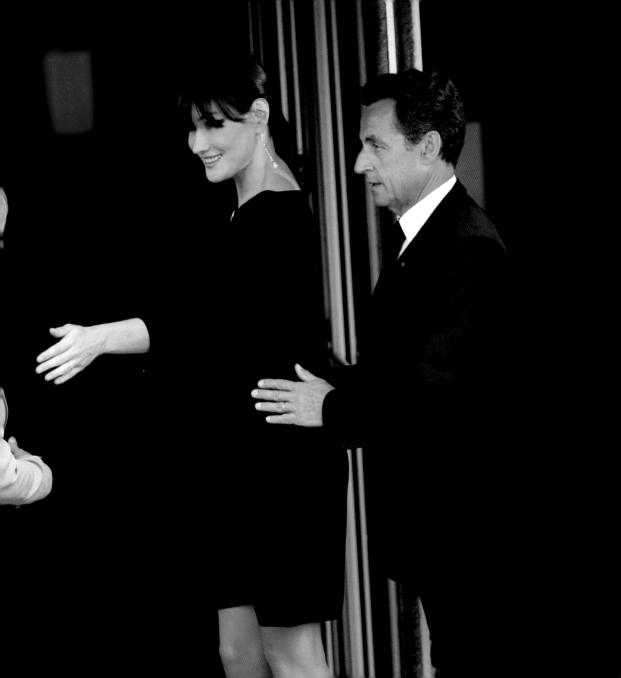

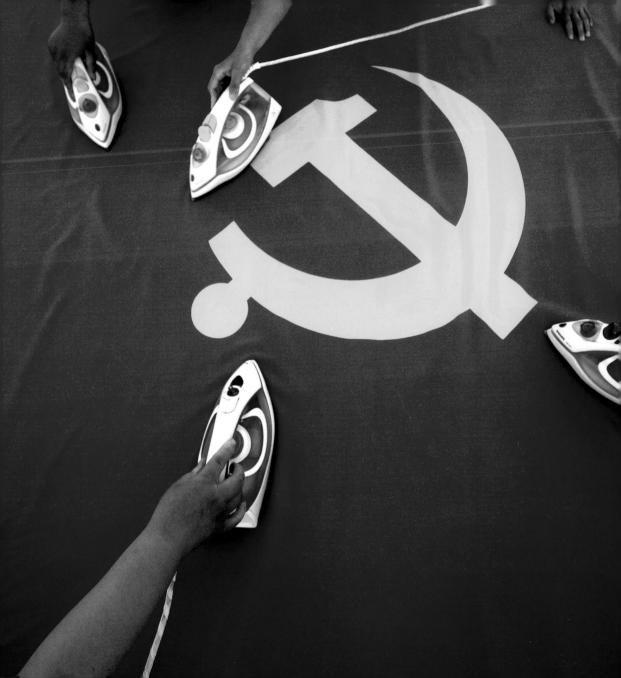

150 An Israeli undercover policeman dressed as a Palestinian woman opens a car door after detaining a protester during clashes at the Shuafat refugee camp, located in the West Bank near Jerusalem. Israeli security forces were on the alert for violence on Nakba Day, the occasion when Palestinians mourn the 'nakba' (catastrophe) of Israel's founding in 1948. 15 May 2011. Shuafat, West Bank. Baz Ratner.

151 Members of the Association of Teachers and Lecturers wait before a union march in central London. Civil servants took to the streets and picketed government buildings across Britain in protest at planned pension reforms, launching what could be a long period of labour unrest over austerity measures. 30 June 2011. London, Britain. Kevin Coombs.

152 West Bank children play with an art installation created by students from Birzeit University in collaboration with Belgium's La Cambre architecture faculty. The participants erected a brightly coloured canopy in the middle of a street in Ramallah. 20 April 2011. Ramallah, West Bank. Mohamad Torokman.

153 A woman talks to her relative, a displaced Syrian, through a fence at a refugee camp in the border town of Yayladaği, southern Turkey. According to Turkish officials over ten thousand Syrian refugees had crossed the border, fleeing President Bashar al-Assad's brutal crackdown on protests in the country. 19 June 2011. Yayladaği, Turkey. Umit Bektas.

154 France 3 TV journalist Hervé Ghesquière waves as he leaves a gathering at France Television headquarters in Paris. Ghesquière and his colleague Stéphane Taponier were captured by the Taliban in Kapisa province, northeast of the Afghan capital Kabul, and were held hostage for 547 days. 30 June 2011. Paris, France. Gonzalo Fuentes.

155 Gerolf Annemans (far right), a member of Flemish party Vlaams Belang, tries to put up a sign reading 'Square of the Republic of Flanders' during a protest. Vlaams Belang ('Flemish Interest') is a far-right party that supports strict immigration laws, and advocates the independence of Flanders. 14 June 2011. Brussels, Belgium. Francois Lenoir.

156 Italian Prime Minister Silvio Berlusconi speaks with Tourism Minister Michela Vittoria Brambilla. Berlusconi pledged to stay to the end of his term in 2013 after winning a confidence vote that followed crushing losses in local elections. 22 June 2011. Rome, Italy. Tony Gentile.

157 French President Nicolas Sarkozy and his pregnant wife Carla Bruni-Sarkozy greet leaders before dinner at the 37th G8 Summit, held in Deauville. She gave birth to a girl on 19 October. 26 May 2011. Deauville, France. Kevin Lamarque.

158 Workers iron a Communist Party flag on a table at the Jinggong Red Flag Factory on the outskirts of Beijing. The factory made more than 30,000 flags in the three months leading up to the 90th anniversary of China's Communist Party. 28 June 2011. Beijing, China. David Gray.

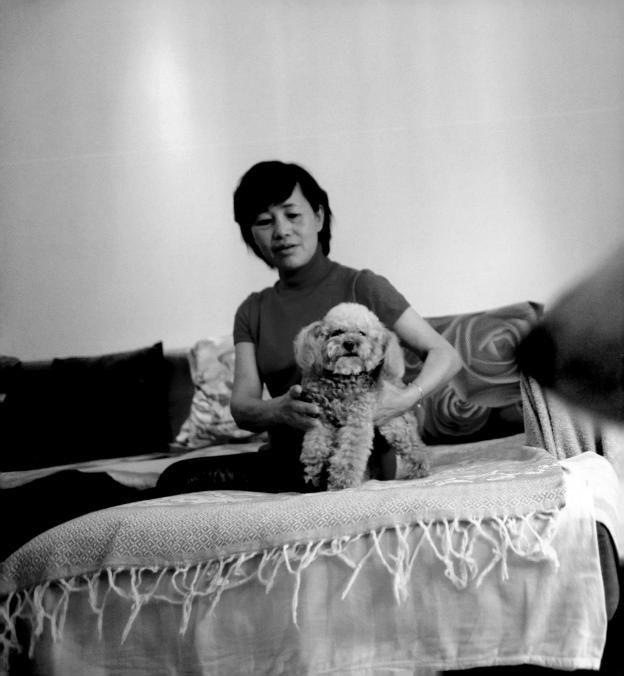

159 Shanghai, China

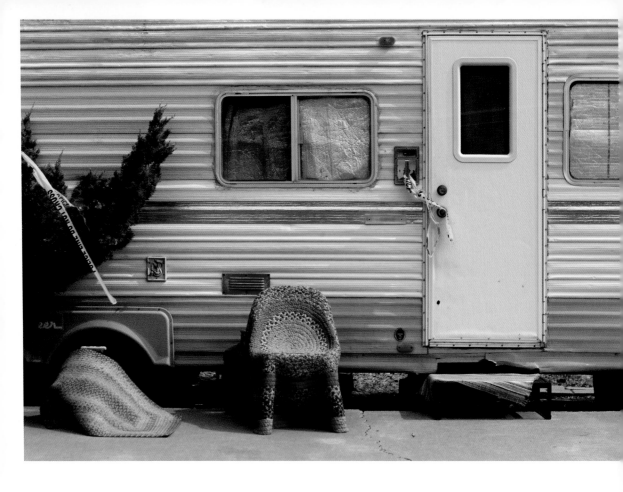

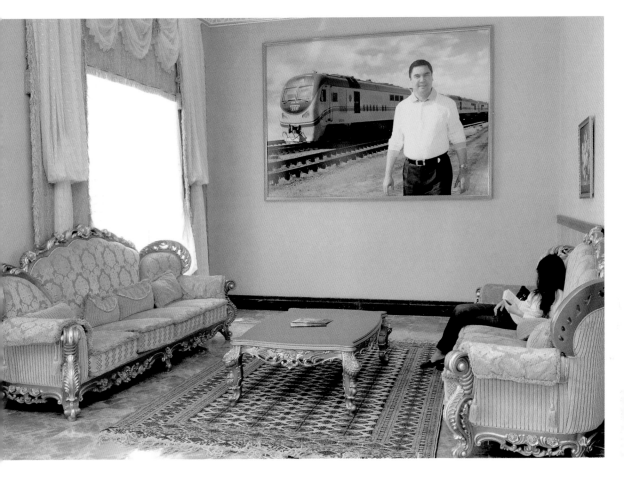

161 Avaza, Turkmenistan

163 Windsor, Britain

165 Tultitlán, Mexico

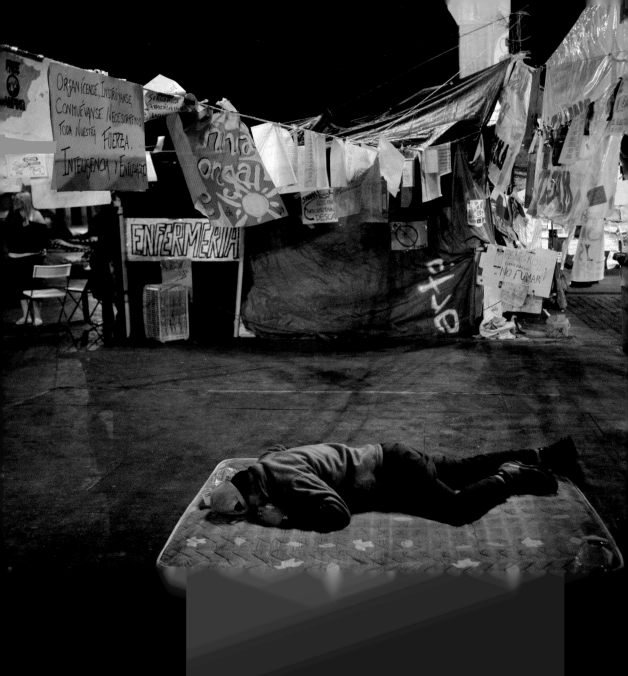

159

160

161

162

163

164

165

166

167

9 Guo Huiying holds one of her two dogs at her apartment in Shanghai. Under the city's one-dog policy, implemented in May, each household can have no more than a single dog. When in public areas, owners must keep their pet leashed and put muzzles on large dogs. Huiying registered her two dogs before the regulations took effect. 13 May 2011. Shanghai, China. Carlos Barria.

0 Yellow police tape indicates that residents have evacuated their trailer home in Springerville, Arizona. The most extensive of Arizona's summer wildfires, the Wallow Fire, displaced 10,000 people, and cost $79 million. 9 June 2011. Arizona, United States. Joshua Lott.

1 A woman relaxes in a reception area underneath a photograph of Turkmenistan's president, Kurbanguly Berdymukhamedov. In developing the resort city of Avaza on the Caspian Sea, the president has built eight luxury high-rise hotels – a project that could eventually cost as much as five billion U.S. dollars. 8 June 2011. Avaza, Turkmenistan. Aman Mahinli.

162 A swimmer wearing a yellow safety cap makes his way past a police boat during the launch of new security measures for swimmers on Lake Zurich. 27 June 2011. Zurich, Switzerland. Christian Hartmann.

163 Irish Guardsman Bortnill St Ange is fitted with his ceremonial uniform by Master Tailor Lance Sergeant Matthew Else. The Guards performed ceremonial duties at the royal wedding in London. 21 April 2011. Windsor, Britain. Eddie Keogh.

164 Karren, one half of Taiwanese duo the Pujie Girls, demonstrates 'planking' outside the National Theatre in Taipei. The trend involves lying face down in unconventional locations, and then uploading a photograph of the event to the Internet. The Pujie Girls are the country's best-known plankers, and hope to use the craze to spread positive social messages. 25 May 2011. Taipei, Taiwan. Nicky Loh.

165 The socks of an illegal migrant hang out to dry at a shelter in Tultitlán, on the outskirts of Mexico City. A director at the shelter said armed men kidnapped at least 80 migrants (including women and children) after holding up a goods train in southern Mexico. 27 June 2011. Tultitlán, Mexico. Bernardo Montoya.

166 Peruvian prisoners look out over a soccer tournament at Castro Castro prison in Lima. About 250 inmates participated in a mock Copa América Argentina 2011 soccer championship, which lasted for one month. 28 June 2011. Lima, Peru. Mariana Bazo.

167 A protester sleeps on a mattress in Madrid's Puerta del Sol, two days after Spanish regional and local elections. Demonstrators camped to protest against the government's handling of the economic crisis that erupted in 2008. The crisis itself refused to abate, and looks set to continue to challenge the solidarity of the eurozone well into the future. 24 May 2011. Madrid, Spain. Susana Vera.

3

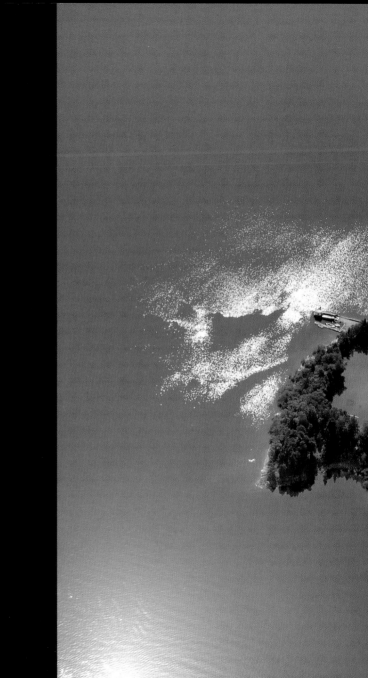

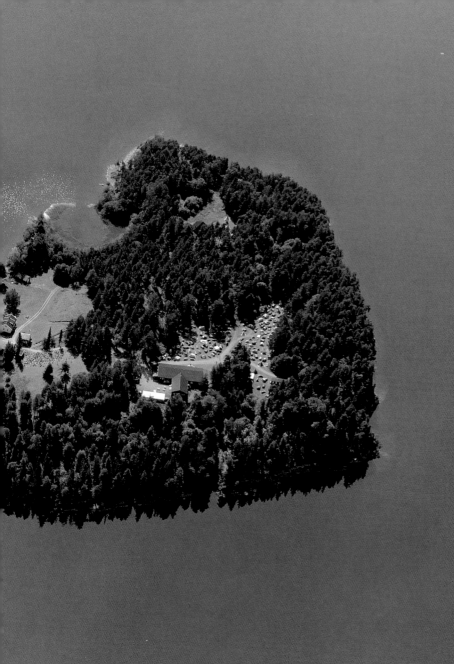

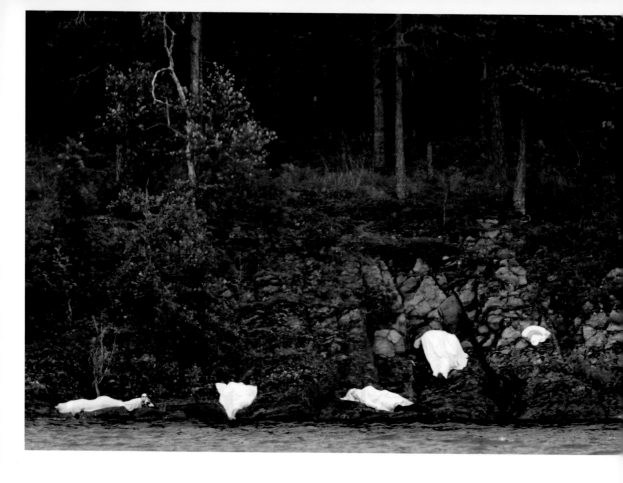

169 Utoeya Island, Norway

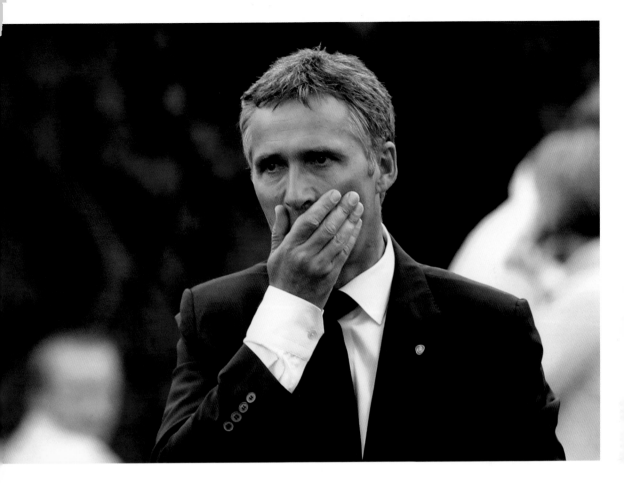

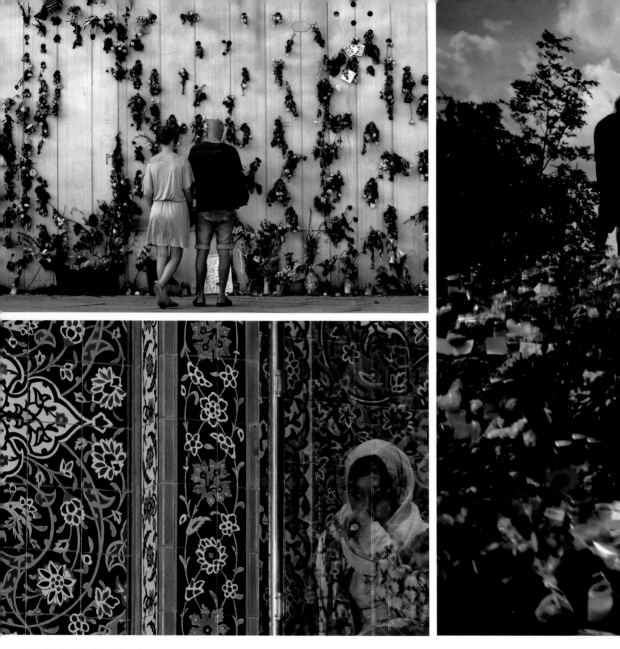

171 [TOP] **172** [ABOVE] Oslo, Norway

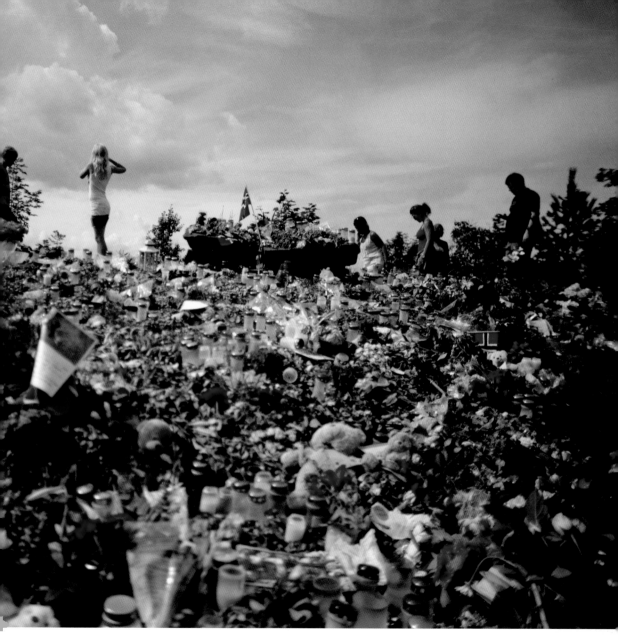

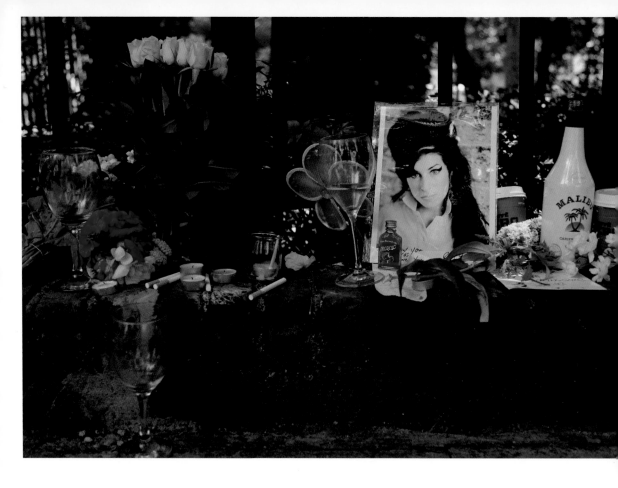

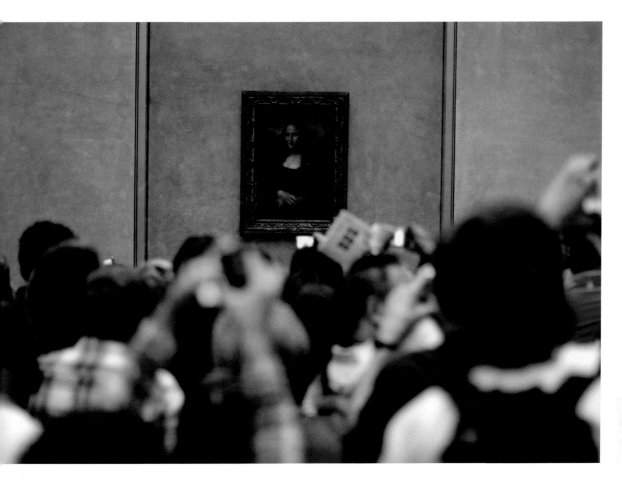

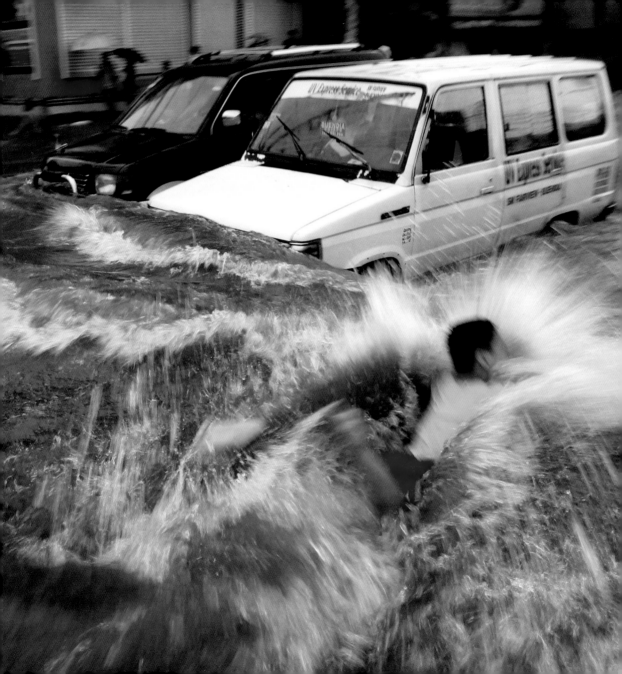

168 An aerial view of the small wooded Utoeya Island, northwest of Oslo, taken one day before a shooting spree took place at the island's summer camp. A gunman opened fire on members of the youth wing of Norway's ruling Labour Party, who scattered in panic, hid or tried to swim to safety. 21 July 2011. Utoeya Island, Norway. Lasse Tur.

169 Covered corpses are seen on the shore of Utoeya Island. On 22 July a right-wing Christian gunman dressed in police uniform killed 69 people in a ferocious attack, hours after a bomb set by the same individual killed eight in Oslo. Witnesses said the gunman, identified by police as a 32-year-old Norwegian, moved across the island shooting for around an hour and a half before surrendering to police. 23 July 2011. Utoeya Island, Norway. Fabrizio Bensch.

170 Norwegian Prime Minister Jens Stoltenberg comforts survivors and family members at a hotel in Sundvollen, northwest of Oslo. 23 July 2011. Sundvollen, Norway. Fabrizio Bensch.

171 A couple stand in front of a wall decorated with flowers in memory of the victims of the island gun rampage. Norwegians were united in mourning as the first funerals took place a week after anti-Islam zealot Anders Behring Breivik killed 77 people in a twin gun and bomb attack that traumatized the nation. 29 July 2011. Oslo, Norway. Stoyan Nenov.

172 A girl looks on as Norway's Foreign Minister Jonas Gahr Støre speaks inside the World Islamic Mission mosque in Oslo. Norway struggled to come to terms with its worst peacetime massacre of the modern era. 26 July 2011. Oslo, Norway. Cathal McNaughton.

173 People stand on a memorial at the shore of Tyrifjorden Lake overlooking Utoeya Island. An opinion poll showed Norwegians believed penalties for serious crimes in their country should be tightened in the wake of the shooting and bomb attack. 1 August 2011. Tyrifjorden Lake, Norway. Stoyan Nenov.

174 Flowers and tributes are seen outside the home of Amy Winehouse in London. Winehouse, one of the most talented singers of her generation, whose hit song 'Rehab' summed up her struggles with drink and drug addiction, died at her home in Camden, north London, on 23 July at the age of 27. 24 July 2011. London, Britain. Stefan Wermuth.

175 People view Leonardo da Vinci's *Mona Lisa* at the Musée du Louvre, Paris. 16 July 2011. Paris, France. Lucy Nicholson.

176 A boy swims in knee-high floodwaters, brought about by continuous rainfall from Typhoon Muifa. Local media said that due to heavy rains and flooding in many places in the capital region of Metro Manila, all classes in schools and work in government agencies were suspended. 2 August 2011. Maceda, Philippines. Romeo Ranoco.

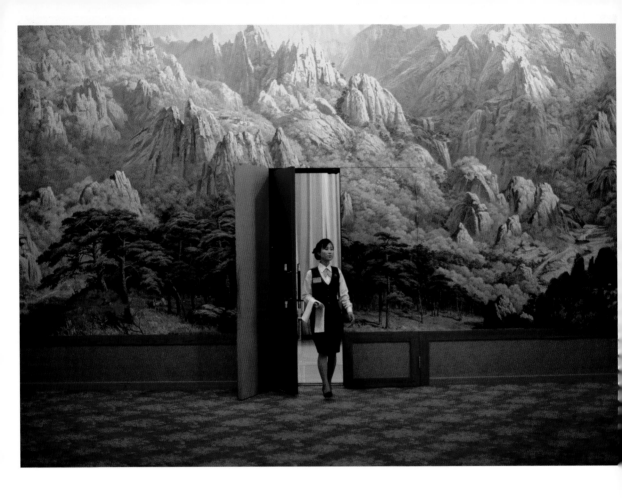

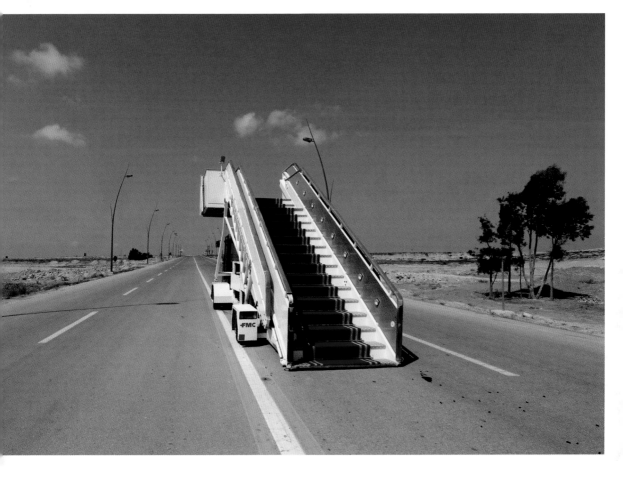

181 Sirte, Libya

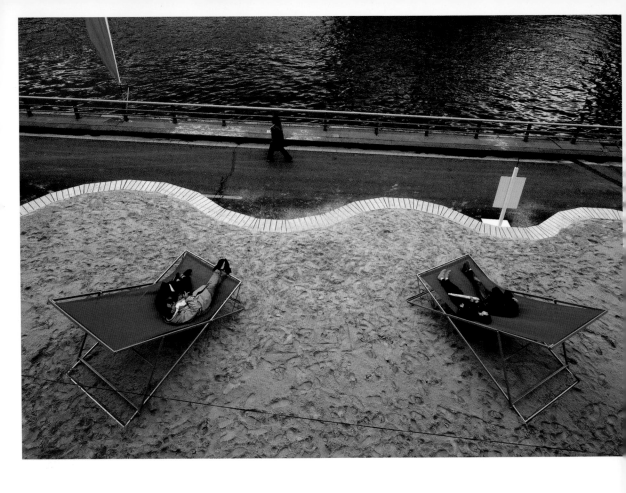

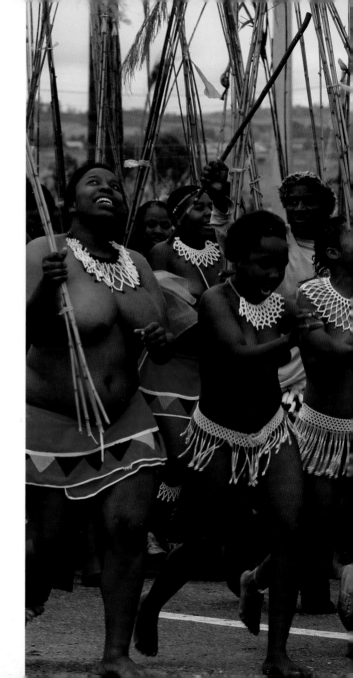

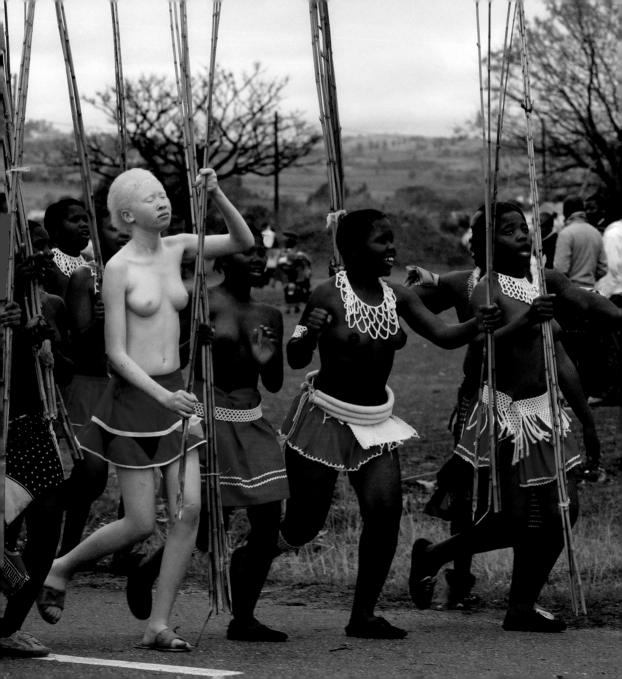

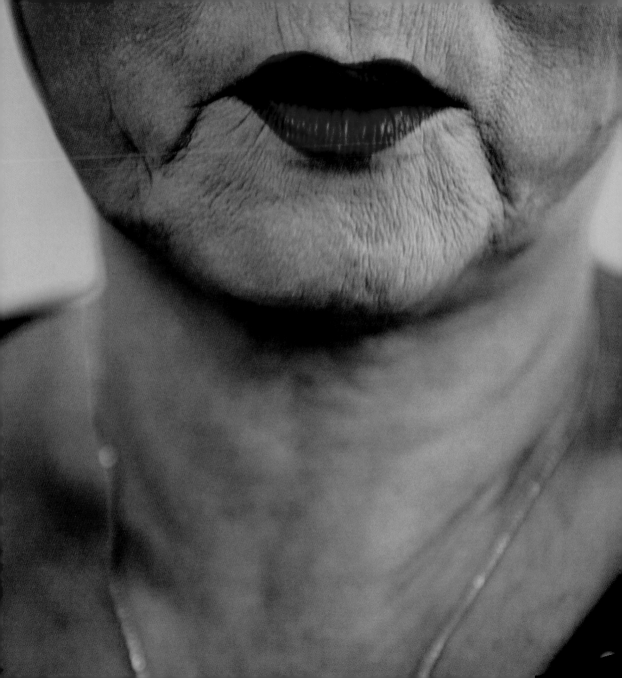

177 178 179 180 181 182 183 184 185

177 A group of enthusiasts practise yoga at the Bobrovy Log resort, near Russia's Siberian city of Krasnoyarsk. The Stolby nature reserve is visible in the background. 14 August 2011. Krasnoyarsk, Russia. Ilya Naymushin.

178 Two 5-year-old girls attempt handstands before a diving training session in Beijing. Some 15 children aged 5 to 12 practise at China's State Physical Training Administration as divers during their summer vacation. 26 July 2011. Beijing, China. Jason Lee.

179 A man jumps from a tree into a river in Mytishchi, outside Moscow. Persistent dry weather, with air temperatures around 28 degrees Celsius (82 degrees Fahrenheit), led many Russians to fear a repeat of the previous year's destructive wildfires. 3 July 2011. Mytishchi, Russia. Denis Sinyakov.

180 An employee enters a room at a hotel in the Mount Kumgang resort in Kumgang, a county in the south of impoverished North Korea. 1 September 2011. Kumgang, North Korea. Carlos Barria.

181 An abandoned V.I.P. airstair is seen on a road near the airport in Sirte, after the forces of Libya's interim government captured the airport in Muammar Gaddafi's hometown. 29 September 2011. Sirte, Libya. Anis Mili.

182 People relax on giant deckchairs as 'Paris Plages' (Paris Beaches) opens along the banks of the Seine. 21 July 2011. Paris, France. Eric Gaillard.

183 Spectators walk during the final practice round of the British Open golf championship at Royal St George's in Sandwich, southern England. Northern Island's Darren Clarke – on his 20th attempt – succeeded in winning the Claret Jug. 13 July 2011. Sandwich, Britain. Eddie Keogh.

184 Women take part in the annual Reed Dance at Ludzidzini in Swaziland. During the eight-day ceremony, virgin maids cut reeds and present them to members of the royal family. The Reed Dance also allows Swaziland's King Mswati III the opportunity to choose another wife, which he did – his 14th. 28 August 2011. Ludzidzini, Swaziland. Siphiwe Sibeko.

185 A Chinese Malaysian shows her heavily made-up lips before performing Chinese opera in Kuala Lumpur. Chinese opera is often associated with heavily painted make-up that transforms performers into larger-than-life characters. They have to sing, act, and perform martial art and acrobatics, as well as apply their own make-up. 4 August 2011. Kuala Lumpur, Malaysia. Samsul Said.

DAMIR SAGOLJ
Photographer
Born: Sarajevo, Bosnia, 1971
Based: Bangkok, Thailand
Nationality: Bosnian

The Hague Hilton

I have followed their bloody trail for 20 years now. As a Bosnian
and as a photojournalist, I have tracked them through the ruins of
Sarajevo, to the mass graves of eastern Bosnia and villages that were
ethnically cleansed and destroyed forever. I followed their war crimes
with the passion of a journalist and the guilt of a survivor. That road
ends at 'The Hague Hilton', as the detention unit of the war crimes
tribunal is sometimes called. There, 40 or so accused war criminals
live while awaiting trial or sentencing. I am the first journalist to
report from inside.

I have butterflies in my stomach when I enter, for I am a prisoner
of my past. Some of the detainees here are accused of crimes against
members of my family. We lived through the siege of Sarajevo. My
Muslim relatives were forced from their homes and ended up in Sweden.
Croat relatives on my father's side were driven out. Some of my relatives
were later found in mass graves.

My first test awaited me in the corridors of the tribunal building,
where I bumped into Radovan Karadžić. My life had been in his
hands back in the 1990s, when he was known as one of the 'butchers
of the Balkans' and controlled the artillery and snipers around Sarajevo.
Our eyes briefly locked and he said a 'hello'. I said nothing, my cameras
still. And then he was gone, escorted to his chair in the courtroom.

For most in The Hague Hilton life is good: they have art rooms,
flatscreen TVs, sports courts and a gym. Men who allegedly
exterminated on the basis of religion or ethnicity in the 1990s now
even have parties, sitting down at the same table to celebrate each
other's birthdays and religious festivals – as they did during Tito's
era of 'brotherhood and unity'.

Back home, the perception of the court and its 'prison' reflects
the divide of a schizophrenic society. For the nationalists, who still
regard the accused as heroes, this place is a dungeon – for others
it's a stopover on what they hope is the road to hell.

186 A waiting room at the International Criminal
Tribunal for the former Yugoslavia in The Hague.
19 September 2011. The Hague, Netherlands. Damir Sagolj.

WITNESS

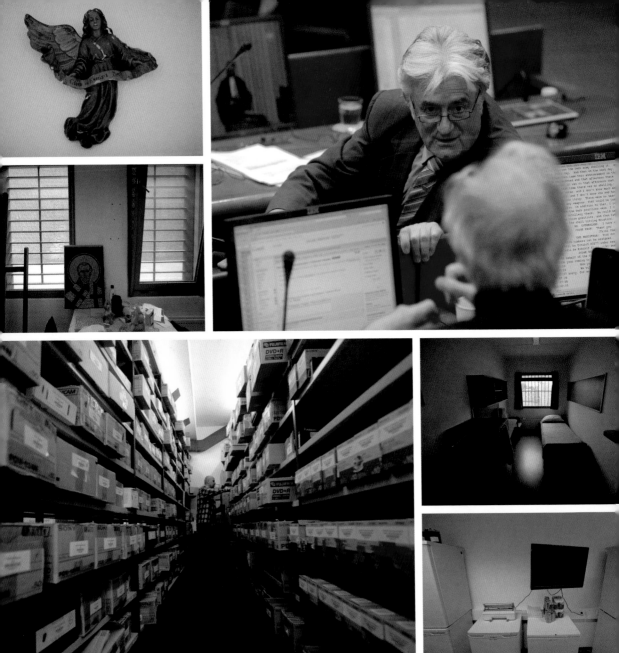

187	189	193
188		
190	191	194
	192	

187 A sculpture of an angel with a broken wing is seen on the wall of the music and spiritual room of the detention unit of the International Criminal Tribunal for the Former Yugoslavia (ICTY) in The Hague. Former Yugoslavia's alleged war criminals end up here, at a detention unit sometimes referred to as 'The Hague Hilton'. 20 September 2011. **188** A painting left by detainees in the art room of the ICTY detention unit. In this section around 40 accused from the former Yugoslavia live in remarkable harmony and comfort awaiting trial or sentencing. 20 September 2011. **189** Former Bosnian Serb leader Radovan Karadžić talks to a member of his defence team during his trial. 19 September 2011. **190** Boxes containing audio-visual recordings are stored on the tribunal's shelves. 20 September 2011. **191** An unoccupied cell is seen at the detention unit. 20 September 2011. **192** A TV screen mounted between refrigerators in a kitchen in one of the wings of the unit. Men who fought or allegedly exterminated on the basis of religion or ethnic group in the 1990s now sit down at the same table to celebrate each other's religious festivals. 20 September 2011. **193** A security guard exercises at the gym, which is shared with those accused of war crimes. 20 September 2011. **194** People seated in the gallery listen to a presentation by an ICTY court official during the courtroom's public open day. 18 September 2011. The Hague, Netherlands. Damir Sagolj.

as legitimate

sorry.

sorry.

e sorry.

...olding others to account.

...occurred.

...ng others to acc...

...uals a...

Page 2B

others to account.

ADVERTISEME...

Murdochs lieutenant forced out...

We are sorry.

The News of the World was in the business of holding others to account.

It failed when it came to itself.

...the serious wrongdoing that occurred.

...suffered by the individuals affected.

...ete steps to res...

...ave caused...

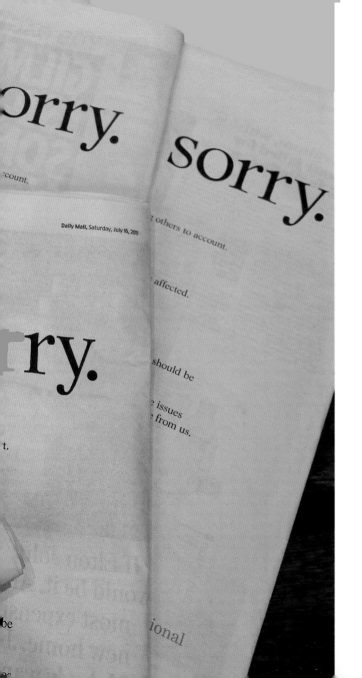

orry.

sorry.

rry.

count.

t others to account.

Daily Mail, Saturday, July 16, 2011

affected.

should be

e issues
e from us.

t.

be

ional

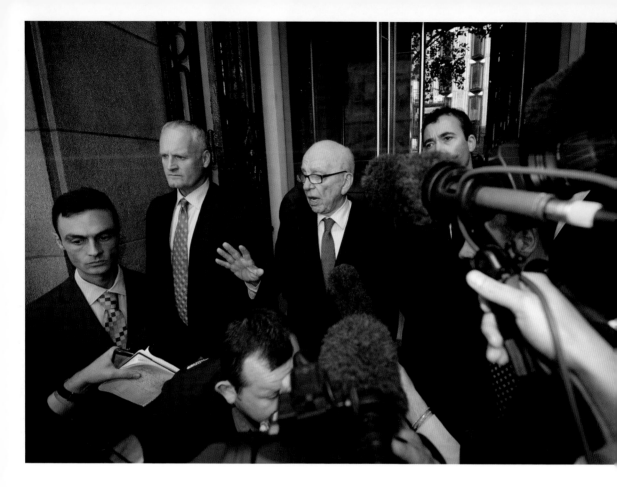

198 [TOP] **199** [ABOVE LEFT] **200** [ABOVE CENTRE] **201** [ABOVE RIGHT] Tripoli, Libya

202 [TOP LEFT] **203** [TOP CENTRE] **204** [TOP RIGHT] **205** [ABOVE] Tripoli, Libya

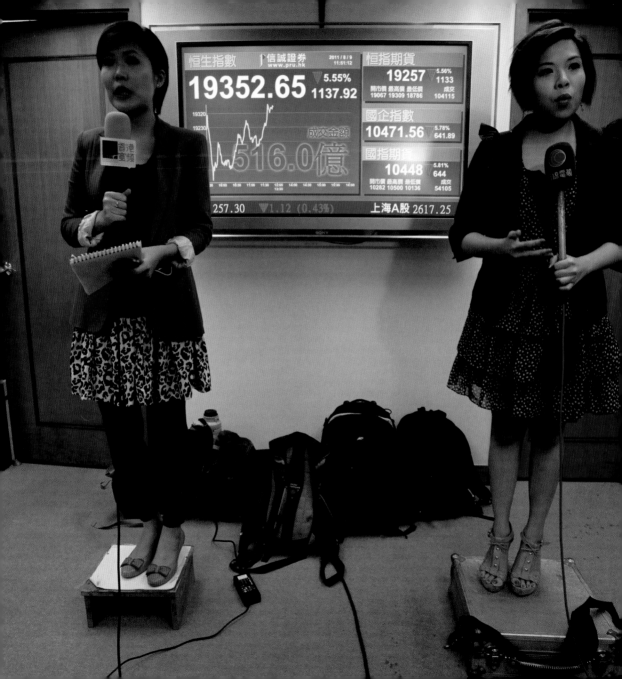

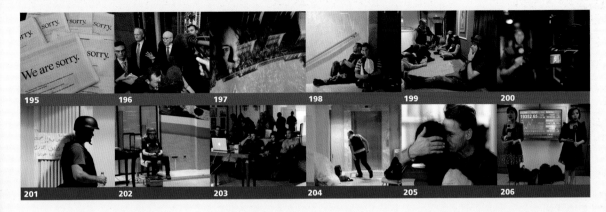

195 On 16 July British newspapers *The Times*, *Sun*, *Guardian*, *Financial Times*, *Independent*, *Daily Mail* and *Daily Telegraph* featured an apology from News Corp Chairman and CEO Rupert Murdoch. Murdoch was contrite as News Corp tried to quell the uproar over the phone-hacking scandal that shook the company, claimed the jobs of its top two newspaper executives, closed the *News of the World* newspaper and forced the Australian media mogul to drop his plan to buy full control of pay-TV operator BSkyB. 16 July 2011. London, Britain. Suzanne Plunkett.

196 Rupert Murdoch speaks outside a hotel where he met the family of murdered teenager Milly Dowler. A lawyer for Dowler's family said he had learned from police that, after she was reported missing, the teenager's voicemail had been hacked – possibly by a *News of the World* investigator. News Corp later said it would pay the family £2 million (U.S. $3.2 million) and that Murdoch would personally donate another million to charities chosen by the Dowler family. 15 July 2011. London, Britain. Paul Hackett.

197 Then-chief executive of News International, Rebekah Brooks, arrives at Rupert Murdoch's flat in central London. On 17 July Brooks was arrested on suspicion of conspiring to intercept communications and facing allegations of corruption. She was later realised on bail. 10 July 2011. London, Britain. Olivia Harris.

198 Two members of the media sit in a corridor at Tripoli's Rixos hotel. Libyan pro-Gaddafi gunmen kept 35 reporters, photographers and TV crew penned up for five days in the hotel, south of Tripoli's city centre. 23 August 2011. Tripoli, Libya. Paul Hackett.

199 Media workers gather in a Rixos hotel corridor. Conditions in the once-opulent hotel deteriorated, with provisions running low. 23 August 2011. Tripoli, Libya. Paul Hackett.

200 A TV reporter speaks during a recording at the Rixos hotel. 23 August 2011. Tripoli, Libya. Paul Hackett.

201 A journalist waits in a corridor of the hotel beside a sign in Arabic that reads 'Don't shoot we are press'. 23 August 2011. Tripoli, Libya. Paul Hackett.

202 Reuters correspondent Missy Ryan uses her phone as she waits to be evacuated by the International Red Cross. 24 August 2011. Tripoli, Libya. Paul Hackett.

203 Correspondents gather in the Rixos hotel basement to watch a film. 23 August 2011. Tripoli, Libya. Paul Hackett.

204 A member of the media runs from the noise of gunfire. As fighting continued outside the Rixos hotel, journalists worried they could be hit in the crossfire, or used as human shields. 23 August 2011. Tripoli, Libya. Paul Hackett.

205 Freelance cameraman Paul Roubicek embraces CNN producer Jomana Karadsheh after being evacuated by the International Red Cross. 24 August 2011. Tripoli, Libya. Paul Hackett.

206 TV journalists report from inside a brokerage firm during trading in Hong Kong. Stock markets plunged sharply throughout August as investors dumped riskier assets in a global rout triggered by fears that political leaders were failing to tackle debt crises in Europe and the United States. 9 August 2011. Hong Kong, China. Bobby Yip.

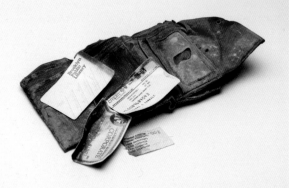

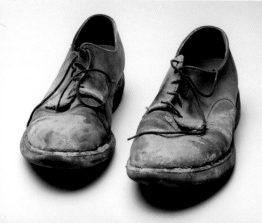
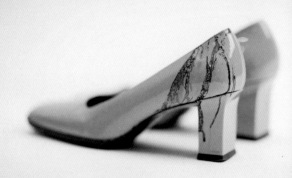

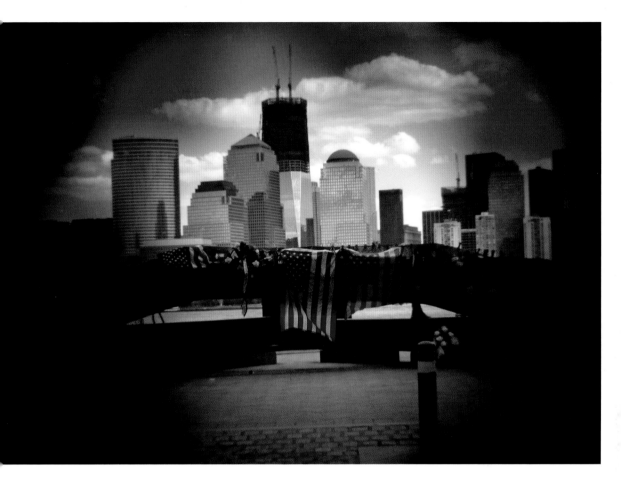

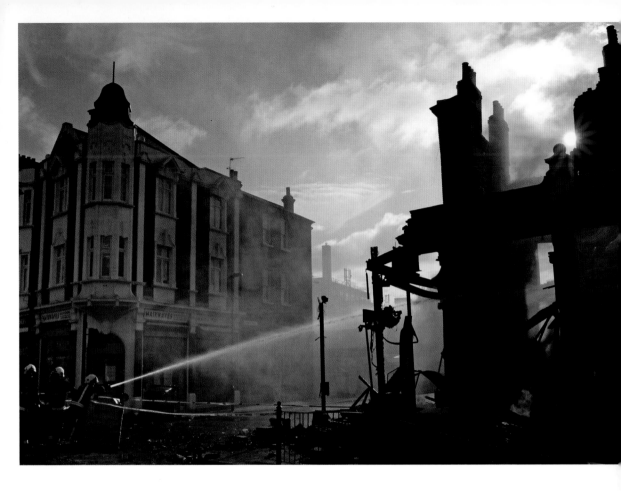

215 London, Britain

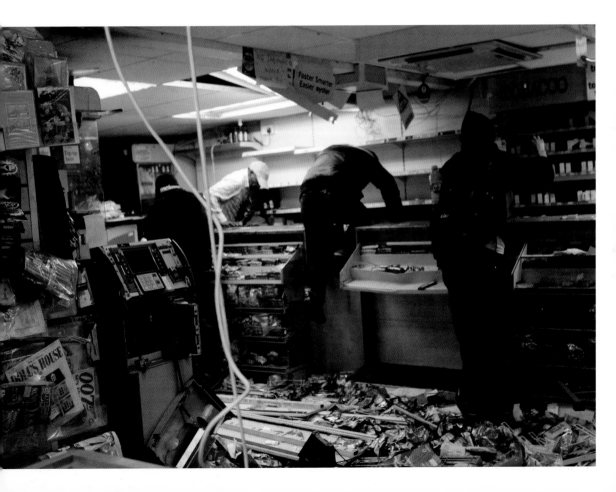

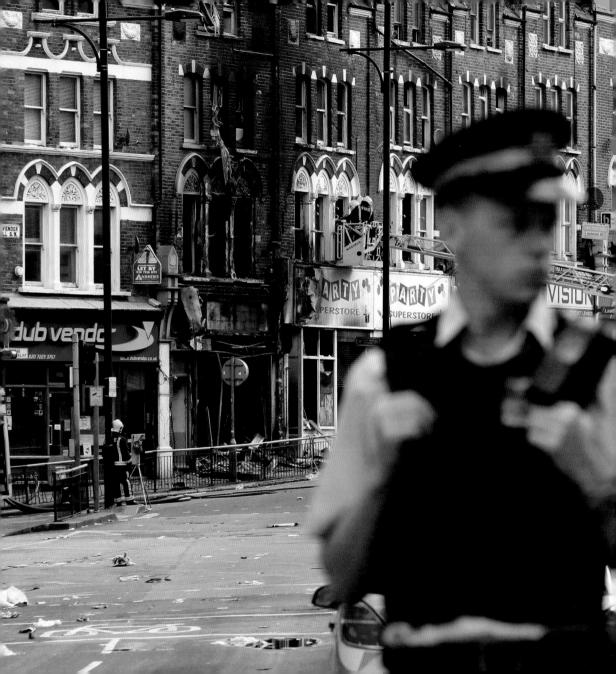

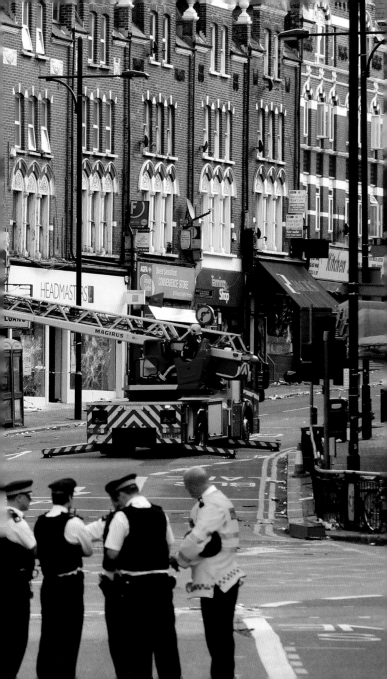

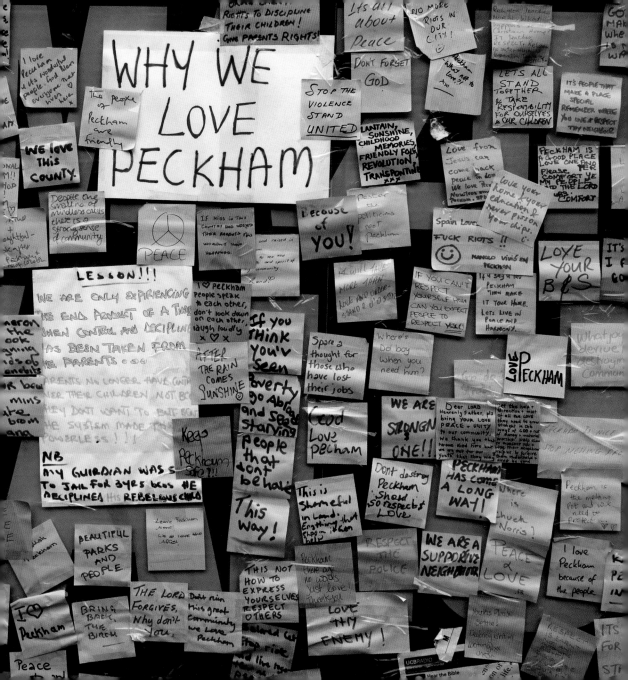

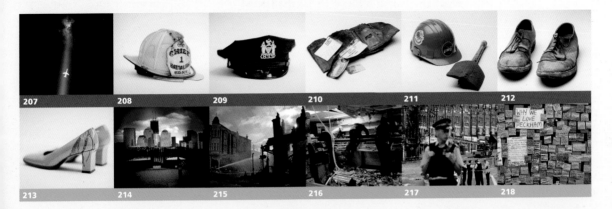

207 A plane flies through the Tribute in Light memorial in lower Manhattan, New York. The city held ceremonies to mark the 10th anniversary of the September 11 attacks on the World Trade Center. 10 September 2011. New York, United States. Eric Thayer.

208 A helmet belonging to fire chief Joseph Pfeifer. Pfiefer was on a routine call in downtown Manhattan when he heard the roar of American Airlines Flight 11 passing overhead on course for the North Tower of the World Trade Center.

Part of a collection of objects photographed before becoming part of the National September 11 Memorial & Museum in New York. The museum is being built at the site of the fallen towers. It is scheduled to open in 2012, on the 11th anniversary of the attacks. All photos: 22 August 2011. New York, United States. Lucas Jackson.

209 A Port Authority Police Department cap belonging to victim Liam Callahan. Callahan had also received a commendation for his heroic actions after responding to the 1993 World Trade Center bomb attack.

210 A wallet belonging to victim Gennie Gambale, recovered from the Marriott Hotel at the World Trade Center. Gambale was working on the 103rd floor of the North Tower when the first plane crashed into the lower floors, trapping those above.

211 A New York City Police Department Emergency Service Unit hard hat and folding shovel used by Officer Kenny Winkler of ESU 1. Winkler was finishing a night shift on the morning of the attacks, but nevertheless rejoined his colleagues on their vehicle and headed towards Ground Zero.

212 Shoes worn by survivor Roger Hawke during his evacuation from the 59th floor of the North Tower. Soon after the first plane crashed somewhere above him, Hawke made his way to one of the increasingly crowded and hot stairways. It took about 90 minutes to descend to safety.

213 Blood-stained shoes worn by Linda Lopez during her escape from the 97th floor of the South Tower. Lopez ran barefoot out of the building, across broken glass and other debris.

214 A piece of steel left twisted by the attack on the World Trade Center is seen at a memorial site across from Ground Zero in Jersey City. 11 August 2011. New York, United States. Shannon Stapleton.

215 Firefighters douse buildings set alight during riots in Tottenham, north London. Rioters throwing petrol bombs battled police in this economically deprived district, setting patrol cars, buildings and a double-decker bus on fire. 7 August 2011. London, Britain. Luke MacGregor.

216 Looters rampage through a convenience store in Hackney, east London, during a second night of violence. 8 August 2011. London, Britain. Olivia Harris.

217 Police officers stand near a burnt-out shop in Clapham Junction, south London. The city, less than a year away from hosting the Olympic Games, saw a third consecutive night of violence. 9 August 2011. London, Britain. Stefan Wermuth.

218 Messages of support from the community of Peckham are seen posted on a looted shopfront. 12 August 2011. London, Britain. Stefan Wermuth.

218 London, Britain

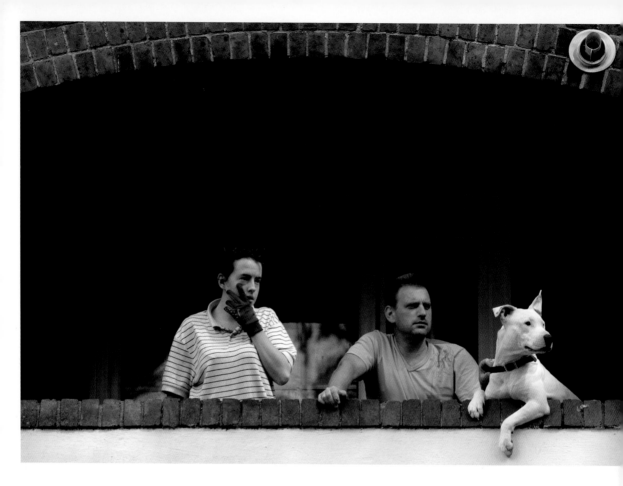

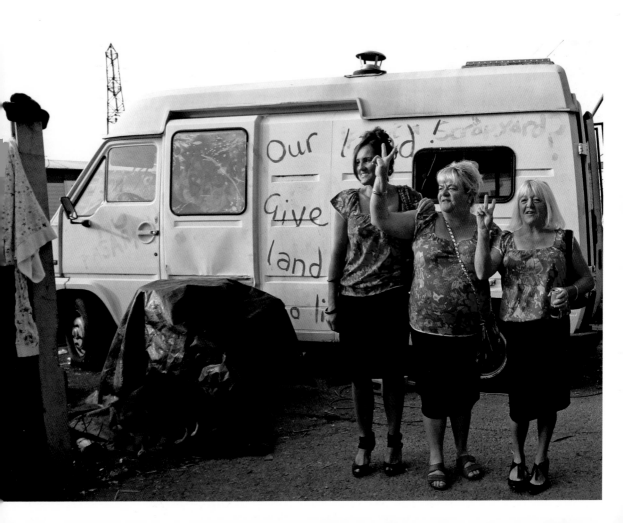

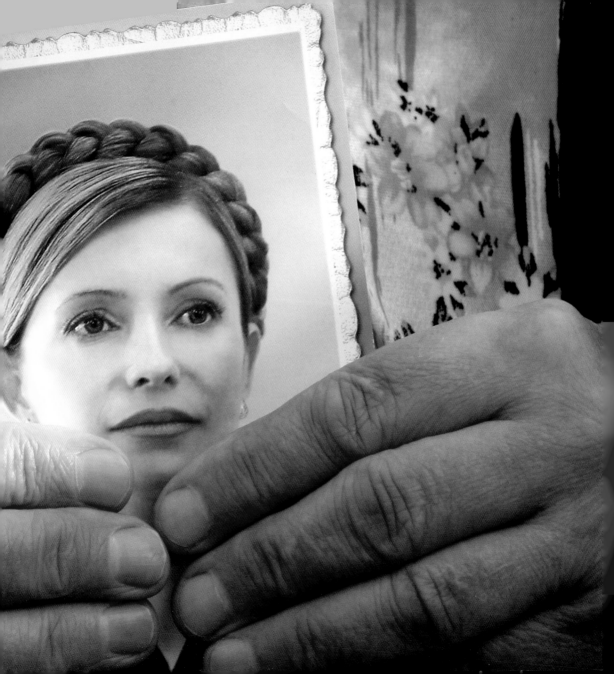

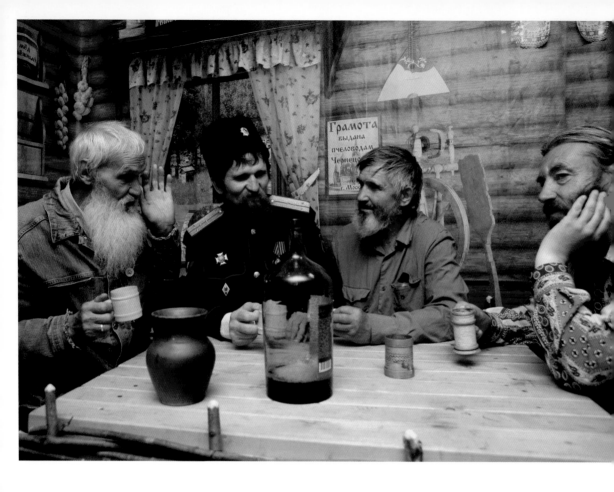

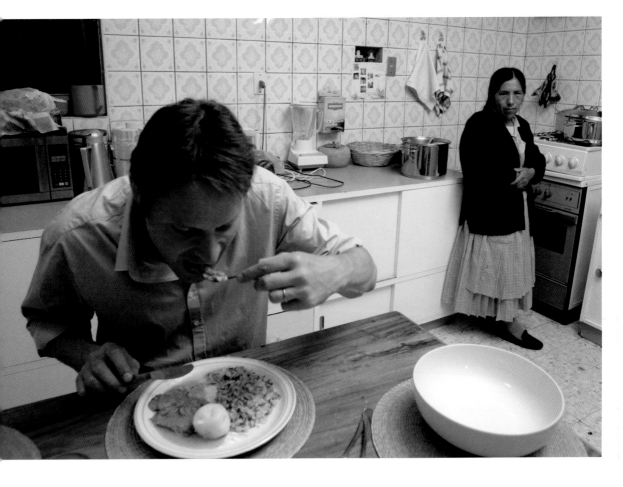

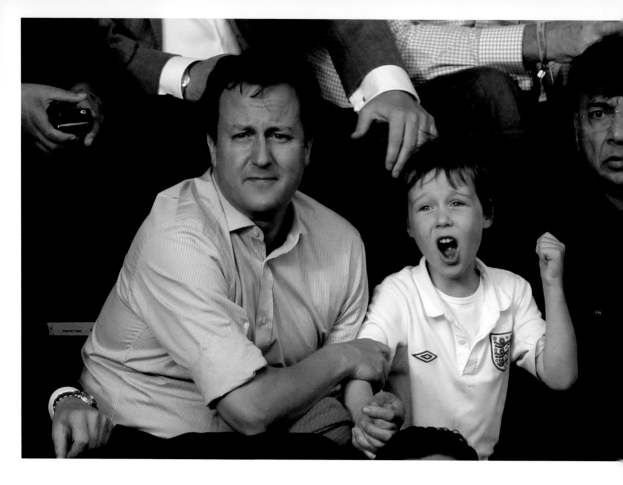

219 Residents of a housing estate watch as demonstrators march in northeast London. The ruling Conservative party said Britain needed to tackle deep-seated social problems following riots and looting in English cities. A U.S. street-crime expert brought in by the government said arrests alone would not solve the problem. 13 August 2011. London, Britain. Cathal McNaughton.

220 Residents gesture as they leave Dale Farm for the High Court. The court was to rule on the legality of evicting Dale Farm travellers from their site in Billericay, southern England. In October the residents were refused permission to appeal, and clearance of Britain's largest illegal travellers' site began. 23 September 2011. Essex, Britain. Luke MacGregor.

221 A supporter holds a portrait of Yulia Tymoshenko outside a court building in Kiev. Tymoshenko had denied the accusations of attempted theft made against her, but the court found the former Ukrainian prime minister guilty of abuse of power, fined her U.S. $188 million and sentenced her to seven years' imprisonment. 6 July 2011. Kiev, Ukraine. Gleb Garanich.

222 Enthusiasts gather to drink *medovukha*, a honey-based alcoholic drink similar to mead, during a meeting of the 'Honey Club' in Russia's Siberian city of Krasnoyarsk. 13 August 2011. Krasnoyarsk, Russia. Ilya Naymushin.

223 Danish chef Claus Meyer eats a typical Bolivian dish called *falso conejo* (faux rabbit) prepared by indigenous Aymara cook Isidora Ascencio, who works at a Danish NGO that supports ethical organizations. Meyer, a well-known chef and co-founder of the Noma restaurant in Copenhagen, was in Bolivia to help create a cooking school that has a true Bolivian identity and uses organic ingredients found in the country. 7 September 2011. La Paz, Bolivia. David Mercado.

224 Britain's Prime Minister David Cameron looks on while his son, Arthur, celebrates a Barry Bannan goal from the penalty spot for Aston Villa during their English Premier League soccer match against Queens Park Rangers at Loftus Road in London. 25 September 2011. London, Britain. Eddie Keogh.

225 U.S. President Barack Obama holds up a baby before eating breakfast with small-business owners at Rausch's Cafe in Guttenberg, Iowa. Obama was on a bus trip through the Midwest states of Minnesota, Iowa and Illinois. 16 August 2011. Guttenberg, United States. Jason Reed.

226 Former IMF chief Dominique Strauss-Kahn and his wife Anne Sinclair try to catch a cab in New York. A U.S. judge dropped all criminal sexual assault charges against Strauss-Kahn after prosecutors lost faith in the credibility of his accuser. 25 August 2011. New York, United States. Allison Joyce.

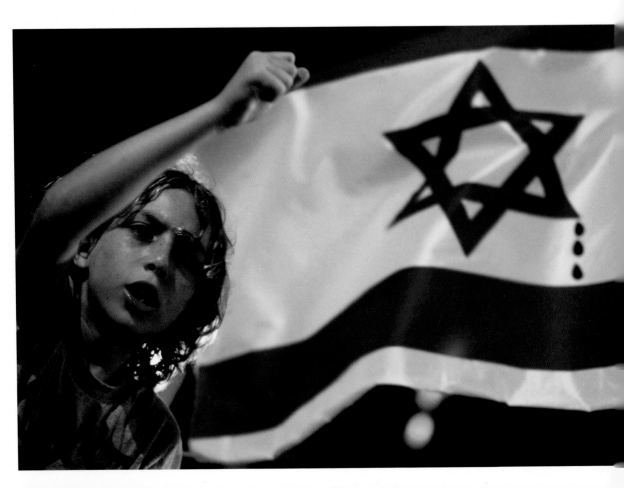

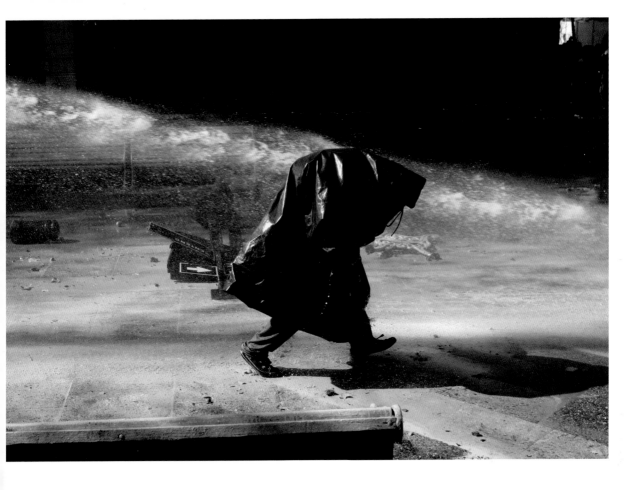

227 A man sets himself on fire outside a bank in Thessaloniki, northern Greece. According to police, the 55-year-old man had entered the bank and asked for a renegotiation of the overdue loan payments on his home and business – which he could not pay – but was refused. 16 September 2011. Thessaloniki, Greece. Nodas Stylianidis.

228 An Israeli boy takes part in a march in Tel Aviv, rallying against rising property prices in Israel. Tens of thousands of Israelis took to the streets to protest against the high cost of living and demand Prime Minister Benjamin Netanyahu undertake sweeping economic reforms. 30 July 2011. Tel Aviv, Israel. Amir Cohen.

229 A demonstrator retreats as a water cannon is fired from a police anti-riot vehicle during a student rally. Protesters in Santiago demanded changes to the state education system. 9 August 2011. Santiago, Chile. Carlos Vera.

230 Police officers receive orders while protesters sleep at Zuccotti Park, New York. Demonstrators camped out before occupying areas outside Wall Street and the New York Stock Exchange, calling for action to be taken against government corruption and corporate greed. 21 September 2011. New York, United States. Eduardo Munoz.

231 A world map, with the Korean peninsula marked in red, is seen at a hotel reception in Rason City, northeast of Pyongyang. 29 August 2011. Rason City, North Korea. Carlos Barria.

232 A man rests inside a booth during a trading session at the Karachi Stock Exchange. Dealers said Pakistani stocks fluctuated in September following worsening relations between Islamabad and Washington. 26 September 2011. Karachi, Pakistani. Athar Hussain.

233 Russian President Dmitry Medvedev and German Chancellor Angela Merkel walk through a garden before their meeting during the German–Russian consultations in Hanover. 18 July 2011. Hanover, Germany. Fabian Bimmer.

234 A tourist looks at a segment of the Berlin Wall covered in chewing gum at Potsdamer Platz in Berlin. In 2011 the German capital marked the 50th anniversary of the building of the Wall. 16 August 2011. Berlin, Germany. Fabrizio Bensch.

235 Feidong, China

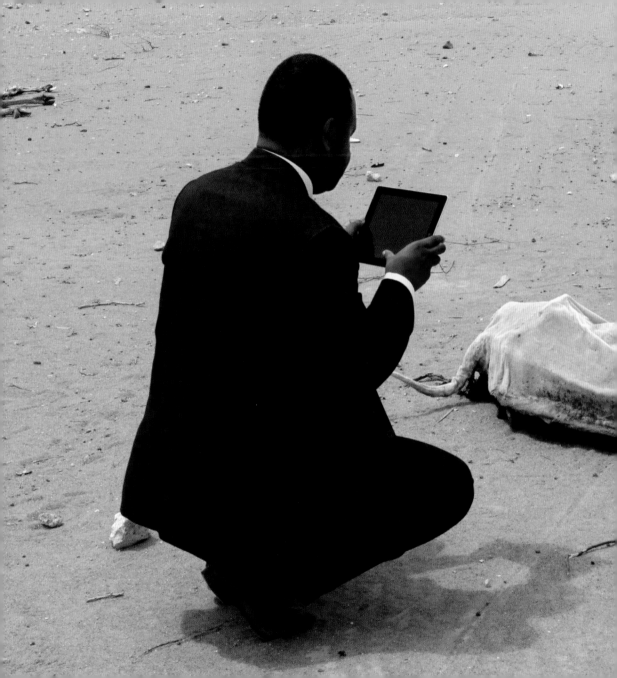

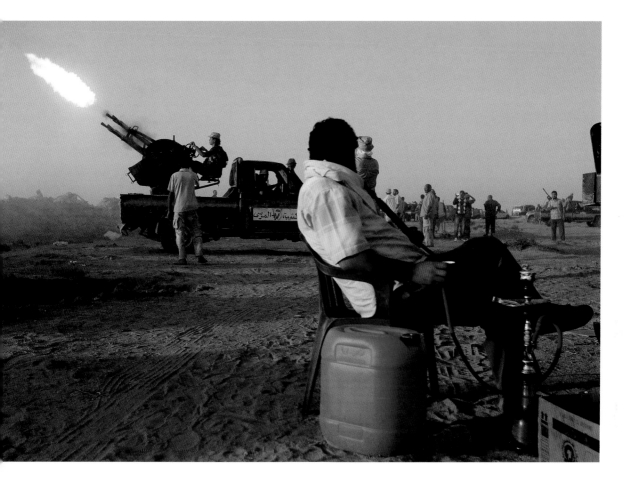

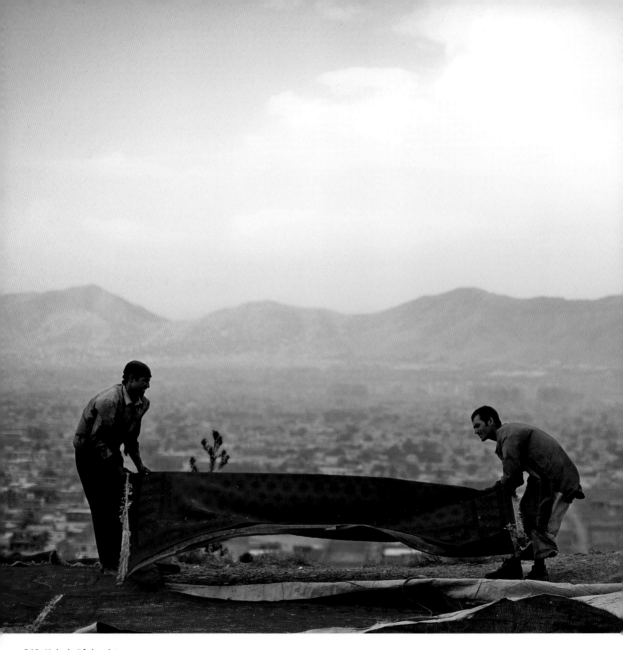

240 Kabul, Afghanistan

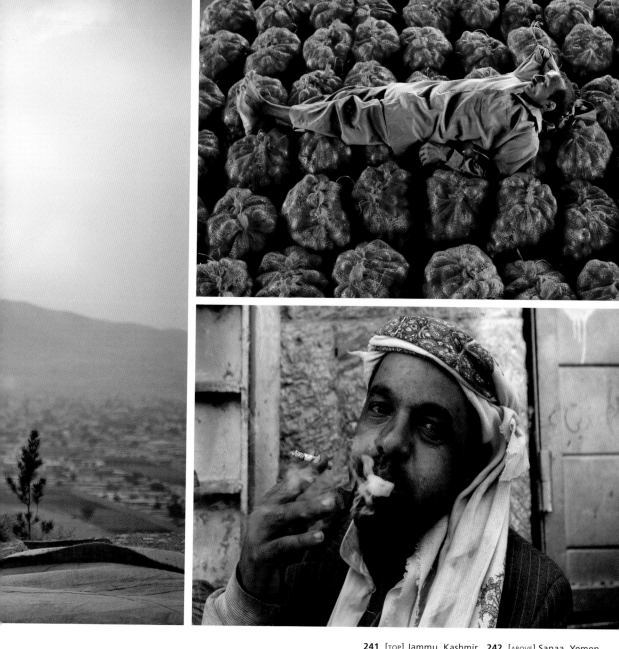

241 [TOP] Jammu, Kashmir **242** [ABOVE] Sanaa, Yemen

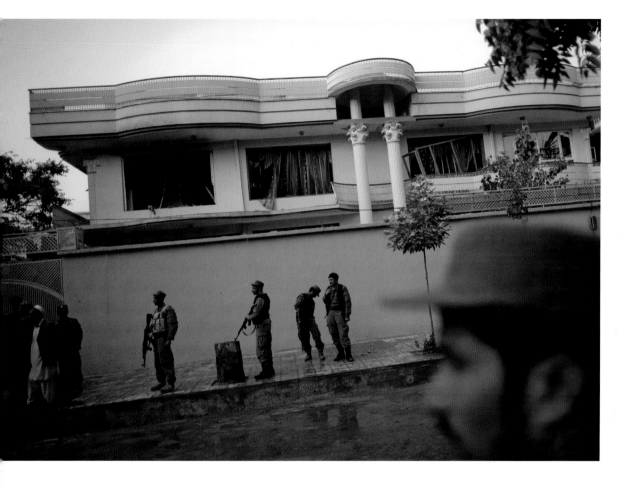

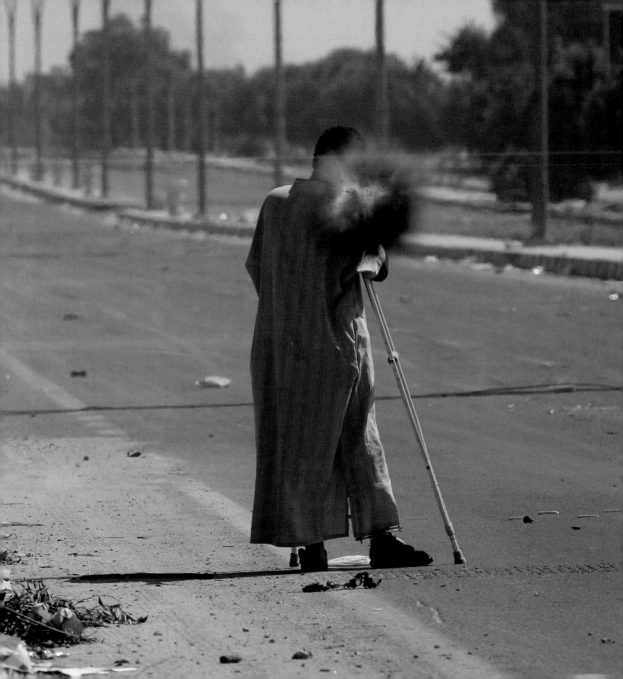

235 Toothbrushes are seen in front of a blackboard bearing Chinese characters that read: 'My heart stays. My alma mater, teachers, goodbye' – left by the previous students at their dormitory at Yangguang Primary School, Feidong county, Anhui province. 31 August 2011. Feidong, China. Jianan Yu.

236 Wang Gengxiang, known as 'Masked Boy', plays on a bed in Mijiazhuang village on the outskirts of Fenyang, in China's Shanxi province. Gengxiang, 6, was severely hurt in an accident involving a pile of burning straw. Most of the skin on his head was burnt off, requiring him to wear a surgical mask to prevent the healing wounds becoming infected. 9 September 2011. Fenyang, China. Jason Lee.

237 An aid worker uses an iPad to film the rotting carcass of a cow in Wajir, near the Kenya–Somalia border. A growing band of aid critics say parts of Africa are doomed to a never-ending cycle of ignored early warnings, media appeals and emergency U.N. feeding, rather than a transition to lasting self-sufficiency. 23 July 2011. Wajir, Kenya. Barry Malone.

238 A young man looks at an Iranian-made Sejil missile at a war exhibition held by Iran's Revolutionary Guard to mark the anniversary of the Iran–Iraq war (1980–88) at Baharestan Square in southern Tehran. 23 September 2011. Tehran, Iran. Morteza Nikoubazl.

239 A rebel fighter tests an anti-aircraft gun southwest of Sirte, one of Muammar Gaddafi's final strongholds. 16 September 2011. Sirte, Libya. Goran Tomasevic.

240 Afghans remove a carpet after the burial ceremony for Burhanuddin Rabbani, a former Afghan president and the country's chief peace negotiator. Rabbani was killed by a suicide bomber posing as a Taliban envoy with a message about possible talks. 23 September 2011. Kabul, Afghanistan. Ahmad Masood.

241 A man takes a nap on sacks filled with onions at a wholesale vegetable market on the outskirts of Jammu. 14 September 2011. Jammu, Kashmir. Mukesh Gupta.

242 A man chews qat, a mild stimulant, as he smokes a cigarette at a Yemen market. 27 September 2011. Sanaa, Yemen. Ahmed Jadallah.

243 Afghan President Hamid Karzai looks down at the grave of his brother Ahmad Wali Karzai during the burial ceremony. The assassination of Ahmad Wali left a power vacuum in Afghanistan's volatile south. 13 July 2011. Kandahar, Pakistan. Ahmad Nadeem.

244 Afghan police keep watch outside the house of Jan Mohammad Khan, who was killed by armed gunmen during an attack in Kabul. Officials said Khan, a top adviser to Afghan President Hamid Karzai and a member of the country's parliament, was killed by gunmen in a residential district of Kabul just days after the president's brother was gunned down at home. 18 July 2011. Kabul, Afghanistan. Ahmad Masood.

245 A Libyan rebel on crutches fires a rocket-propelled grenade while fighting on the front line in Sirte. 24 September 2011. Sirte, Libya. Anis Mili.

4

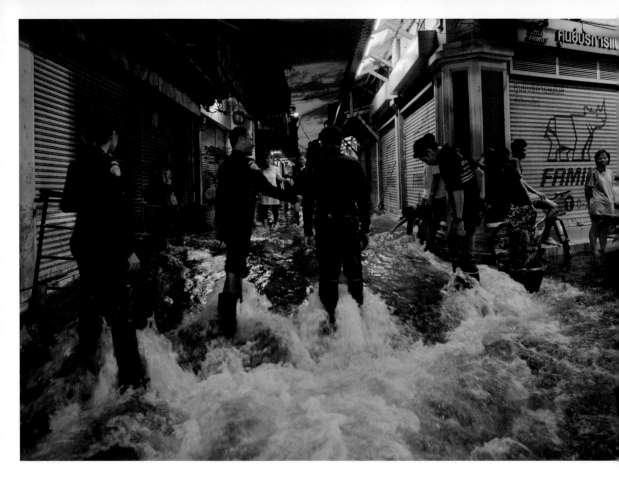

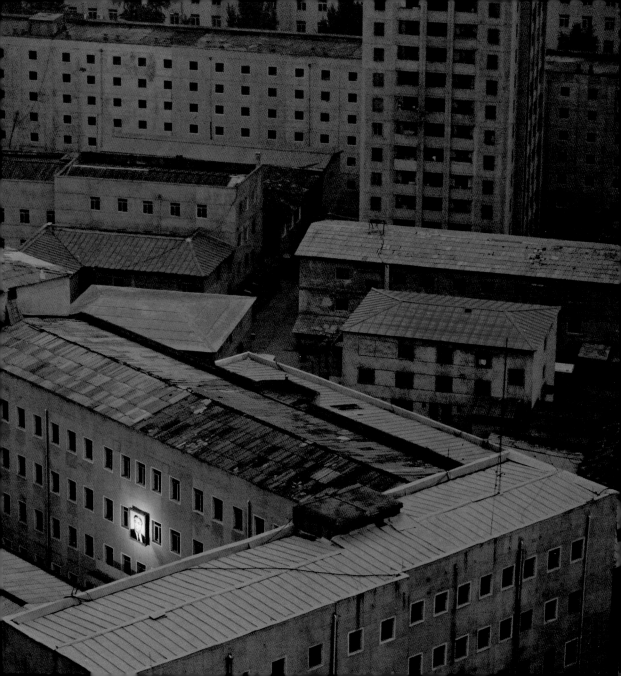

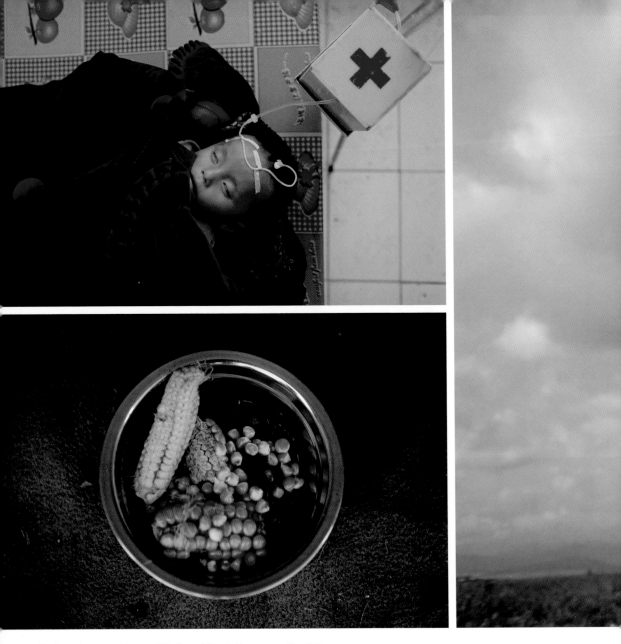

250 [TOP] Haeju, North Korea **251** [ABOVE] South Hwanghae, North Korea

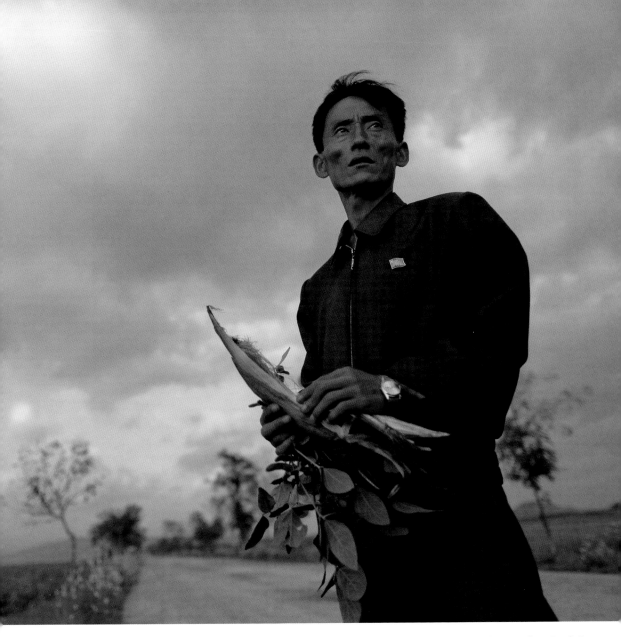

252 South Hwanghae, North Korea

246 247 248 249 250 251 252 253

246 A woman stops to talk to a neighbour emptying flood waters from her residence in Bangkok's Bang Phlat district. Monsoon rainfall and peak tides breached some of the Thai capital's flood defences, as well as swamping suburbs and provinces. As the worst flood waters in over five decades began to recede there was increasing concern about the possibility of outbreaks of waterborne diseases. 30 October 2011. Bangkok, Thailand. Adrees Latif.

247 Police officers wait to assist residents passing through the flood waters in Bangkok's Chinatown. The flooding claimed over 550 lives and affected 63 of Thailand's 77 provinces. 29 October 2011. Bangkok, Thailand. Adrees Latif.

248 Submerged vehicles are seen at the Honda factory in Ayutthaya province. Officials said clean-up work had enabled some factories to resume production by mid-November, though some elements of infrastructure would be out of action until February 2012. 14 November 2011. Ayutthaya, Thailand. Damir Sagolj.

249 A portrait of North Korea's founder, Kim Il-sung, decorates a building in the capital Pyongyang. On 17 December, Kim Il-sung's son and successor, Kim Jong-il, died of a heart attack and state media announced his son Kim Jong-un as the 'Great Successor'. 5 October 2011. Pyongyang, North Korea. Damir Sagolj.

250 A North Korean child suffering from malnutrition rests in a hospital in Haeju, the capital of an area damaged by summer floods and typhoons in South Hwanghae province. Following the disasters, the politically isolated country appealed for food aid. 30 September 2011. Haeju, North Korea. Damir Sagolj.

251 The meal of a woman who lost her house during the natural disasters is prepared in her tent in South Hwanghae province. The region usually produces about a third of the country's cereal supply, but officials say the cold winter wiped out 65 percent of the barley, wheat and potato crops, and summer floods and storms destroyed 80 percent of the maize crop. By the end of September only 30 percent of a U.N. food aid target for North Korea had been met. 30 September 2011. South Hwanghae, North Korea. Damir Sagolj.

252 Pak Su Dong, manager of the Soksa-Ri collective farm in South Hwanghae province, shows damage to agricultural produce. In March, the World Food Programme estimated that 6 million North Koreans needed food aid and a third of children were chronically malnourished or stunted. Rising global commodity prices, sanctions imposed for its nuclear and missile programmes, and a dysfunctional food distribution system had already created a hunger crisis in North Korea, before devastating summer floods and typhoons compounded the emergency. 29 September 2011. South Hwanghae, North Korea. Damir Sagolj.

253 Results showing the previous achievements of a collective farm are displayed in South Hwanghae province. The United States and South Korea, the North's two biggest donors before sanctions, said they would not resume aid until satisfied the military-led communist regime would not divert donations for its own uses and progress was made on disarmament talks. 30 September 2011. South Hwanghae, North Korea. Damir Sagolj.

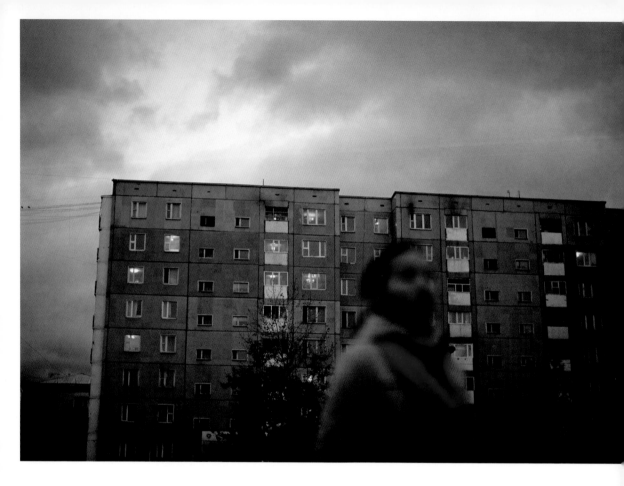

254 Ulan Bator, Mongolia

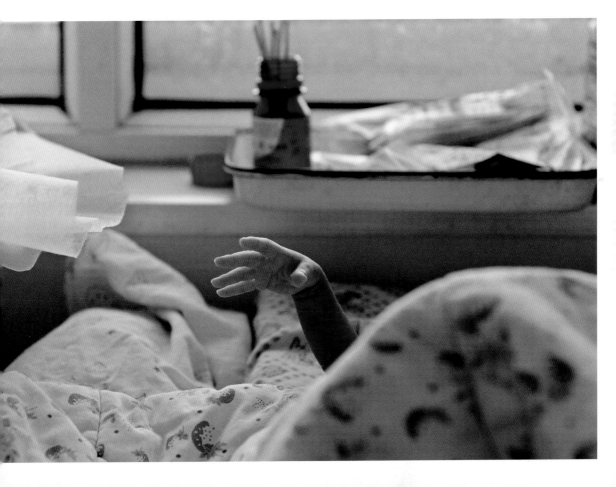

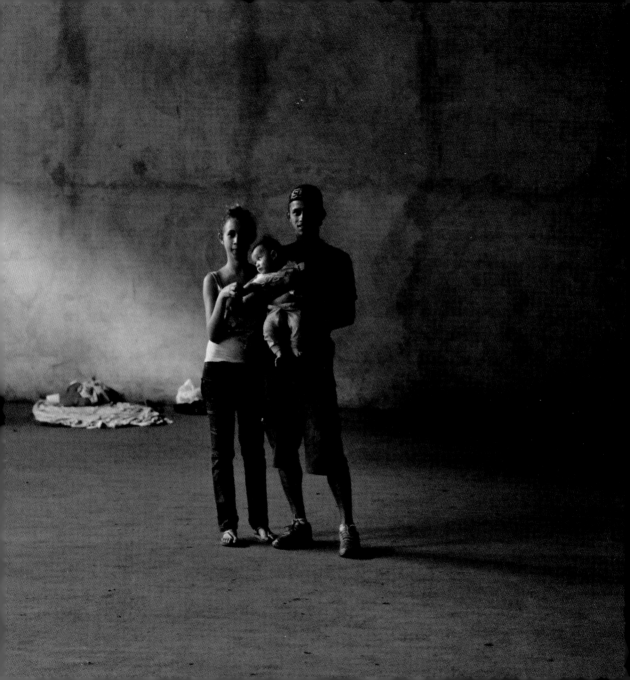

257 Madrid, Spain

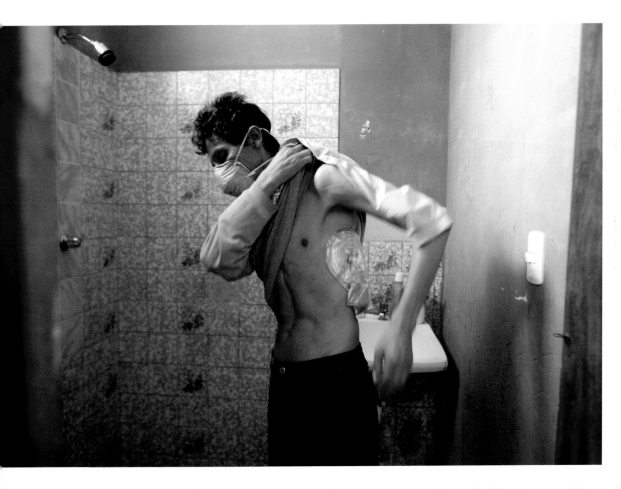

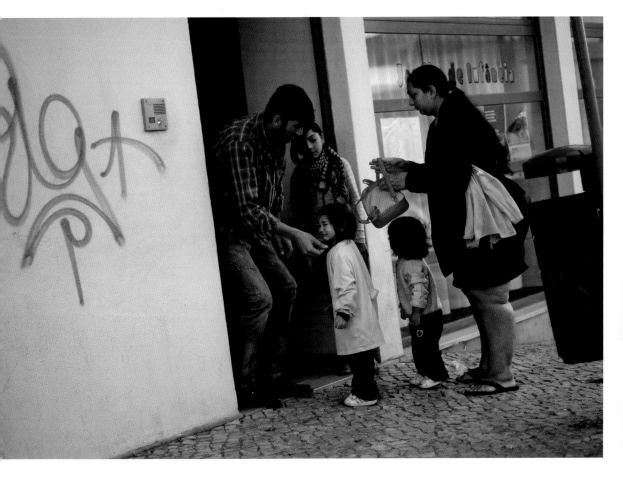

254 A young Mongolian stands outside a block of apartments in the capital, Ulan Bator. Mongolia is the world's least densely populated country, with 2.7 million people spread across an area three times the size of France. 13 October 2011. Ulan Bator, Mongolia. Carlos Barria.

255 A baby stretches its hand from under a quilt at a hospital in Jiaxing, in China's Zhejiang province. According to official U.N. projections, the world's population reached 7 billion on 31 October 2011 – an event the United Nations Population Fund described as both a challenge and an opportunity. 25 October 2011. Jiaxing, China. Chu Yongzhi.

256 Wellington, his wife Tamires and their seven-month-old son pose during the occupation of an empty building in São Paulo. More than 3,500 members of Brazil's Movimento dos Sem Teto (Roofless Movement) occupied 10 buildings in the city's downtown district on 7 November. According to the Brazilian Statistic Institute, São Paulo has 290,000 empty properties. 9 November 2011. São Paulo, Brazil. Nacho Doce.

257 Covadonga Jimenez hangs out washing in front of her demolished residence in the Puerta de Hierro neighbourhood, near Madrid. Spanish gypsy families settled and built houses in the area in the 1960s. The settlers are registered with the town hall and have access to public services, but for the past year and a half have been subject to evictions, with Madrid's town planning board saying the dwellings are illegal. 8 November 2011. Madrid, Spain. Susana Vera.

258 Patients receive treatment at the CareNow healthcare clinic in the Los Angeles Sports Arena, California. The free, four-day clinic offers medical, dental and vision services to those in need. 20 October 2011. California, United States. Jason Redmond.

259 A woman is seen inside a Caesarean section operating unit at Escuela Hospital in Tegucigalpa, Honduras. According to health authorities, about 220,000 babies are born in Honduras each year. Some 65 percent of Hondurans live below the poverty line, and the cost of having a baby delivered at a public hospital is U.S. $10. 21 October 2011. Tegucigalpa, Honduras. Edgard Garrido.

260 Eloy Pacheco, a Peruvian tuberculosis patient, adjusts a lung catheter at his home on the outskirts of Lima. Treatment for tuberculosis costs more than U.S. $2,500 per patient and can last two years. 10 November 2011. Lima, Peru. Enrique Castro-Mendivil.

261 Julieta Gonzalez, 2, waits to go into a back-to-school giveaway at the Fred Jordan Mission in Los Angeles, California. Five thousand homeless and underprivileged children were given clothes, shoes, backpacks and haircuts for the new school year. 6 October 2011. California, United States. Lucy Nicholson.

262 Mateus Silva consoles his daughter as they arrive at her school in Lisbon, Portugal. Silva is unemployed and has been living in a caravan with his wife and their two daughters for 18 months as the family has no money to rent an apartment. 19 October 2011. Lisbon, Portugal. Rafael Marchante.

263 An apartment building is seen from a construction site in downtown Shanghai. The city, with an estimated population of over 23 million, is the largest in the world. 18 November 2011. Shanghai, China. Carlos Barria.

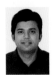

DANISH SIDDIQUI
Photographer
Born: Najaf, Iraq, 1983
Based: Mumbai, India
Nationality: Indian

My Mumbai

I have never before been in a city that is so vibrant in terms of contrast. Mumbai is the country's financial capital, yet also the most populous city in India with migrants pouring in by the hour. Somehow Mumbai provides everyone living in it with an opportunity to earn and survive – be that a white-collar job in a plush high rise, or killing rats by night in the dirtiest parts of the city.

For me, an average day in Mumbai starts with scanning the major dailies and making a few calls before deciding which part of the city to visit. If I commute by rickshaw or taxi I try to chat with the drivers, and if I stop at a roadside tea stall I engage with the owner or the people sitting there. These conversations sometimes lead to the most amazing stories. When I reach my destination, I just walk, observe and take pictures.

With the world's population hitting the 7 billion mark, I decided to visit a slum to photograph the cramped living conditions of Mumbai's migrant population. It was difficult to get access, as the migrants were apprehensive of a journalist, but over a cup of tea I was able to convince a couple of them to open the doors of their one-room world to me. Each 4.5 x 3 m tenement is shared by 5 to 20 people, sometimes more. The one room acts as bathroom, kitchen and living room.

In one tenement, Salim's father was helping him get ready for school – straightening the dark tie of his uniform. A year ago, the 8-year-old made a 22-hour train journey from his village in the northern Indian state of Uttar Pradesh to Mumbai. He joined his 12-year-old brother, who migrated four years ago, and taxi-driver father Zameel in the room they share with other migrants from the same village. 'I came to Mumbai with lots of dreams – to earn money, to have a house. The city has given me a lot', said 44-year-old Zameel, who drives a rented taxi for 12 hours each day. 'My children would not have gotten a city education back in the village. I hope they don't have to drive a taxi like me, I hope they sit in the back of the taxi. If they are able to do that, I will owe that too to Mumbai.'

264 Javed Sheikh, 61, kills a rat. Pest control department employees are expected to kill at least **30 per night.** 18 October 2011. Mumbai, India. Danish Siddiqui.

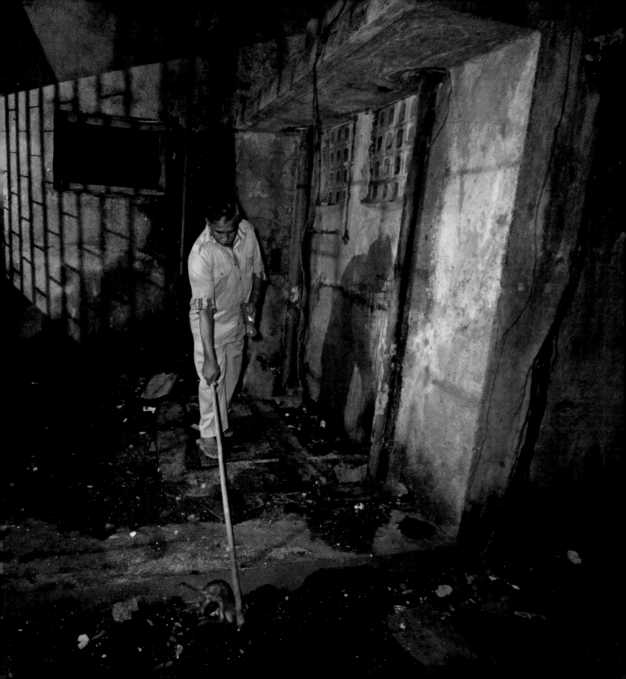

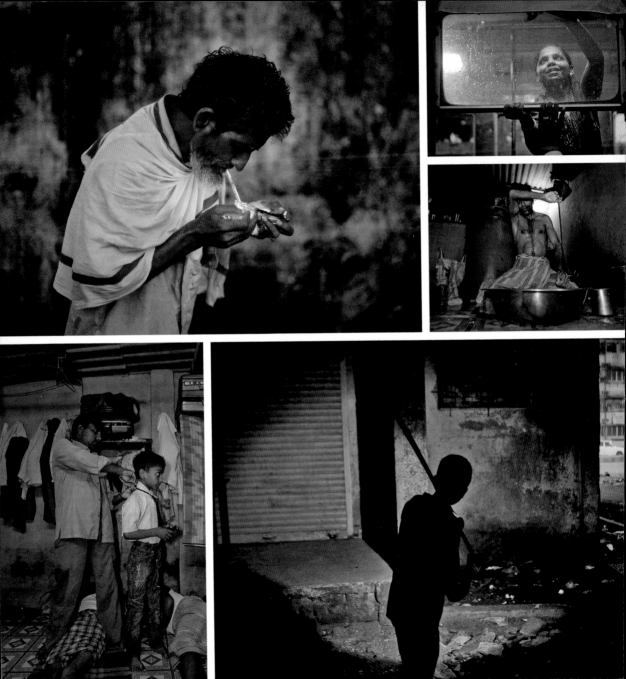

	266	
265	267	270
268	269	271

265 A homeless man smokes crack under a bus shelter in a suburban station. 13 October 2011. **266** Commuters shut the window of a bus as it rains. 13 October 2011. **267** Naseem, a 43-year-old migrant cook, takes a break while kneading flour for 'roti' (Indian bread). 8 October 2011. **268** Zameel adjusts his son's tie inside their one-room dwelling. Ten migrant workers pay a monthly rent of 6,000 rupees (U.S. $123) to live in the small room. 7 October 2011. **269** Waseem Sheikh, 12, holding an improvised stick, searches for rats with the help of a torch outside a residential complex. About 44 night rat killers are employed by the pest control department to kill rodents in Mumbai – the only city in the world that employs full-time night rat killers. 21 October 2011. **270** Naseem walks up a staircase to his dwelling. According to a 2011 census conducted by the government of India, the population of Mumbai is more than 12 million – about 20,482 people per square kilometre. 5 October 2011. **271** Migrant workers watch a movie on a mobile phone. 3 October 2011. Mumbai, India. Danish Siddiqui.

WITNESS

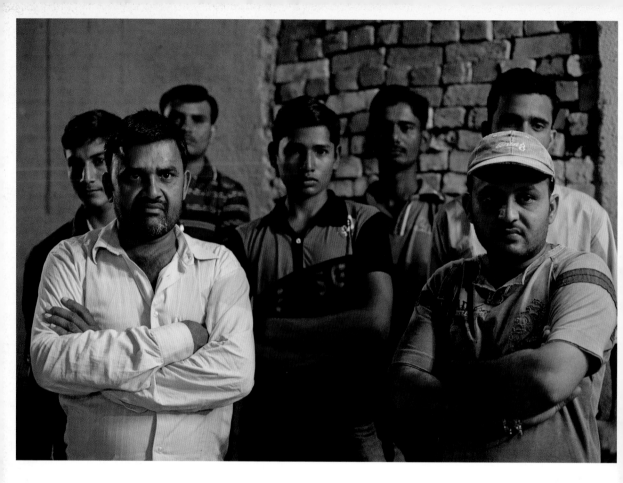

272 Gujarat, India

273 [OPPOSITE] Mizoram, India

274 Lucknow, India

272 Unmarried men watch women dance during the Dussehra festival in the remote village of Siyani, about 140 km (85 miles) west of Gujarat's state capital Ahmedabad. Siyani is typical of many Indian villages in having a low (and diminishing) ratio of women to men. The village has some 350 unmarried men over the age of 35. 4 October 2011. Gujarat, India. Vivek Prakash.

273 Twenty wives – all married to the same husband, Ziona – pose at their residence in Baktawng, in the northeastern Indian state of Mizoram. Ziona is the head of the 'Chana' religious sect, which was founded by his father Chana in 1942 and allows polygamy. Ziona has 39 wives, 94 children and 33 grandchildren. All 181 members of his family live together in a 4-storey, 100-room house. 7 October 2011. Mizoram, India. Adnan Abidi.

274 Simran and Aryan, children of Vishal Singh, relax in their bedroom in Lucknow. Vishal is a fan of the Bollywood actor Shah Rukh Khan and has decorated his house with pictures of the star selected from the 22,000 in his collection. 24 October 2011. Lucknow, India. Pawan Kumar.

275 Teacher Noorzia Khan, 16, writes letters from the Kalasha alphabet on a blackboard at the Kalasha Dur school in Brun village, located in the Bumboret Kalash valley, Khyber Pakhtunkhwa province. The Kalash are a tiny religious community that claim descent from Alexander the Great's army. They make up about 3,500 of Pakistan's population of 180 million. 13 October 2011. Khyber Pakhtunkhwa, Pakistan. Rebecca Conway.

276 A worker stands in front of an Iranian handmade carpet at a workshop in Kashan, 240 km (150 miles) south of Tehran. Persian carpet weaving is an historical part of Iranian culture, dating back 2,000 years. A larger carpet will take two workers about six months to complete and the price is set by officials from the national carpet company after examining each completed work. 13 November 2011. Isfahan, Iran. Morteza Nikoubazl.

277 An attendee holds a rosary while waiting in a hotel lobby during the United States Conference of Catholic Bishops in Baltimore, Maryland. 14 November 2011. Maryland, United States. Kevin Lamarque.

278 Dissident Chinese artist Ai Weiwei closes the door to his studio on his way to the government tax office in Beijing. Ai paid a bond of 8.45 million yuan (U.S. $1.3 million), paving the way to file an appeal against a charge of tax evasion. Shortly after, Ai said: 'The whole procedure, up till today, every step has been illegal and unreasonable.' 16 November 2011. Beijing, China. David Gray.

279 Employees lift an oil painting called *Big Airplane* by artist He Dan as they prepare for an exhibition at a gallery in Xi'an, Shaanxi province. The exhibition's organizer explained that as transportation vehicles become larger, so too does people's fear of them. 13 October 2011. Shaanxi, China. Rooney Chen.

280 Leaves inscribed with the names of female victims of crimes committed during the internal armed conflict in Guatemala lie scattered in front of the Guatemalan embassy in Madrid. A protest was held on the International Day for the Elimination of Violence against Women to denounce the atrocities. 25 November 2011. Madrid, Spain. Andrea Comas.

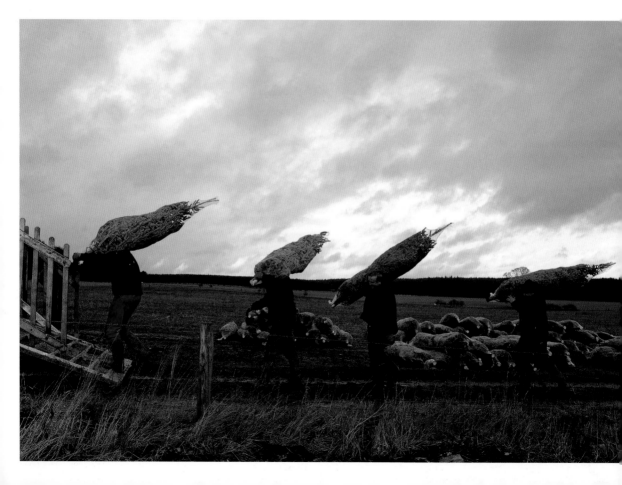

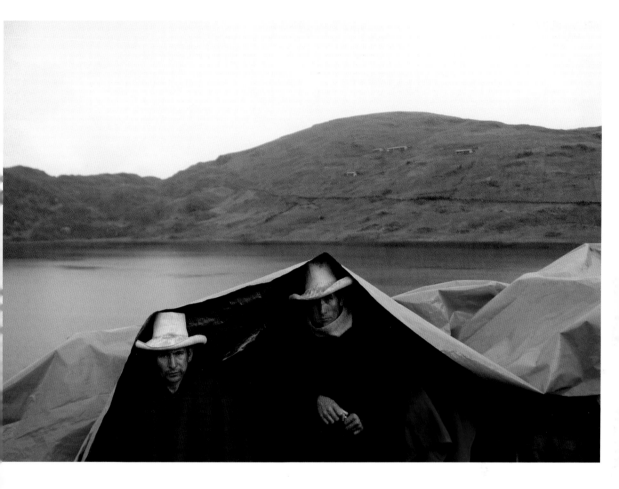

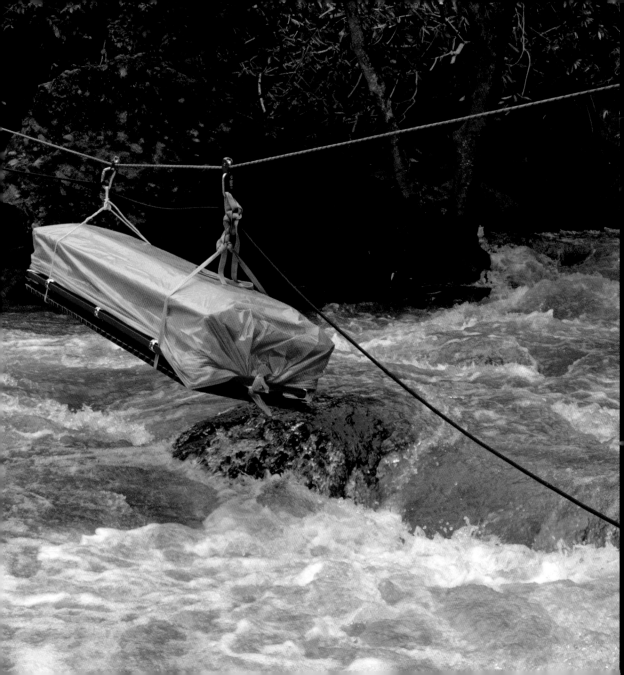

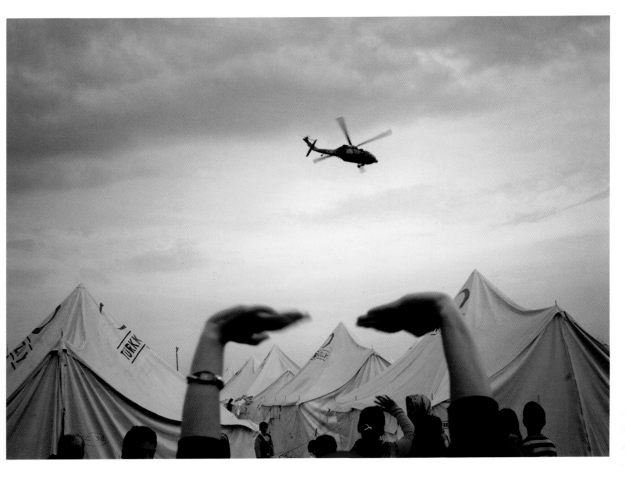

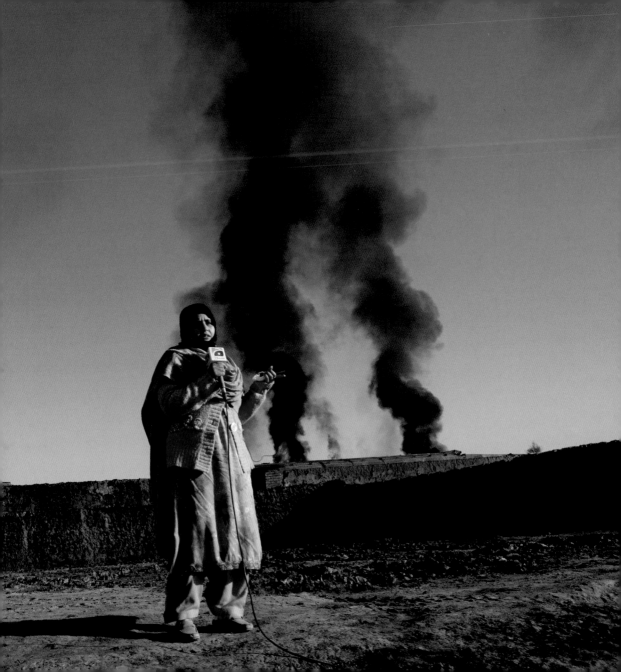

281 282 283 284 285 286

287

281 Workers load trees into a lorry at the Duncombe Park Estate in Helmsley, northern England. The estate has 50,000 fir, spruce and pine trees growing on a 40-acre site. Some 3,000 of the 5,000 trees felled per year are sold at Christmas. 25 November 2011. North Yorkshire, Britain. Nigel Roddis.

282 Andean people shelter from the rain under a plastic sheet in front of the El Perol lagoon in the region of Cajamarca. More than a thousand demonstrators marched in the area to protest against a proposed gold mine, saying it would cause pollution and damage water supplies by replacing a string of alpine lakes with artificial reservoirs. 24 November 2011. Cajamarca, Peru. Enrique Castro-Mendivil.

283 A man travelling to collect the body of a relative conveys a coffin across a river using ropes and pulleys. Twelve people died in the remote community of San Nicolas, 150 km (95 miles) north of Managua, Nicaragua, after heavy rains caused flooding in the area. 20 October 2011. Estelí, Nicaragua. Oswaldo Rivas.

284 A dog sleeps on a sofa next to Van Lake near the eastern Turkish town of Ercis. A 7.2 magnitude quake that devastated southeast Turkey on 23 October displaced an estimated 100,000 residents, and claimed the lives of some 600. 29 October 2011. Ercis, Turkey. Osman Orsal.

285 People wave at a military helicopter flying over a stadium used as a relief campsite for earthquake victims in Ercis. Worried by the prospect of an early snowfall, state authorities attempted to provide tents and prefabricated houses for those left homeless by the quake. 26 October 2011. Ercis, Turkey. Morteza Nikoubazl.

286 Yunus, a 13-year-old earthquake survivor, waits to be rescued from beneath a collapsed building in Ercis, near Van. Over 180 people were pulled from the rubble alive, some of whom had been trapped for over 100 hours. 24 October 2011. Ercis, Turkey. Umit Bektas.

287 A journalist reports while smoke rises from burning fuel tankers in the city of Quetta in Pakistan's Baluchistan province. Police officials said Taliban militants fired rocket-propelled grenades at trucks loaded with fuel and supplies for NATO troops in Afghanistan, setting fire to 25 vehicles. 9 December 2011. Quetta, Pakistan. Naseer Ahmed.

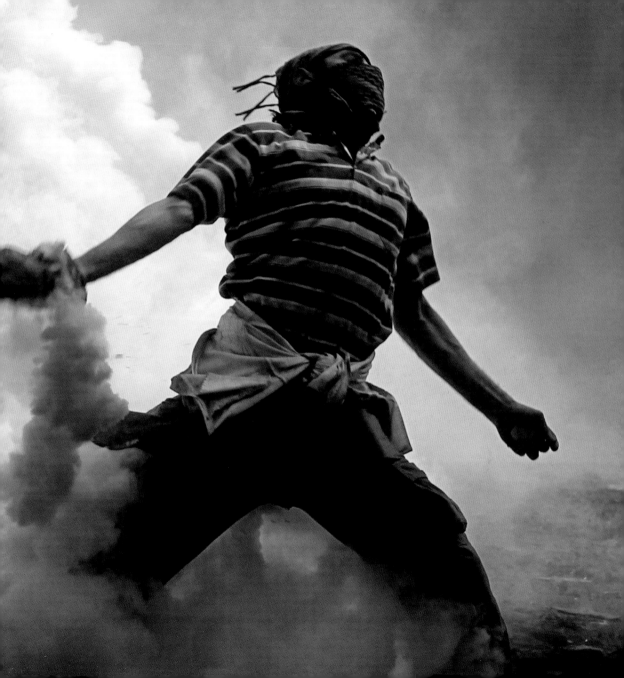

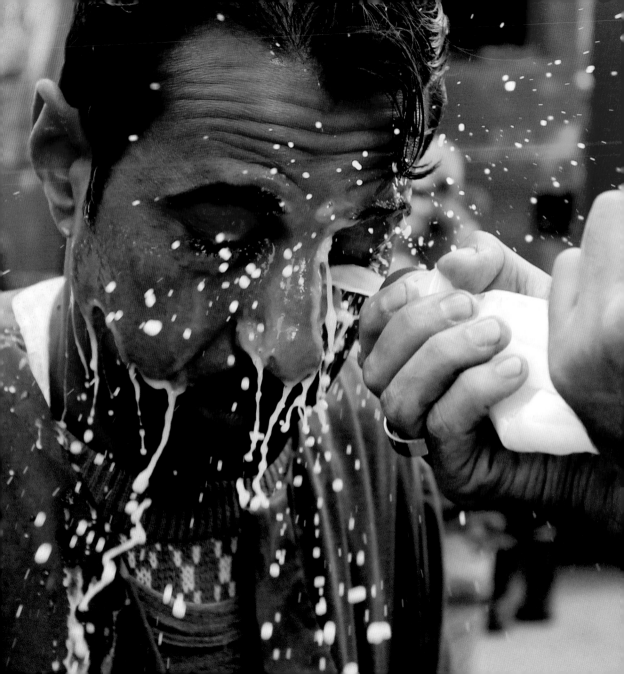

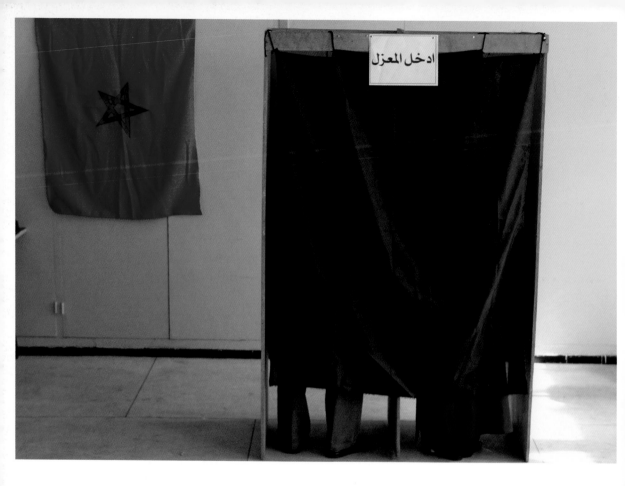

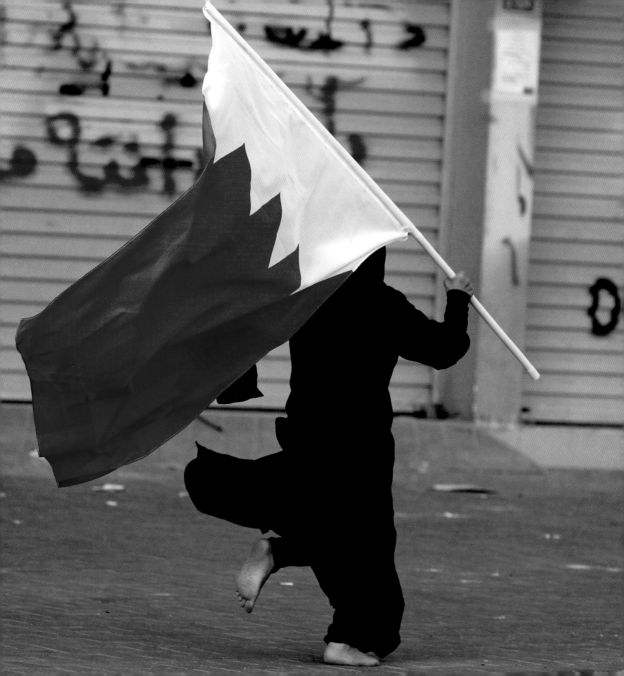

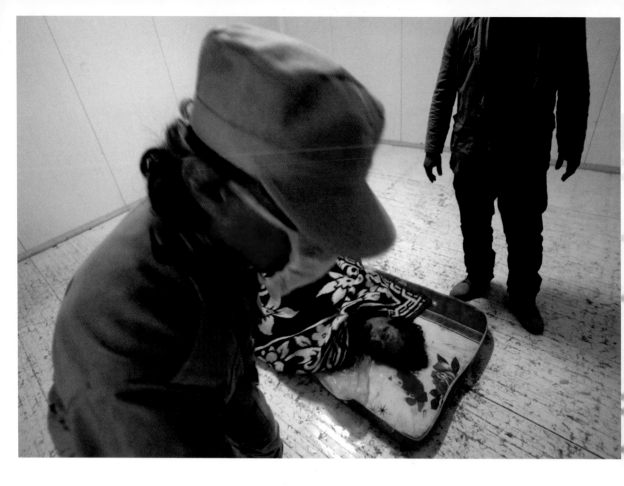

293 Misrata, Libya

294 Sirte, Libya

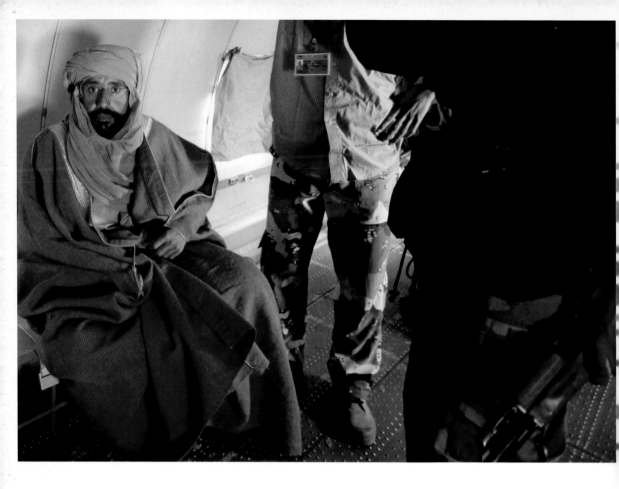

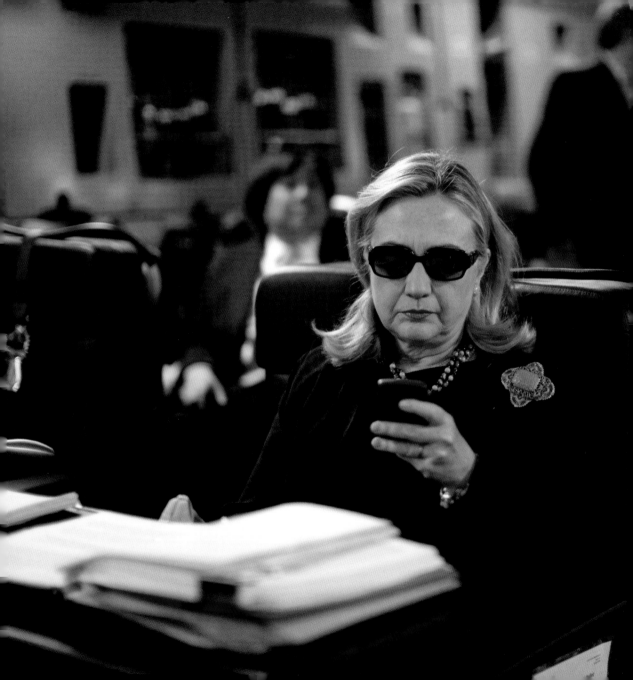

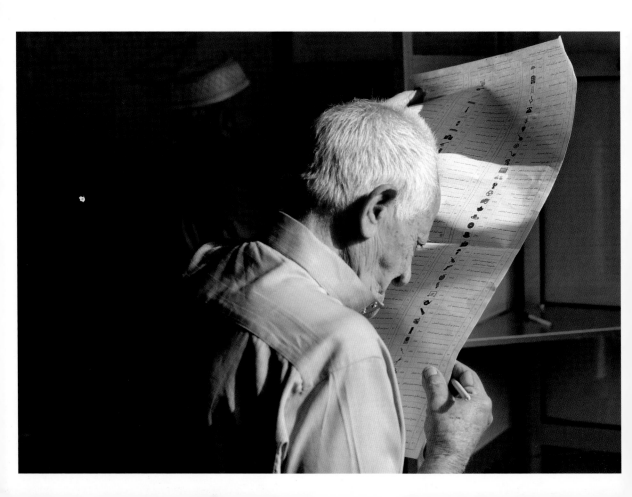

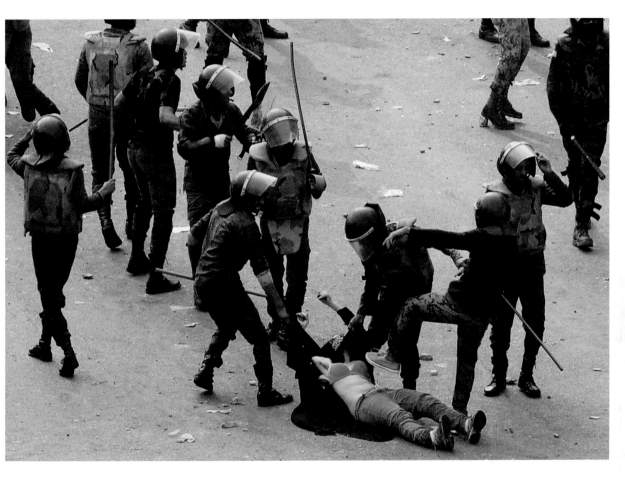

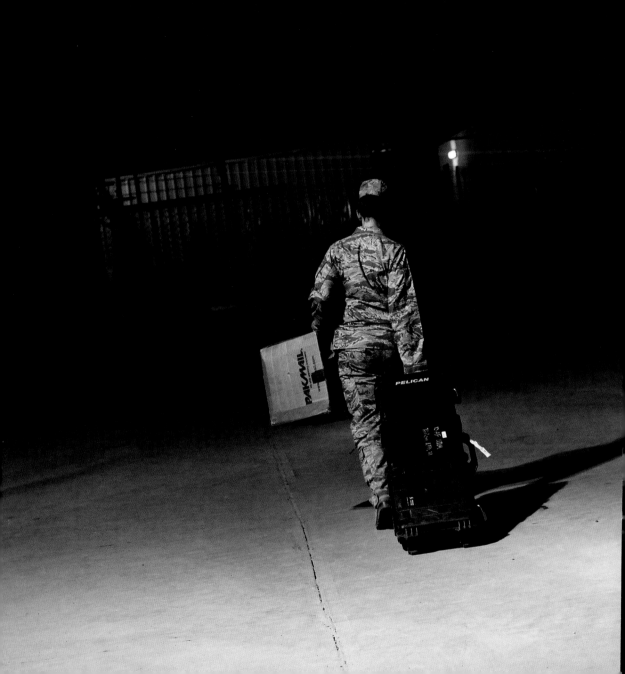

288 A protester throws a teargas canister back at riot police during clashes on a road near Tahrir Square, Cairo. Egyptians frustrated with military rule fought police in the streets, threatening plans for Egypt's first truly competitive election in decades. 22 November 2011. Cairo, Egypt. Amr Abdallah Dalsh.

289 A protester has his eyes washed with milk to protect against teargas, during battles with police in Cairo. 21 November 2011. Cairo, Egypt. Goran Tomasevic.

290 Moroccans stand inside voting booths at a polling station in the capital Rabat. The moderate Islamist Justice and Development Party won most seats in elections, which took place after King Mohammed ceded some powers to prevent any tumultuous spillover of the Arab Spring uprisings. 25 November 2011. Rabat, Morocco. Youssef Boudlal.

291 A girl runs with a Bahraini flag in Aali, south of Manama. Bahrainis clashed with police after the Bahrain Independent Commission of Inquiry found evidence of systematic abuse by security forces during the crushing of pro-democracy protests in February. 24 November 2011. Minṭaqah, Bahrain. Hamad I Mohammed.

292 An anti-Gaddafi fighter fires from a window to suppress loyalist snipers as liberators pushed forwards towards the centre of Sirte – one of the Libyan dictator's last strongholds. 10 October 2011. Sirte, Libya. Anis Mili.

293 The body of Muammar Gaddafi, bloodied and half-naked on a filthy mattress, is seen inside an industrial freezer in Misrata. The exact circumstances of the dictator's death on 20 October are unclear – a senior source at the National Transitional Council said: 'They [NTC fighters] captured him alive and while he was being taken away, they beat him and then they killed him. He might have been resisting.' 22 October 2011. Misrata, Libya. Suhaib Salem.

294 A hat that belonged to a member of Gaddafi's forces is seen on the ground amid spent bullet cartridges. A convoy of loyalist forces, including Gaddafi, had attempted to escape from a compound in Sirte, provoking the clashes in which Gaddafi was taken. 9 October 2011. Sirte, Libya. Asmaa Waguih.

295 Saif al-Islam Gaddafi sits in a plane after being captured by some of the same fighters who overthrew his father. 19 November 2011. Zintan, Libya. Ismail Zitouny.

296 U.S. Secretary of State Hillary Clinton, checks her phone from a military Boeing C-17 Globemaster plane en route to Tripoli, Libya. 18 October 2011. Tripoli, Libya. Kevin Lamarque.

297 A man examines the ballot paper before casting his vote at a polling station during parliamentary elections in Cairo. 28 November 2011. Cairo, Egypt. Ahmed Jadallah.

298 Egyptian army soldiers arrest a female protester during clashes in Tahrir Square, Cairo. Soldiers beat demonstrators with batons in altercations that killed 17 people and wounded over 300, marring the first free election since Hosni Mubarak came to power. 17 December 2011. Cairo, Egypt.

299 A U.S. air force major awaiting withdrawal from Iraq carries luggage to a loading paddock at the former U.S. Sather Air Base near Baghdad. The base was handed over to the Baghdad Diplomatic Support Center on 1 December, marking the end of an eight-year war that cost almost 4,500 American lives and tens of thousands of Iraqi lives. 14 December 2011. Baghdad, Iraq. Shannon Stapleton.

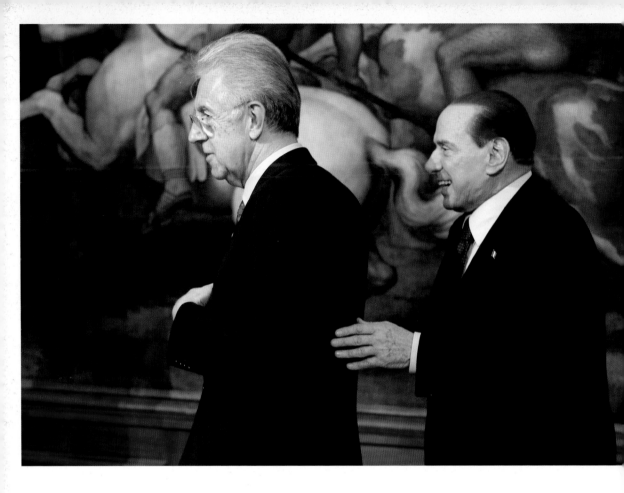

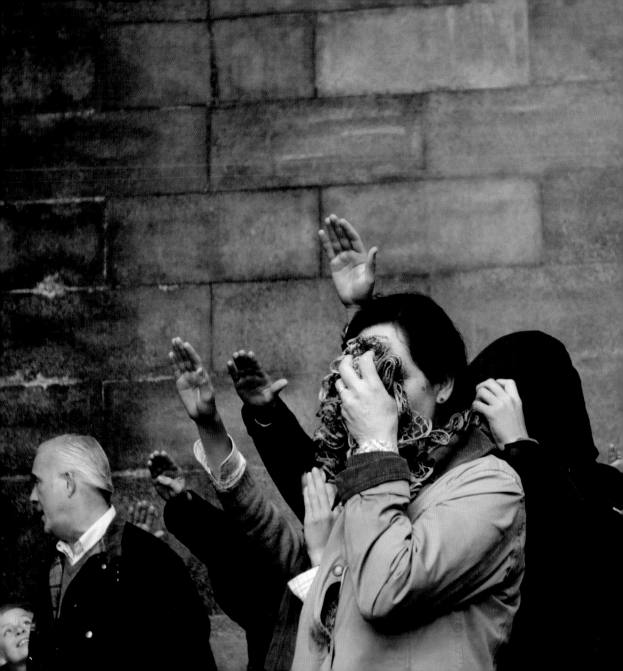

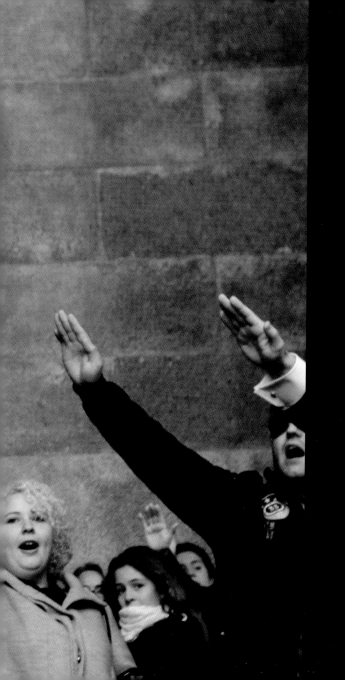

304 Madrid, Spain

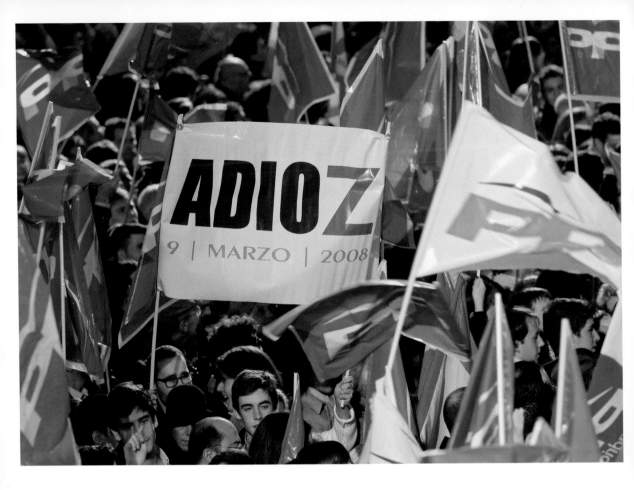

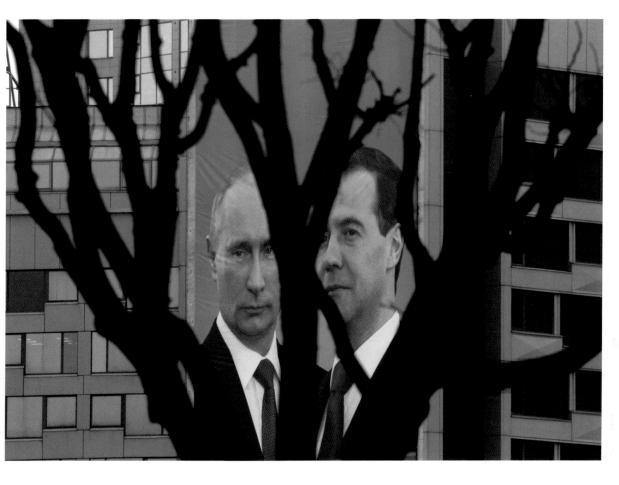

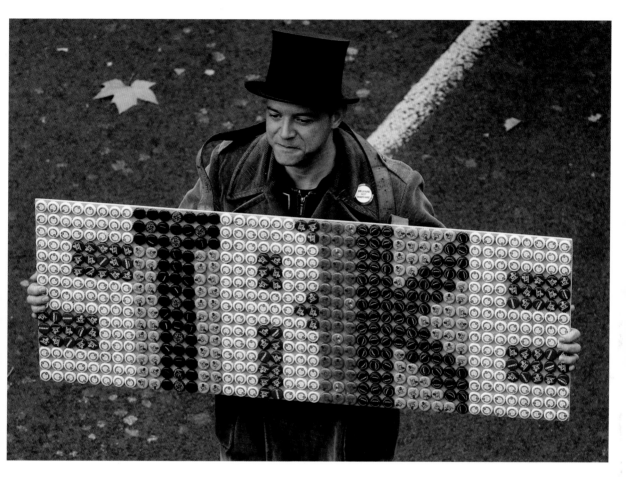

300 François Hollande, one of France's six Socialist Party primary election candidates, appears on stage in Laguenne, central France. On 16 October Hollande was selected to represent the party in the April 2012 presidential election. 9 October 2011. Laguenne, France. Regis Duvignau.

301 People walk past a billboard in Paris showing a photoshopped image of U.S. President Barack Obama kissing China's President Hu Jintao. The Unhate Foundation (set up by the Benetton group) seeks to create a culture of tolerance, partly through this campaign, which shows world leaders kissing each other. 17 November 2011. Paris, France. Charles Platiau.

302 Newly appointed Italian Prime Minister Mario Monti walks ahead of predecessor Silvio Berlusconi in Rome. Monti formed a new technocrat government to tackle the major debt crisis threatening the eurozone. 16 November 2011. Rome, Italy. Tony Gentile.

303 Newly appointed Greek Prime Minister Lucas Papademos (right) shakes hands with outgoing premier George Papandreou in Athens. Papademos took office hoping to save Greece from bankruptcy – heading a coalition cabinet filled with many of the same politicians who led the nation into crisis. 11 November 2011. Athens, Greece. John Kolesidis.

304 A woman covers her face as she performs a Fascist salute. Far-right supporters attended a mass service outside the basilica containing the tombs of Spain's former dictator General Francisco Franco and José Antonio Primo de Rivera (founder of the right-wing Falange group) to mark the anniversary of their deaths. 20 November 2011. Madrid, Spain. Susana Vera.

305 Spain's People's Party supporters wave banners as they wait for the results of the country's parliamentary elections. The centre-right People's Party won an absolute majority, taking 44 percent of the vote. The Spanish Socialist Workers' Party won only 29 percent – the party's worst-ever result. 20 November 2011. Madrid, Spain. Sergio Perez.

306 A poster of Russia's President Dmitry Medvedev (right) and Prime Minister Vladimir Putin is displayed in St Petersburg. Results of the 4 December election, which the opposition said was rigged to favour Putin's United Russia party, triggered discontent with the prime minister months before he attempted to reclaim the presidency at the polls. 1 December 2011. St Petersburg, Russia. Alexander Demianchuk.

307 Britain's Prime Minister David Cameron looks at Germany's Chancellor Angela Merkel during a European Union summit. 9 December 2011. Brussels, Belgium. Yves Herman.

308 A protester takes part in a march by unionized public service workers in London. Teachers, nurses and border agency staff demonstrated over pension reform – Britain's first mass strike for over 30 years. 30 November 2011. London, Britain. Suzanne Plunkett.

309 International Monetary Fund Managing Director Christine Lagarde visits Brazil, hoping to drum up international cooperation for addressing the global financial turmoil. 1 December 2011. Brasilia, Brazil. Ueslei Marcelino.

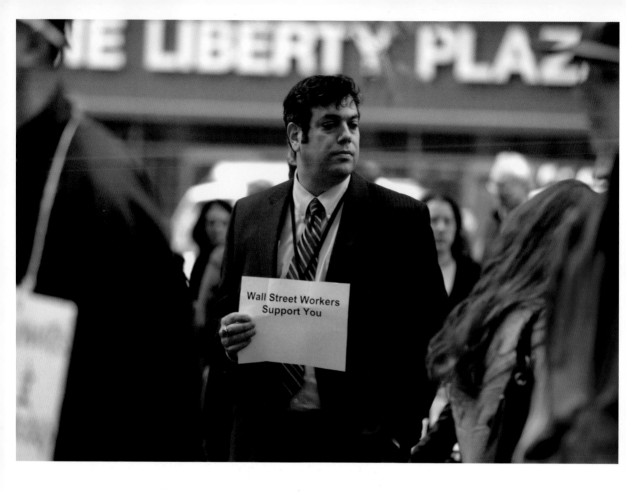

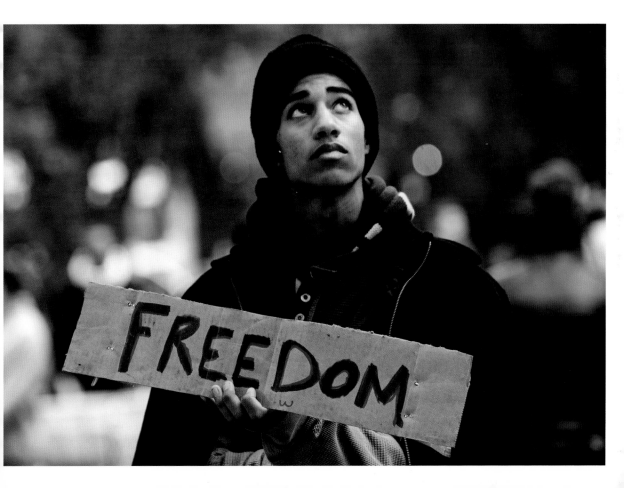

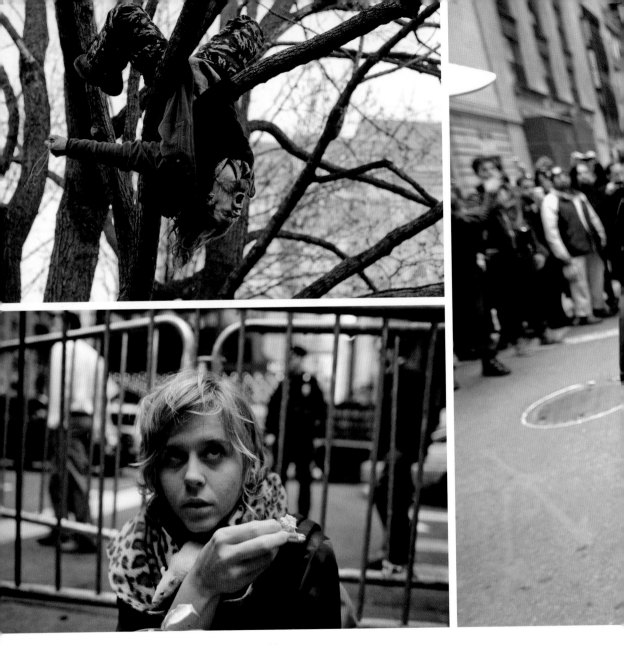

313 [TOP] Toronto, Canada **314** [ABOVE] New York, United States

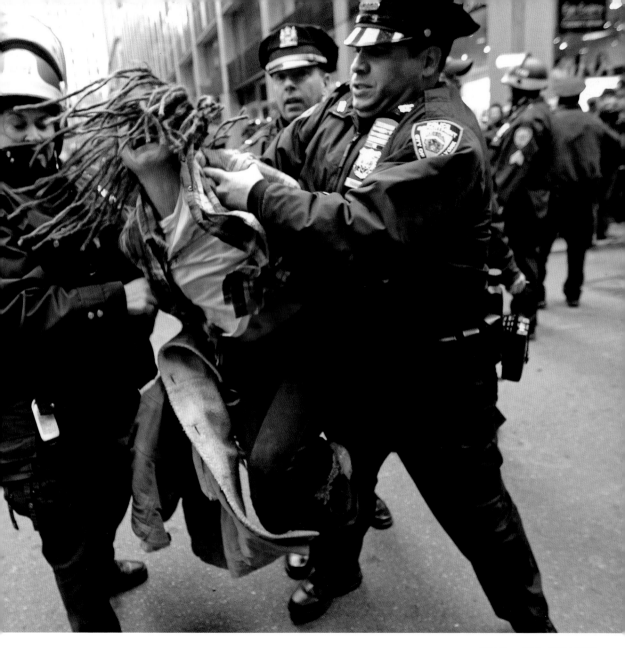

316 [TOP] London, Britain **317** [ABOVE] California, United States

310 Adam Murray, a member of the protest camp outside St Paul's Cathedral, sits in a coffee shop close to the camp, in central London. Adbusters, the social activist group that sparked the movement, called for global protests to demand G20 leaders impose a 'Robin Hood' tax on financial transactions and currency trades. 9 November 2011. London, Britain. Paul Hackett.

311 A man carries a sign expressing solidarity with the Occupy Wall Street protesters in New York's Zuccotti Park. 24 October 2011. New York, United States. Brendan McDermid.

312 At the makeshift headquarters for the Occupy Toronto movement in St James Park a man holds a sign. 17 October 2011. Toronto, Canada. Mark Blinch.

313 A demonstrator shouts from a tree as police walk through St James Park, evicting Occupy Toronto protesters and removing unoccupied tents and garbage. 23 November 2011. Toronto, Canada. Mark Blinch.

314 An Occupy Wall Street protester sits with a mouse in Zuccotti Park, New York. On 15 November, the police began clearing the park. A court order was subsequently released, allowing protesters to return, but police refused to allow them back in. The New York Supreme Court later issued the injunction banning protesters from camping or sleeping in the park. 15 November 2011. New York, United States. Eduardo Munoz.

315 An Occupy Wall Street demonstrator is arrested by New York City Police during what protest organizers called a 'Day of Action'. Hundreds of Occupy Wall Street protesters marched through New York's financial district towards the stock exchange to protest against economic inequality at the heart of American capitalism. 17 November 2011. New York, United States. Mike Segar.

316 A demonstrator uses his laptop in a tent outside St Paul's Cathedral. 18 October 2011. London, Britain. Luke MacGregor.

317 A camper reads a book by candlelight at the Occupy Oakland protest in Frank Ogawa Plaza, California. Demonstrators rejected a call from the city's police union for them to leave their encampment. 14 November 2011. California, United States. Beck Diefenbach.

318 Occupy Wall Street protesters kiss while standing on top of a bus stop during an unannounced early-morning raid by the New York City Police Department outside Zuccotti Park. 15 November 2011. New York, United States. Andrew Burton.

319 Impromptu tributes to the late Steve Jobs are left outside an Apple Store in London. Technology and design admirers flocked to Apple stores worldwide to express their sorrow at the death of Jobs – a visionary who transformed the daily lives of millions. The Apple co-founder, who inspired the Macintosh computer, iPod, iPhone and iPad, died on 5 October at the age of 56 after a long battle with pancreatic cancer. He stepped down as Apple chief executive in August. 6 October 2011. London, Britain. Suzanne Plunkett.

Acknowledgments

Our World Now Picture Editor Ayperi Karabuda Ecer is Vice-President, Pictures at Reuters. She is currently on secondment as Editor in Chief of Picture Today Inspire Tomorrow (ADAY.org). After being Bureau Chief for Sipa in New York, she became Editor-in-Chief at Magnum Photos Paris. Ayperi nominates and judges many international and regional awards, recently chairing the World Press Photo jury. She also shares her expertise with generations of photographers worldwide.

Ayperi has applied her broad editorial experience to help shape a new vision of news photography with the Reuters Pictures team, creating innovative books, exhibitions and multimedia. These include previous best-selling Reuters books, notably *The State of the World* (Thames & Hudson 2006), published in 10 languages. She has produced a programme of touring exhibitions, showcasing the work of Reuters photographers from Shanghai to London. Ayperi initiated the production of award-winning multimedia essays *Bearing Witness*, reflecting on 5 years of war in Iraq, and *Times of Crisis*, charting the impact of the global financial crisis.

With the support of
Reuters Global Head of Multimedia & Interactive Innovation Jassim Ahmad
Reuters Pictures Project Manager Shannon Ghannam

Thanks to: Lynne Bundy, Hamish Crooks, Clarissa Dias Cavalheiro, Ginny Liggitt, Simon Murphy, May Naji, Johanna Neurath, Simon Newman, Candida Ng, Corinne Perkins, Alexia Singh, Laurence Tan, Amanda Vinnicombe, Thomas White, Alison Williams and all Reuters photographers, editors and deskers.

Contributing Photographers

The country that follows each name represents the photographer's nationality

Adnan Abidi, India
Adrees Latif, Pakistan/United States
Afolabi Sotunde, Nigeria
Ahmad Masood, Afghanistan
Ahmad Nadeem, Afghanistan
Ahmed Jadallah, Palestinian Territories
Akhtar Soomro, Pakistan
Alessandro Bianchi, Italy
Alexander Demianchuk, Russia
Ali Jarekji, Jordan
Allison Joyce, United States
Alonso Castillo, Mexico
Aman Mahinli, Turkmenistan
Amir Cohen, Israel
Ammar Awad, Palestinian Territories
Amr Abdallah Dalsh, Egypt
Andrea Comas, Spain
Andrew Burton, United States
Anis Mili, Libya
Asmaa Waguih, Egypt
Athar Hussain, Pakistan
Barry Malone, Ireland
Baz Ratner, Germany
Bazuki Muhammad, Malaysia
Beck Diefenbach, United States
Benoit Tessier, France
Bernadett Szabo, Hungary
Bernardo Montoya, Mexico
Bobby Yip, Hong Kong
Bogdan Cristel, Romania
Brendan McDermid, United States
Caren Firouz, Iran
Carlos Barria, Argentina

Carlos Gutierrez, Chile
Carlos Vera, Chile
Cathal McNaughton, Northern Ireland
Charles Platiau, France
Chris Helgren, Canada
Christian Hartmann, Switzerland
Chu Yongzhi, China
Damir Sagolj, Bosnia and Herzegovina
Danish Siddiqui, India
Darren Staples, Britain
David Gray, Australia
David Mercado, Bolivia
David Moir, Britain
Denis Sinyakov, Russia
Desmond Boylan, Ireland
Diana Markosian, Russia
Dylan Martinez, Britain
Eddie Keogh, Britain
Edgard Garrido, Chile
Eduardo Munoz, Colombia
Emmanuel Braun, France
Enrique Castro-Mendivil, Peru
Eric Gaillard, France
Eric Thayer, United States
Erik de Castro, Philippines
Fabian Bimmer, Germany
Fabrizio Bensch, Germany
Faisal Mahmood, Pakistan
Finbarr O'Reilly, Britain/Canada
Francois Lenoir, France
Gleb Garanich, Ukraine
Gonzalo Fuentes, Mexico
Goran Tomasevic, Serbia
Hamad I Mohammed, Bahrain
Ilya Naymushin, Russia
Ismail Zitouny, Libya
Ivan Alvarado, Chile

Jason Lee, China
Jason Redmond, United States
Jason Reed, United States
Jianan Yu, China
John Kolesidis, Greece
Jon Nazca, Spain
Jorge Dan Lopez, Mexico
Joshua Lott, United States
Kevin Coombs, Britain
Kevin Lamarque, United States
Khaled Abdullah, Yemen
Khuram Parvez, Pakistan
Kim Kyung-Hoon, South Korea
Lasse Tur, Norway
Lee Jae-Won, South Korea
Louafi Larbi, Algeria
Luc Gnago, Ivory Coast
Lucas Jackson, United States
Lucy Nicholson, Britain
Luke MacGregor, Britain
Marcelo del Pozo, Spain
Mariana Bazo, Peru
Mario Anzuoni, Italy
Mark Blinch, Canada
Mike Segar, United States
Mohamad Torokman, Palestinian Territories
Mohamed Nureldin Abdallah, Sudan
Mohammed Salem, Palestinian Territories
Morteza Nikoubazl, Iran
Mukesh Gupta, India
Murad Sezer, Turkey
Nacho Doce, Spain
Naseer Ahmed, Pakistan
Nicky Loh, Singapore
Nigel Roddis, Britain
Nir Elias, Israel

Nodas Stylianidis, Greece
Olivia Harris, Britain
Osman Orsal, Turkey
Oswaldo Rivas, Nicaragua
Pascal Rossignol, France
Paul Hackett, Britain
Pawan Kumar, India
Phil Noble, Britain
Rafael Marchante, Spain
Rebecca Conway, Britain
Regis Duvignau, France
Romeo Ranoco, Philippines
Rooney Chen, China
Samsul Said, Malaysia
Sergio Perez, Spain
Shannon Stapleton, United States
Sharif Karim, Lebanon
Siphiwe Sibeko, South Africa
Sivaram V, India
Stefan Wermuth, Germany
Stoyan Nenov, Bulgaria
Suhaib Salem, Palestinian Territories
Susana Vera, Spain
Suzanne Plunkett, United States
Thomas Peter, Germany
Toby Melville, Britain
Tony Gentile, Italy
Toru Hanai, Japan
Ueslei Marcelino, Brazil
Umit Bektas, Turkey
Vincent Kessler, France
Vivek Prakash, Australia
Yannis Behrakis, Greece
Yasser Hassan, Yemen
Yiorgos Karahalis, Greece
Youssef Boudlal, Morocco
Yuriko Nakao, Japan
Yves Herman, Belgium
Zohra Bensemra, Algeria

A year in the life of our world

www.thamesandhudson.com £10.00

ISBN 978-0-500-28986-0

9 780500 289860

Thames & Hudson